Banker and philanthropist

A PORTRAIT OF ANTHONY DE ROTHSCHILD

Banker and philanthropist

A PORTRAIT OF ANTHONY DE ROTHSCHILD

David Kynaston

HURTWOOD

Contents

Mayer Amschel Rothschild 1744–1812 = (1770) Gutle Schnapper 1753–1849

Jeanette 1771–1859	Salomon 1774–1855	Isabella 1781–1861	Carl Mayer 1788–1855	Henriette 1791–1866

Amschel Mayer 1773–1855

Nathan Mayer 1777–1836 = 1806 Hannah Barent Cohen 1783–1850

Babette 1784–1869

Julie 1790–1815

James Mayer 1792–1868

Lionel 1808–1879 = 1836 Charlotte von Rothschild 1819–1884

Leopold 1845–1917 = 1881 Marie Perugia 1862–1937

Family tree

Lionel 1882–1942 = 1912 Marie-Louise Beer (Mariloo) 1892–1975 issue

Evelyn Achille 1886–1917

Anthony Gustav 1887–1961 = 1926 Yvonne Cahen d'Anvers 1899–1977

Renée Louise Marie 1927–2015 = 1955 Peter David Robeson 1929–2018

Anne Sonia 1930–1971

Evelyn Robert Adrian b.1931 = [1] 1966 Jeanette Bishop 1940–1981 = [2] 1973 Victoria Lou Schott 1949–2021 = [3] 2000 Lynn Ann Forester b.1954

Children of Evelyn and Victoria

Jessica b.1974 = 2010 Alexander (Sacha) Gervasi b.1966

Anthony James b.1977 = 2005 Tania Maren Strecker b.1973 issue

David Mayer b.1978 = 2020 Karina Aleksandra Deyko b.1984 issue

OPPOSITE
Anthony in the colours
of I Zingari cricket club

FOLLOWING PAGE
Page from Anthony's
diary, dated 'Friday July
1st 1910'.

Friday, July 1st 1910. Miyako Hotel, Ky...

By train through various tunnels to Kameoka ...
then shot the rapids of Katsuragawa back again,
water low and really the "rapids" nothing very grand
but the river runs between steep hills all the...
wooded, winding and twisting, the views and sce...
being very attractive, giving also a pleasant vi...
of rural life, men tending rice ... of this I
saw in a long rickshaw ride across country,
green, fertile and cheerful, rice... com...
pretty without any striking feature but all
where... looked prosperous and contented... at
work. Stopped at the Omuro temple where there...
a rice pagoda and the Kinkakuji where I... was
shown through some apartments similar but greatly in...
to Yesterdays. The gardens were the best part and
golden pavilion is well... matching a...
I really think very... next stopped at a Shri...
a few later as arranged. However the deal is done and I
returned to find in the similar shops here the prices...
marked to be exorbitant and considerably higher than
I paid. There are many amount shops here full
attractive goods and I found some nice fra...
... one, of course inferior but supposed to be

Preface

It was a considerable privilege to be asked by The Rothschild Archive Trust to write this book about Anthony de Rothschild (1887–1961). I knew relatively little about him when I began; and I have greatly enjoyed, through a biographical approach based mainly on my research in The Rothschild Archive in London, attempting to draw a rounded portrait of the man in all his variousness as well as the banker at New Court. One day a detailed business history of NM Rothschild & Sons during Anthony's working lifetime will be written, but this is emphatically not that book. My task has been made easier by the much-appreciated help of a number of people: above all, Melanie Aspey, the Director of The Rothschild Archive, for skilfully and sympathetically overseeing this project; her colleagues at the Archive, particularly Natalie Attwood for research on the images and Justin Cavernelis-Frost; Sir Evelyn de Rothschild and Geoffrey Bond for sharing with me some memories of Anthony; Martin Cawthorne for his knowledge of the history of the Royal Hospital Chelsea; Harry Ricketts and Lionel de Rothschild for reading the book in draft form; Sally McIntosh for designing the book; Francis Atterbury of Hurtwood Press, an exemplary publisher; Vaughan O'Grady for copy-editing; Christopher Phipps for compiling the index; and my wife Lucy, not only for her typing, but also for her insights as the draft unfolded. Anthony de Rothschild was a remarkable person. I hope to have done some sort of justice to him.

David Kynaston, June 2022

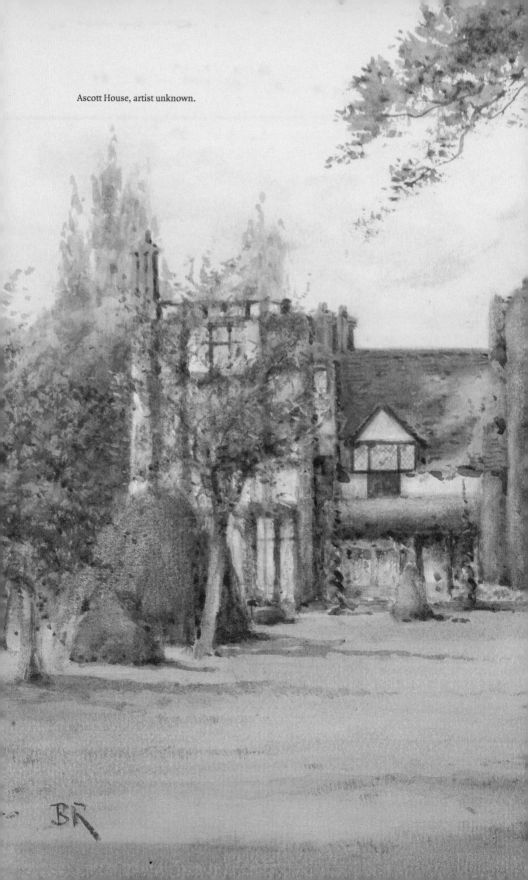

Ascott House, artist unknown.

CHAPTER ONE

I wish I knew my own ambition

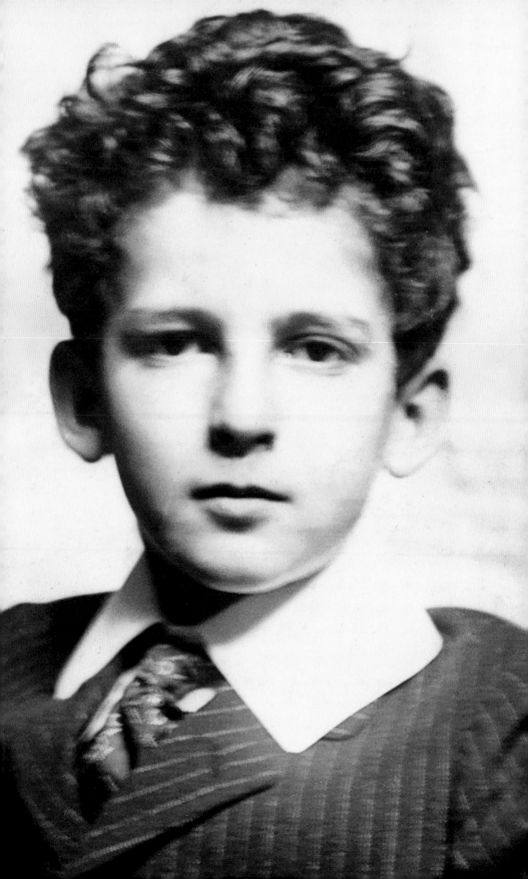

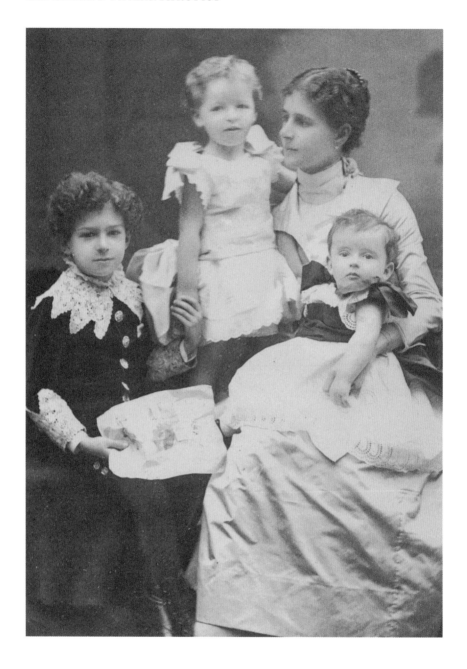

CHAPTER OPENING
Anthony de Rothschild.

ABOVE
Anthony as a baby with his
mother, Marie, and older
brothers Lionel and Evelyn.

Anthony Gustav de Rothschild was born on 26 June 1887 – six days after the celebration of Queen Victoria's Jubilee – at 5 Hamilton Place, his parents' Georgian town mansion just off Piccadilly at the Hyde Park Corner end. His father was Leopold (Leo), a partner in the merchant bank NM Rothschild & Sons; his mother was Marie (daughter of Achille Perugia, of Trieste); and he had two older brothers, Lionel (born in 1882) and Evelyn (1886).[1] As with them, the assumption from the start was that in the fullness of time Anthony would gravitate to the City, where at its handsome premises of New Court in St Swithin's Lane, the bank had been based since 1809 and where the indispensable double qualification to becoming a partner was to be male and to be a direct descendant of Nathan Rothschild, the great founding father.

We have some scattered early glimpses. 'Anthony is very well and is a good boy,' Evelyn reported to their mother in August 1889 during a holiday in Westgate-on-Sea. 'I am very naughty,' he added. We first hear Anthony's own voice in a small pencilled note, circa 1890:

Dear Papa,
Please do come to my doll's Tea Party
　　　　Your
　　　　Thony

Soon a regular correspondence was under way with his mother that would last almost half a century. 'We went to the aquarium this morning and saw such funny fishes and birds there,' he wrote from Brighton in 1891. 'We saw the sea lion also. Coming home we saw punch and judy.' A year later, also from Brighton: 'I had a swimming lesson on Thursday, and I was not at all frightened.'

By 1896 the nine year old was already a clear and lucid correspondent. 'Will you please thank Papa for his nice letter and Lionel has hurt his foot at football but is in quite good spirits,' he wrote from Gunnersbury Park, also owned by his father. 'We brought him some fruit. This morning it was very foggy but it cleared up. Is it not a pity that one of Judy's puppies is dead and the others are as bad as they can be. Mr Tarver remembers himself to you.' JRT Tarver seems to have been an intimate of the family, at this stage probably acting as Anthony's tutor, and next year featured in Anthony's match report on a Gunnersbury cricket team easily defeating the local police: 'Mr Tarver made 81 and took seven wickets for only 6 runs so he had a very successful day.' So too in May 1898: 'Yesterday morning I played a little golf but played very badly. In the afternoon Mr Tarver and I went out for a walk and got drenched.'[2] This was written from Ascott, his father's country house and estate near Leighton Buzzard; and one way and another it was, as so often with the offspring of the very rich, a somewhat peripatetic childhood.

In January 1899, with Harrow in the offing, Evelyn and Anthony were sent to Ashdown House (a leading prep school located in Forest Row, Sussex) to get some training in boarding-school life. 'A more delightful little pair I have seldom seen,' the

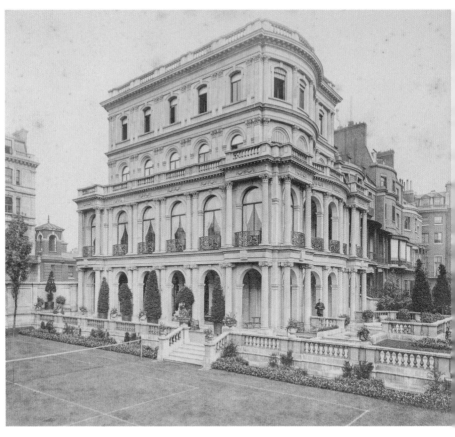

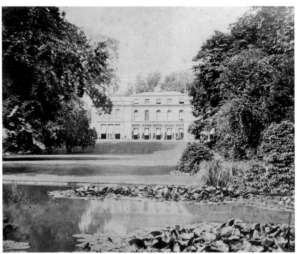

TOP
5 Hamilton Place, London.
Anthony was born here in
1887.

BOTTOM
Gunnersbury Park, the
west London country estate
acquired by Anthony's
great-grandfather, Nathan
Mayer Rothschild, in 1835.

headmaster told their mother a few weeks later. 'They are so keen all round, on their play as well as their work, and so pleased with any little thing one may do for them.' By the summer term, cricket loomed largest in Anthony's despatches home, over the years almost invariably more detailed than Evelyn's. 'We play the Evan's on the 27th,' he informed Marie on 21 May. 'I am afraid we will be beaten as they are very strong, about the strongest we play.' Anthony called it right. 'They made 101 for six wickets and we made 36. Evelyn made 1 and I made 0.' Still, he added considerately, 'I hope you have been playing well at golf lately'. He also included the most recent abstract of marks, showing him lying first in a class of eight (72 out of 120 for Classics, 39/48 for Mathematics, 39/42 for Modern Languages, 48/60 for English Subjects, and an almost suspect 30 out of 30 for Conduct).[3]

By September the boys were ensconced at Harrow School in Newlands with Frank E Marshall as their housemaster. 'Delightful little fellows,' he informed Leo later that autumn. 'Possibly Anthony is a little too gay & needs a little steadying to his work, – but it is very natural at his age in this very free life.' 'At his age' indeed: tellingly, the 'Pupil Room' report in October which called Anthony 'decidedly bright' also revealed that the average age of the boys in his form was 15.1, whereas he had only turned 12 a few months earlier. 'Am very satisfied with his general conduct & punctuality: has done his best to please in every respect: has worked hard at his Hebrew, delighting in his task,' ran his report at the end of the Michaelmas term. In short: 'Am well pleased with him.'[4]

New Year's Eve 1899, by most contemporary reckoning the end of the century, saw Leo, Marie, the three sons, the former prime minister Lord Rosebery (who had married a Rothschild), Tarver, and other friends and relations all gathered at Ascott, the house that was always closest to Anthony's heart. Also among those present were the racecourse manager Hwfa Williams and his wife Florence, a renowned socialite:

From outside Ascott looks like a very old and charming Tudor cottage [she recalled in the 1930s about the place as she had known it before the First World War]. It is a long, low house with lattice windows; from outside it does not appear large, but when one gets inside it seems to expand into an enormous country house...

Looking out from the bay windows of one of the lovely long rooms, one sees a vista of the most perfect garden imaginable, winding down into a wonderful stretch of open country. Such a garden, all designed by himself [i.e. Leo]. In the spring the cherry trees and beds of flowering shrubs and tulips, forget-me-nots and irises make the most perfect setting...

I think I would rather live at Ascott, Wing, than at any other country place I know, because it is so *heimlich* and peaceful. Everything is perfect. But with all its perfections there is no touch of ostentation in the house or gardens; the

kitchen gardens and their mellow red-brick walls against which are trained espalier fruit trees; the hothouses that are filled with roses in the depth of winter; the luxurious fruit trees that supply them with fruit the whole year round – what a lovely place it is!

'What fun we had at that party!' she remembered about that historic New Year's Eve. 'Lord Rosebery made a delightful speech after we had all drunk to the new century and we were given lovely little gold charms, with two hands clasped, set in diamonds and sapphires. Our names were all carved in one of the oak panels of the dining-room wall.' Next day there was 'a meet', for the local foxes a perilous start to the 20th century, and she admired Leo, Marie and their sons 'each with a second horseman, and all beautifully mounted'.[5]

Yet perhaps the old century had not in fact ended in 1899, for on New Year's Eve 1900 another Rothschild gathering was held – this time at Mentmore, Rosebery's home, in order 'to see the 19th century out', according to the senior Treasury official (and Rothschild confidant) Sir Edward Hamilton, who had also been present at Ascott a year earlier. Those attending this time included Nathaniel ('Natty'), 1st Lord Rothschild, and his two sons, as well as 'the Leos and their three boys'. 'Rosebery after dinner,' continued Hamilton, 'proposed "prosperity to the house of Rothschild" in a touching little speech, which elicited tears from Natty & Leo.'

In truth, now and over the next few years, the consensus amongst informed observers was that the best days for that house were behind it. 'The Rothschilds have nothing now but the experience and great prestige of the old Natty,' reflected Morgan Grenfell's Clinton Dawkins just a few weeks later; soon afterwards, the great financier Sir Ernest Cassel offered his crisp verdict that Rothschilds were 'absolutely useless & not remarkable for intelligence'; 'they refuse to look into new things,' observed Lord Revelstoke (senior partner of Barings) two years later, adding that 'their intelligence and capacity is not of a high order'; while in 1905, even the loyal Hamilton admitted that though the firm had 'a sort of prescriptive right to be consulted by the Government,' they were 'being rather left behind in the great race'.

Natty, Alfred and Leo were by this time all in their sixties, so the question of who would follow them was starting to become pressing. Dawkins back in 1901 had offered the bleakest of assessments: 'The coming generation of the Rothschilds est à faire pleurer.' He was surely thinking of Natty's two sons, Walter (born 1868) and Charles (born 1877), neither of whom, especially Walter, took to finance with any great relish – so much so in the case of the older brother that he would abandon New Court in 1907 and devote himself full-time to zoology.[6] It did not take a Nostradamus to predict that, with Alfred childless, a huge amount would in time depend on Leo's 'three boys'.

Anthony's career at Harrow suggested that he was made of the right stuff. Certainly, reports between March 1900 and March 1901 were broadly positive:

A most promising boy.

Excellent work. A little gloomy in manner.

Good. Sometimes inclined to be childish in behaviour, but he is a child at present, and it is a pleasure to teach one so quick.

I consider him distinctly the abler of the two [i.e. Anthony and Evelyn] and am sure he is not doing his best. He can be as sharp and precise as anyone when he likes, instead of which he is dreamy & lets his wits go wool gathering.

Doing v. fairly. I have a very high opinion of this boy's ability.

Has a quick and ready mind, assimilating new information without difficulty.

His work is always interesting and often acute.

'His place is very remarkable for his age' was the comment in December 1901, as Anthony (14½) came sixth out of 26 in a form where the average age was a little over 17. Over the next two years he seems to have been ill quite a lot of the time, including a bout of scarlet fever which had him away from school for several months; but in February 1904 he won the headmaster's literature prize, with Marshall telling Leo that 'taken with the mass of Homer he read in the holidays it is a very considerable achievement'. The apogee was in September 1905, when Anthony became head of the school – the first Jewish boy to do so in Harrow's history; and Marshall, now retired but still in the loop, informed Leo in October, 'I hear that he seems to have entered on his headship of the school with spirit: and to promise well in that capacity.' A flavour of his actual work comes through in a passage near the end of a very lengthy essay (undated but probably from his last year or two) entitled 'Manners maketh Man: Character':

> ... But character often seems contradictory and incongruous: in the same man are found not infrequently two opposite attributes. This difficulty, however, need not detain the student of character, for to be understood character must not be dissected, it has an individuality of its own as a whole. Hence to know the several qualities that may make up a man's character may be to know nothing. It is like a dish made from a receipt by an inexperienced cook: though all the ingredients may be there, what the result will be no man can tell.

'Excellent' wrote his housemaster on his final report, in July 1906. 'I am very grateful to him & part from him with very real regret.'[7]

For most of his Harrow years, it is the letters written to his mother that give us a more intimate sense of the young, developing Anthony. Take a dozen or so brief extracts:

> Is it not good that Spion Kop is captured? (26 January 1900)

> Did Mrs Maguire go to Ascott? If she did do write and tell me what she says about the seige of Kimberley. I had a letter from Lionel on a great big

sheet of <u>fool</u>scap with nothing on it but about 6 words. Very *poor* joke don't you think so. (*21 February 1900, or possibly 21 March 1900*)

Is Buller going to advance through Laing's Neck or what is he going to do? (*16 May 1900*)

I have had my photograph taken. Is it not good of me? I find that it will come to 10s/6d. Could you send it to me. Is it not a bore about Papa's gout? (*1 December 1900*)

I liked the idea of getting Ruskin's works very much and so I have asked Aunt Emma for them. (*9 November 1901*)

I want a good many clothes for next holidays, a pair of medium thick black boots with nails, flannel shirts, riding suits and boots? Evening suit, and as I have got a medium thick suit tweed for wear but not a very thick one, I don't know if I want one. (*20 November 1901*)

I hope you are not too good at Ping Pong and will beat me as if you are I won't play you. (*2 December 1901*)

I am still the lonely and solitary occupant of this place so luckily till now I don't appear to have infected anyone with my disease. (*5 February 1902, in the school sanatorium recovering from measles*)

Have you read the So-So stories in Punch, I can't make out which the Campbell-Bannerman one is. Is it the Armadilloes? (*29 October 1902*)

We tried to play cricket on Thursday but the ground was like a mud pie. So really I have had nothing to do the whole week, except wait to hear what won the races at Ascot, then to read the Sportsman, and afterwards to speculate on how many Derby winners Papa has got. (*21 June 1903*)

Lionel [five years older than Anthony] is coming down here [Harrow] next Saturday; I suppose he is quite the busy City man now; will we have to treat him with even more respect than is usual? (*11 November 1903*)

I can now think of nothing else except St Amant and the Derby... (*1 May 1904, a few weeks before Leo's horse triumphed at Epsom in a memorable thunderstorm*)

I thought my report rather dull, containing a good deal of meaningless stuff which they had to put in as they wanted to say something. (*14 November 1904*)[8]

Letters to his father are less revealing of his emerging character, but a nice touch came in 1904 in relation to Leo's latest racehorse: 'Is "Loplolly" any good, but how could you give it such a name! I am sure Mamma was not there when you decided on it.' The following year, the eighteen year old Anthony, methodical and self-improving, started compiling regular lists of books he had read; among those featuring in December 1905 were Sir Walter Scott's *The Legend of Montrose*, Oscar Wilde's *De Profundis* and

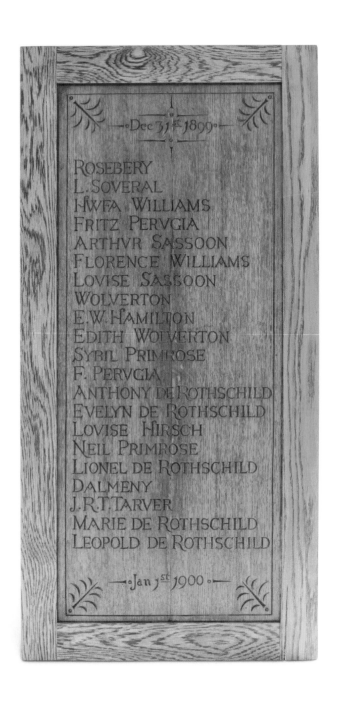

Guests at Ascott, New Year's Eve 1899.

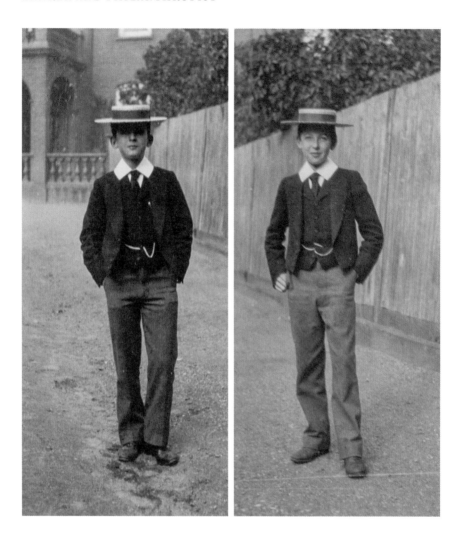

Anthony and Evelyn,
'delightful little fellows',
at Harrow.

Charlotte Brontë's *Jane Eyre*.[9] He would soon be reading History at Cambridge, but from the start it was literature that mattered at least as much to him.

At Trinity College itself, despite reputedly hunting for five days out of seven, as well as representing the university at tennis against Oxford, Anthony still secured a First in both parts of the Historical Tripos. Two-thirds of the way through, in June 1908, he received a touching coming-of-age letter from Uncle Alfred to 'My dear Tony':

> At 21 years of age a man is supposed to become suddenly emancipated, and as such, to become cognisant of his position in life – we however in that respect have a great advantage because we for some years past have recognised & appreciated in you a youth especially endowed with intelligence, an intelligence in its turn especially embellished with all the charms & attractions of an exceptionally sweet & modest nature; to such a combination I do not think that you can add...

It is clear that Alfred identified in his nephew the qualities that the family firm would need for its long-term survival. He continued with a nod to Anthony's recent admirable performance in the examination rooms: 'I am sending you a little water colour drawing for your kind acceptance, and the man who can write a prize essay on the respective merits of the law giver & the soldier must, I am sure, have in his composition an appreciation of everything that is artistic & poetic.'[10]

Soon after going down from Cambridge, Anthony undertook the semi-ritual, for someone of his background, of a round-the-world trip. He kept a diary for roughly the first half, including time in Africa, but it does not survive. Happily, though, we do have his diary for the second half, starting in the Far East in April 1910; and, like all good diaries, it is the best possible source for helping to bring its subject, for the first time, into something like 3-D focus:

> ... it is indeed sad to leave Burma tomorrow: these three weeks have flown like magic and seem more like three days, just a glimpse and then one is off! (4 *April, in Mandalay*)

> The only fault I find is the drink question: in these hot countries everybody seems to surrender to their thirst and always quench it with alcohol and press others: I can hardly believe it is so necessary, but when one is not tempted it is easy to be superior. (11 *April, in Taiping, staying with English hosts*)

> How often the fable of the forbidden fruit repeats itself now followed by the same unavailing regrets without the acceptance of his just punishment, which half redeems Adam. (14 *April, still in Taiping, reading Milton*)

> I have got into the bad habits of doing what I like, so that it is a terrible effort to have to be civil and make oneself polite. (17 *April, in Ipoh*)

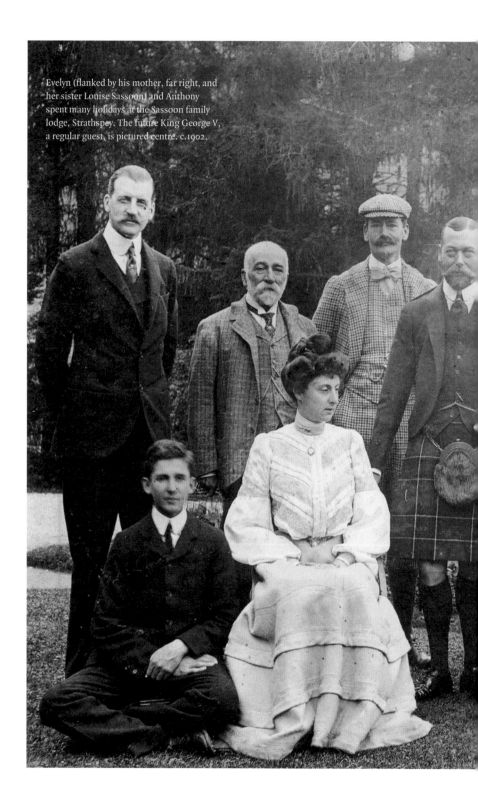

Evelyn (flanked by his mother, far right, and her sister Louise Sassoon) and Anthony spent many holidays at the Sassoon family lodge, Strathspey. The future King George V, a regular guest, is pictured centre. c.1902.

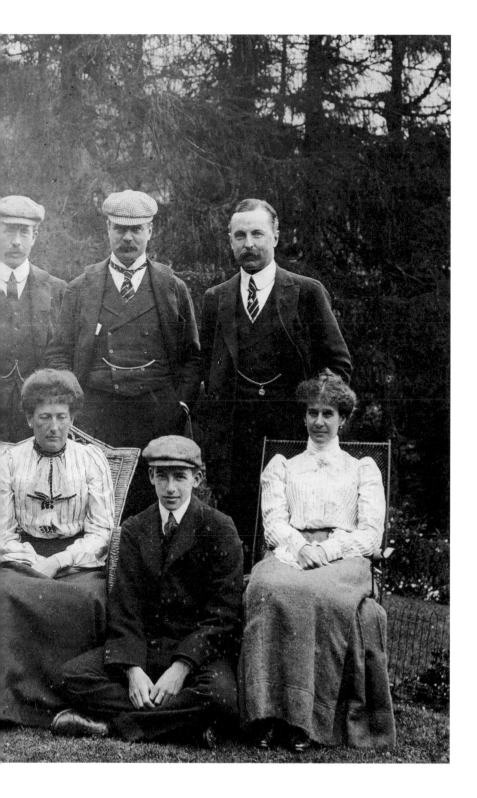

... a marvellous satire but owing to its unflinching satire composed mainly of truth it is inclined to leave rather an unpleasant taste behind. (*23 April, on ship from Singapore to Java, reading* Vanity Fair)

The Dutch are rather heavy and do not impress as Eurasians... In fact there is practically no distinction of colour and the superiority of the white race socially is barely noticeable: tonight the pure natives in their bright colours looked a great deal superior to the whites. (*29 April, in Djokya* [i.e. Jakarta], *going to a club*)

... rather a cheap form of wit... (*4 May, in Sourabaya, reading* Sketches by Boz)

Came on board after dinner and found a most unprepossessing crowd, too unpleasant to contemplate individually, the men offensive bounders and the women common folks from the street. (*12 May, leaving Singapore for Canton*)

... the more I read the more firmly convinced do I become, that Scott is my favourite novelist... (*13 May, still on board*)

Bridge and reading, a little Carlyle: he overdoes the inversion and apostrophising and so weakens the effect besides becoming wearisome. He also has the irritating knack of using long words, often Latin in form, when a short simple one would have done equally well. To counterbalance he often creates wonderful expressions and I pay him a compliment he would value highly, he has an ego. It is however necessary to know all the history & facts before reading him... and so I turned to Carroll: I had never read Hunting of the Snark before, but it is not unworthy of the author of Alice which to me never loses its flavour, though I fear I have lost all the freshness and lightheartedness of a child. (*15 May, still on board*)

I am afraid I do not rank Kipling in a v. high class but such as he is, he is undoubtedly good & one or two of his stories are excellent. His imagination & invention is the best part of his gruesome stories as they do not show the same art & skill of Poe or Stevenson: Kipling tells too much and puts it down in black & white, the others achieve better results by subtle suggestion. (*22 May, in Hong Kong, reading* Life's Handicap)

After dinner went & gambled with the Chinese with dice & lost a little after being up at one time: a gamble always fascinates me but I can never stop when I am up. (*24 May, on ship to Shanghai*)

Too much bridge again today and of course I was playing such low points; however the others as usual said I always won and this hardly produced the right frame of mind in me. As a matter of fact it is terrible waste of time, and if I have not yet learnt to play without unpleasantness it would be better to stop playing. Tonight I had to play to make a fourth but in the future I seriously think I shall give cards a miss. (*30 May, on ship from Shanghai to Hankow*)

In the evening could not resist the attraction of roulette: of course I lost and tomorrow I shall have my last fling: disgraceful waste of money and time but there is nothing else to be said except that it amuses me. (11 June, in Peking)

Roulette in the evening and the inevitable result: what a fool but I shall now probably give all gambling a miss till I return home. (12 June, still in Peking)

Finished Tom Jones, by many supposed to be the best novel in the English language so that comment is superfluous. Also reread some of my old diary with the object of expunging doubtful parts, and yet I wonder whether this is right... I flatter myself too much to think that anybody should care if I choose to write indiscreetly in my diaries and assume to myself a fictitious importance in my fears; again I rather suspect that they are the only portions worth preserving so that now I feel inclined to pause. (19 June, on train from Port Arthur to Mukden)

... of course I suppose it can easily be urged that it is full of the moral casuistry of a weak man pandering to his weakness but after all this is common to humanity. (22 June, in Seoul, having finished 'Quincy's Opium Eater')

I wandered about the shops but found nothing till unfortunately a 'Damascene-work' man unearthed me and this work always tempts me: I bought 4 pieces paying 10 Yen, and then in the evening an old mirror for 10 Yen; I am not sure whether I was done or not, he may have been a most accomplished hypocrite, capable of any fraud and finding me an easy victim: otherwise 'he can pass' as an honest artisan rather anxious to sell owing to special circumstances, nice to deal with and trustworthy. I fear that the Orientals are beyond me... (29 June, in Khobe [i.e. Kobe])

I was caught this morning and eventually persuaded to buy the two boxes of yesterday for which I gave 575 Yen: they are rather attractive, will do for presents, and to me seem to be very good work. They were so anxious to sell without any disguise and pleaded so hard that it was the end of the month and they wanted money very badly that I gave way and I really think they were honest... (30 June, still in Khobe)

Tonight being the first of the month, the ancestral temple was thronged and I went there to see the crowd and watched them come up all ages & sorts to ring the bell and clap their hands and then pray. Curious to watch the different ways in which they came & rang, some hurried up, others came leisurely, some very seriously but to all it was something definite to be done and not a routine as Western services so often become. I think it is rather a nice idea this summoning of the object of one's invocation and thus making sure of his attention: of course it depends on the spirit in which it was done. Also I could not help thinking of all these people worshipping openly and together

and then contrasting the Western reserve, which is so anxious to conceal the little religion it has, that it ends by having none to conceal. All the streets too were thronged by a most orderly, clean, and respectable crowd, moving along quietly and seeming contented and happy, buying and selling. I believe it was composed mainly of the middle classes but it would certainly compare very favourably with any English crowd and I must admit that in outward appearance they looked superior, most of them being quite well favoured and hardly ever did I see an unpleasant or vicious face. (1 July, in Kyoto)

Papa has again given me some money... and now when I get home if only I do not bet high I really have more than enough money... On this trip I have seen what a lot can be done by a comparatively small sum of money and so begin to realise the absurdity of wasting it in that way. (11 July, in Tokyo, staying at the Imperial Hotel)

Read in train Meredith [The Amazing Marriage] & Smiles 'Self help', quite different to what I had imagined. It is stimulating and interesting, but oh, what a fool I am! (8 August, on train to Yokohama)

Went to see Jones the manager of Hong Kong Bank: he turned out to be very amiable but slightly vulgar with peculiar mannerisms, always saying hmmm after every sentence ... I went on to lunch & found his wife, best left undescribed... (13 August, in Yokohama)

... a long gas with a shipping man from Vancouver. Politics etc: there is no doubt that these 'new' lands make people more liberal and I suppose rightly so: it is no use fighting against the spirit of the age, especially when I really sympathise with the object. A great deal in England will have to go by the board, much that one admires and cherishes... (13 September, on train from Minneapolis to Chicago)

... v. interesting, an extraordinary sight, typically American & an awful din & row, all business done by signs. Watching from above the men below might almost have been gesticulating monkeys. (14 September, in Chicago, taken to see the Grain Exchange)

I have just read Collier's book 'England and the English' [Price Collier's England and the English from an American point of view, published the previous year]: it is most irritating to read, mainly because it is nearly all absolutely true and based on facts incapable of denial but prominent in such a way that the result is most misleading, unfair and inaccurate. (2 October, on the Lusitania from New York to Southampton)[11]

Anthony reached England next day, still seriously unsure what to do with the rest of his life.

* * *

October 1910 proved a thoroughly miserable time for the restless twenty three year old, mainly based at Gunnersbury Park:

> A wet day & cold and so a miserable day at Newmarket, very crowded and needless to say I lost, betting much higher than was necessary but it was an effort to raise some interest and even then a failure. (12 October, after going to the races)

> Day of Atonement spent in synagogue. The usual service and I really think from the religious point of view it would be better only to attend a short time and read suitable books for the rest. However the other is customary and appearances are not always a complete sham and may do some good, but the Hebrew question increases the difficulty. (13 October)

> Bridge and tennis – and that is all. I have not read a word since I have come back! (16 October)

> I went into the Book Room, but could not fasten on anything to read, am all fidgets & can settle down to nothing. (18 October, at Ascott)

> Up to London and saw [Max] Warburg, who was most amiable but the prospect [i.e. of a training stint in Hamburg at the bank MM Warburg & Co] is not alluring & it means dull drudgery: still it is obviously right and has to be done. (19 October)

> ... it is high time I was up and doing and there is the call within me. But oh, for strength! (24 October)

> ... a nice lot of fellows of the usual type, which seems to be a perpetual repeater... (27 October, after dinner at the Pitt Club in Cambridge)

> How unfortunately true it is in this world that one can never do the 'As You Were'. (28 October, still in Cambridge, feeling 'out of it' and 'past it')

> ... various talks on the future, which is not altogether plain sailing especially as far as New Court is concerned [probably a veiled reference to his cousin Charles]. Besides I do feel very strongly that I want to do something besides that and somehow am rather reluctant to take up politics. (29 October, at Gunnersbury Park)

> A good deal of bridge and Edward Sassoon came to dinner. And so farewell to Gunnersbury for another year: I always think more time is wasted here than anywhere else! (30 October)

Soon afterwards, Anthony called in at New Court, prior to his banking apprenticeship in Germany:

An extraordinary row with Charles: with absurd stupidity he almost wilfully misunderstood me, chose to think himself insulted and then abused me before Papa with the resultant inevitable explosion & scene till Uncle A. [Alfred] tried to act as mediator. A sort of make-belief reconciliation followed but he is mad as a march hare & the whole thing incurable, but most unfortunate.

Two days later he was at the Atlantic Hotel in Hamburg, mulling over the prospect of office life:

I wonder how long my present good intentions will stand the strain of dullness in this atmosphere: one should never be prejudiced but to me German is almost synonymous with dull, practical, sensual and gross and is essentially unsympathetic. (4 *November*)

Oh, the weariness of the flesh! So far so dull: I cannot say that I learnt much business today and what is more see little prospect of learning more. The German is difficult and the task, I fear, uncongenial: I succeeded in copying out a couple of letters automatically like a parrot and then only at the nth effort! (5 *November, after starting in the correspondence department*)

Quite a busy day in the office, and I am with difficulty learning to rule a straight line! Possibly glimmerings are beginning to dawn, also as the result of a lesson on bills of exchange in the evening. (7 *November*)

Nothing very new and I begin to be able to do mechanical copying more neatly! (8 *November*)

Another day in the office, which is already becoming quite customary. A conversation or lesson with the clerk in the evening on finance and I really began to understand something about discount and exchange. My [German] lesson with Wollmann in the morning still continues: today we touched on politics and I suppose the Germans are also individually as anxious for peace, as we are. (9 *November*)

Another day in the office, it is all rather narrowing and narrow: I cannot say that I learn much, it seems to be mainly red-tape and all sorts of trifles: there seems to be a lack of common sense and proportion. (12 *November*)

I now think it is best to stick it out until Xmas time here in one go and learn as much as I can by then… If I really struggle for these 6 weeks… I ought to have laid some foundations and anyhow will have given the thing a chance, in order to express an opinion on it. (14 *November*)

Kreife is very German in his ideas & conceits & certainly annoyed me: of course I am not a fair judge but I don't think an Englishman would ever seem this extremely conceited & almost bumptious… (16 *November, after a German lesson that morning*)

A slightly better lesson & I think my German is improving: I must try to learn German if nothing else here! (*17 November*)

We discussed New Court etc & I think he understands a good deal of my feelings about it all: undoubtedly to go through this thoroughly I will have to stay till April at least with a couple of intervals: flitting backwards & forwards will not work. The question is whether it is worth it. (*18 November, after a train journey to Berlin with Max Warburg*)

... all this is deadly dull and I can only watch & time hangs heavy... (*21 November, back in Hamburg*)

A v. wearisome day in the book-keeping dpt, especially as I found a stunner of a clerk who was frightfully conceited (whose breath stank!) who could explain nothing and tried to explain less! (*22 November*)

Another very dull day [Wednesday] in the book-keeping department; I must just last out the week and then try another job [i.e. at Warburgs] after getting just a superficial idea of the working... I fear that on the whole except for the gambling & scheming parts, business has no charms for me & no interests. (*23 November*)

A very interesting Literary Supplement to the Times this morning, according to it Lord R's book [Rosebery's biography of Pitt the elder] might have been better in spite of its inevitable interest & brilliance: article on Tolstoy [who had just died] very good: I had no idea he was such a great man, I wonder whether this is already the verdict of posterity, anyhow I must read something of his! (*25 November*)

Banking? Or history-cum-literature, conceivably going back to Cambridge to teach? Or politics, especially given that there had already been several Rothschild MPs and that Lionel was about to stand? The general election was due in December, turning on the attempt by Asquith's Liberal government to reduce the powers of the House of Lords, and Anthony was following it all closely:

... though I am strongly in favour of government by consent & representation... yet it seems to me that for a country to be well governed there must be a governing class: it must however have nothing whatever of a caste in it and must be a true aristocracy of merit, the reverse of exclusive and capable always of assimilating the best in every station of life. The present bitterness of party-strife cannot go on indefinitely without very serious consequences. The worse alternative means the victory of irresponsible democracy, fed on class prejudice & hatred. The solution of the problem lies in the reconciliation of two seemingly hopeless contradictions: the growing power of the people – and this growth should be

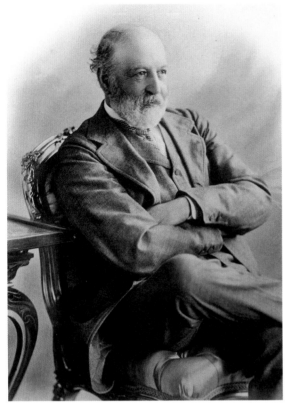

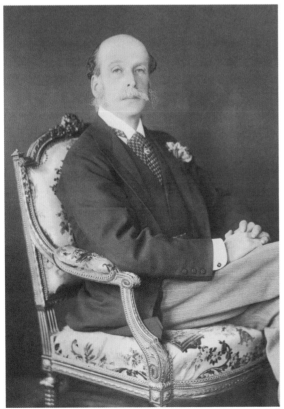

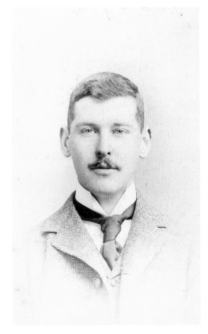

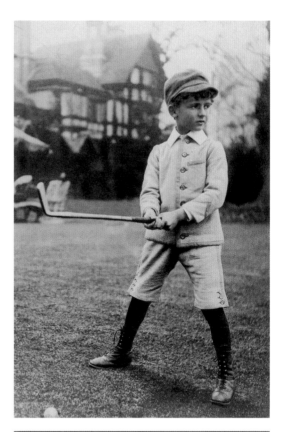

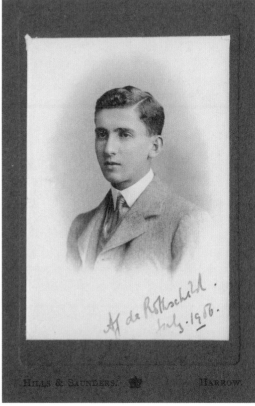

TOP
Anthony playing
golf at Ascott House.

BOTTOM
Portrait of the 'excellent' Anthony
on leaving Harrow, 1906.

fostered and not checked – and their governance by their own free will by the ablest men in the country.

For the moment, though, it was back to the office:

> ... when I repine & grumble at the slowness of my learning & the general dullness & drudgery I feel very guilty, when I think of the many who have nothing half so good to do all their time and yet persevere cheerfully... after 4 weeks I complain of hard work, etc, etc, and give myself airs of superiority as being too good for this work! What a rotten gutless creature! (*30 November*)

> Finished copying out my old diary which disappointed me: in many places it is hardly English and hardly anywhere is any description really consecutive and complete, any pretence at anything but an idle scribble... (*3 December*)

> I wish I knew my own ambition, also how much ability I have got & how much is only conceit! (*4 December*)

Two days later, it was a telling mixture of the practical and the idealistic, ultimately the Yin and Yang of Anthony's life:

> Did quite a lot of letter writing for Max W. and talked about business, in this form it is quite interesting, especially the loan for Chinese Currency with all the political undercurrents... I have been wool-gathering today and dreaming ambitious schemes of the future, education (of Harrow), Jews & land, emigration etc etc, what schemes might be set on foot and the uses of wealth. In this impractical method I could dispose of countless millions all most beneficially!

He was back in England on the 10th, but intending – as encouraged by Max Warburg, promising more interesting work – to return to Hamburg in the New Year. Mainly based at Ascott over the next few weeks, and spending a lot of time with Evelyn, his brain continued to whirr:

> A ride in the morning with E. & discussed business: of course it is the old story of the young criticising the old... (*11 December*)

> Evelyn very keen for me to go into politics but I think better to wait. (*15 December*)

> Politics seem to me very unsatisfactory... the Unionist [i.e. Conservative] party are rotten in many ways, but am against Home Rule & the Lib party methods & the abolition of the veto [for the House of Lords] and yet in spite of this... I feel more Liberal than Unionist! (*16 December*)

> I now think I should go to New Court pro tem: but things seem rather empty & purposeless. (*3 January 1911*)

> A quiet day with Evelyn & Mamma. Asked E. about some business and he seems to understand it all very clearly. (*4 January*)

Went with T. [probably Tarver] to the British Museum, a lovely Lapis Lazuli
cup etc in the Waddesdon Room & we looked at the Chinese porcelain,
which grows on one immensely. (7 January)

The seeds were being sown of a lifelong aesthetic passion; but in the here and now,
delaying his return to Hamburg, it was the City that almost inexorably summoned
him, albeit – in his own mind – still on a trial basis:

My first day at New Court, not very startling or very instructive and the chief
necessity seems to be to waste as much time as possible!... I talked to the
Harrow boy Hill, a nice quiet creature but it is good for me to think of him
having to come straight from Harrow & work & learn in the dullest possible
way with the prospect of an ordinary living wage in the future and to note
how cheerfully contented he seemed and then to contrast my own selfish
and useless thanklessness! (10 January)

Went to various departments and tried to learn something about it all.
Uncle A. [Alfred] is very seedy & has had something in the nature of a stroke,
at least he cannot get his words out properly so everything is in a state of
turmoil. (12 January)

Quiet day at New Court, nothing much doing. I poked my nose into various
accounts but it is difficult to do anything but to waste time. (13 January)

I am trying to study Bagehot's Lombard Street and it is wonderfully lucid...
Charles & Rozsika [Charles's wife] paid a visit [to Hamilton Place] this
evening, it is curious how ill at ease I always feel with him even when most
friendly. (14 January)

Quite a lot doing in the city... When I go back to Hamburg I think I shall
be able to learn more and anyhow I see how necessary it is, also how
easy it would be to slip into a groove at New Court & get along very well
without thoroughly understanding anything. (16 January)

Everything settled about the Chilean Loan, so all very pleased... I was sent
round to Baring, Huth, & Gibbs with an offer, rather an alarming mission
and I invaded their various sanctuaries and was received affably & with
curiosity. It was not easy to retire with much dignity! Uncle N. [Natty]
pleased & communicative and ready to do more business. (17 January)

The Chilean at New Court and the contract discussed in detail, a slight
difficulty as to whether all the laws should be mentioned. Other business also
about the Brazilian currency & whether we could hold the gold here against
the issue of notes there. Finished Bagehot today, it is clear and
helpful. (18 January)

Finished Withers book today [probably The Meaning of Money, by Hartley

Withers], it is v. clear and helpful but I must read some more about it all to soak it in and get familiar with it. (22 January)

The loan oversubscribed about 8 times over! An extraordinary success and Uncle Natty said it was the first time New Court had ever brought out a loan without buying some stock to steady the market. Talked a good deal with Charlie about business and I seem to have got on surprisingly well with him the last fortnight and I am inclined now to alter my opinion & disagree with Evelyn. (23 January)

Dentist and then New Court: allotment going on, I read the old telegrams to Brazil which are interesting and then Uncle Natty dictated a long Paris letter [to the Rothschild cousins in Paris] to me, he is v. nice to me & says he takes particular care when he dictates to me and actually it is a wonderful opportunity of learning. He expresses everything with great lucidity, this he does by thoroughly digesting it all first. I think now I shall be able to turn my time at Hamburg to better account & know what to look for when I go back. (25 January)

Nothing much doing in the city, I talked to Stephani [Samuel Stephany, the rising man at the firm] and tried to learn something about Arbitrage... (2 February)

Charles took me over the Refinery [i.e. the Royal Mint Refinery, owned and managed by Rothschilds] & we talked business: his views seem reasonable and sound but it is more than difficult to alter anything [i.e. at New Court generally] by a hair's breadth. (13 February)

Six days later, he was back in Hamburg, this time for a month or so:

It will be curious to see how much more business I can learn this time, I feel terribly vague & ignorant but yet too lazy for really giving myself up to it properly. I pretend to myself that I have higher ambitions than the mere pursuit of money & yet the only obvious one of politics I am firmly decided against for the present. Patience! Perseverance! (19 February)

I now so to speak act as M.W.'s [Max Warburg's] shadow, which is instructive and I read all the letters and studied contracts, etc. (27 February)

It is impossible to avoid thinking of what the future will be, but then too I fear my own capacity for drifting and lack of initiative and energy: paradoxical as it sounds, if everything were not so very easy for me, it would be still easier! In business too again it seems I have that fatal facility and quickness which is yet beyond my talents: it allows me to attain a certain point easily, but my persistence & perseverance are not enough nor have they a sufficiently deep basis of real ability. (6 March)

Wired to Charles... I begin to see how things might develop themselves successfully in the future. (8 March)

By the 25th, after some travelling in Germany, Anthony was back at Ascott and unable any longer to delay his decision:

> Evelyn down in evening, Brazilian loan a great success and already over-subscribed! Personally rather vague & out of a job, must settle down again and start reading! (27 March)

> Day in city office full of Brazilian loan... an extraordinary success. (29 March)

> Lionel made his maiden speech today but I know no details. I am beginning to realise and almost to accept my own lack of ability and am becoming reconciled to doing what I can. Boyish dreams and phantastic ideas cannot last forever & must vanish before humdrum reality. (31 March)

> Usual day in city, nothing much doing, I was given the signature! (3 April)

> ... no very striking speeches but Winston C. [i.e. Churchill, well known socially to the Rothschilds] was surprisingly nervous and got an insight into the difficulties of leading the house or even of addressing it. The most striking thing was the appalling waste of time and the dreary quibblings, how much better it could all have been settled by half a dozen *sensible* men in a room. (11 April, *after going to the House of Commons*)

> It is certainly fascinating to listen to, but strange to say my ambition is now quite gone, and I am satisfied & even pleased with the prospect of other things. (20 April, *after another visit to the Commons*)

> Politics and social conditions etc, the latter is still the proper field for effort. (21 April)

> I have now come to the conclusion that by nature as a rule I am dull and inclined to be taciturn and like dull things & to be humdrum & above all a bookworm. (29 April)

> Couple of rounds of indifferent golf, about which I don't seem to care as much as formerly. (30 April)

> I now am on the salary list, which should more than suffice even for my extravagance! (4 May)

> Passed a poor tramp & a woman today lying apparently exhausted by the gates [of Ascott]: it seems strange that they should prefer to keep out of a permanent workhouse, equally wrong that they should suffer so much but human endurance is wonderful. (18 May)

Anthony's diary finished exactly a week later, on the 25th, with the words 'Bought two hunters!' Two days earlier, his entry had neatly encapsulated contrasting aspects of his life: playing for MCC against Hampton Wick, he cheerfully 'knocked up 29 including one 6 out of the ground'; but that evening, he attended two balls and afterwards concluded, 'I don't think these things are in my style at all!'[12]

He was now in effect committed to New Court. It can only be surmise, but ultimately there were perhaps three main reasons behind the decision: with the elders starting to fade, and Charles a troubled man, the strong call of family duty, especially as tacitly encouraged by Natty and Alfred; a desire to spend his working life alongside Evelyn, always his closest companion; and the desire also to master a particular activity, however baffling and rebarbative it may have seemed at the outset. But whatever the motives, what was undeniable was that by May 1911, a month shy of his twenty-fourth birthday, Anthony had become a City man.

★　★　★

Anthony's first three years at New Court are only thinly documented; but he was soon sufficiently trusted to be given occasionally the task of writing one of the almost daily letters from the London Rothschilds to their cousins in the Paris bank. 'Here we are busy with priorities,' he told them laconically as early as June 1911, 'and my Uncles have gone to the garden party at Buckingham Palace which I am glad to say is favoured with fine weather.' That summer he topped the batting averages for Buckinghamshire (admittedly on the basis of only two innings), while the following year he became a 'Zingaroo', i.e. a member of the exclusive cricket club I Zingari. In 1912 he also attended a Royal Buckinghamshire Hussars summer camp at Stowe Park. 'The cricket match was our fault, as we ought to have made more runs and it was my fault I got out,' he wrote from there to his mother explaining how Evelyn had hurt his hand. 'A full day today,' he added, 'and our side was successful: I rode round with my troop and captured the camp.' Two days later, 'Evelyn's hand is better and he is taking good care of it,' was the report, which went on: 'We had a strenuous day yesterday, finishing with a night attack on Padbury. This afternoon we are playing cricket against Buckingham.'

The world of cricket knew few worries, but in the City there was at least some recognition of the potentially threatening international picture. 'The news from the Balkans continues to be satisfactory as far as it goes,' Anthony wrote cautiously to the cousins in August 1913, 'and at the moment the horizon is clearer than it has been for some time but there certainly remains a decided feeling of uneasiness as to the future.'[13]

A few weeks later, Anthony, Evelyn, Stephany and 'Reggie' were on board the *Arlanza* heading for South America, with Anthony as usual the dutiful correspondent to his parents (usually his mother) about a trip intended partly for the sake of experience, but partly also to convey the views of Rothschilds to the local politicians:

We play a certain amount of bridge, at which Stephany more than holds his own. (*7 September, from the ship*)

There does not seem to be anybody very exciting on board, most of them South Americans, but as we are a rubber to ourselves and also a table we have been rather too self-contained, and have not really made as

TOP
Anthony (centre) in one of the many
photographs taken of him and Evelyn
during their tour of Latin American
countries in 1913.

BOTTOM
On familiar ground: at the
cricket pavilion, Ascott.

much of our fellow-travellers, as we might. (*18 September, shortly before reaching Rio*)

Everybody is extremely hospitable and more than kind: it is quite alarming to find oneself/ves looked upon as individuals of importance and I can often hardly help smiling. There is a comic side to it all, and I felt it very keenly when we went to our first interview with His Excellency the Minister of Finance ... We assumed or tried to assume an air of cool indifference, as though accustomed every day to call on Ministers of Finance. (*23 September, from Rio*)

... there was an enormous crowd, and even the poor people were well-dressed: there were no roughs or beggars, such as frequent Epsom, though I dare say these people were even greater scoundrels underneath. (*21 October, from Buenos Aires after going to the races*)

I believe I have met a thousand new people the last few days, and have had to try to be polite to all of them. I am glad to say the speech-making such as it is has fallen to Evelyn who made an excellent little speech today to the Chamber of Commerce. (*28 October, from Santiago*)

Every now and then, Anthony's letters touched on matters back home. 'You must not expect me,' he warned Marie in early November, 'to get less Radical by travelling and by visiting new countries, though all these lands are full of abuses political and financial which thank goodness, we have left far behind in England.' But mainly the emphasis was on travellers' tales, including from Chile an element of frustration about what they were, and were not, being allowed to inspect:

We went to see a brewery founded by Germans last century and were shown everything except how the beer was made... We went down a coal mine, which was excellently ventilated but again we were shown everything except the coal being taken out, and thirdly we were taken to Corral to see a large iron ore and steel plant which was lying idle and has not been working for $2^1/2$ years because of a quarrel with the government, so again we saw nothing.[14]

Last stop of the trip, at the end of November, was more familiar terrain. 'TWO OF RICHEST YOUTHS IN WORLD VISIT NEW YORK' announced a local paper. 'Anthony is a stocky youth, with dark hair and gold-rimmed glasses – rather a student type,' it informed readers. 'Evelyn is slenderer, with light hair and quite pronounced of feature... Both are slow of speech until some such theme as football arises, and then each is animation itself.' And the joint profile ended portentously enough: 'What each is to become in the great house of Rothschild is a matter for time to determine.'[15]

'We have spent today listening to the regular and monotonous chant of brokers with their dreary refrain of "nothing doing,"' Anthony informed Paris at the start of 1914; his list of books read during January, fourteen in all, included an influential

work of socio-economic reportage, *Round About a Pound a Week* by Maud Pember Reeves; in April, in the context of the ongoing Irish crisis, he expressed his hope to the cousins that the sides would come together and find a 'peaceful solution'; in mid-July, a fortnight or so after the assassination of Franz Ferdinand at Sarajevo, his update to Paris made no mention of that ticking time-bomb; but on 29 July, writing from Ascott to his mother (who was abroad), it featured prominently, but not quite exclusively:

> Here everything has been in a terrible state of uncertainty, and upset ... I suppose the crux of the question is the policy of Russia because if she holds off, it may be possible to localise the war.
>
> We had a very good match against the Eton Ramblers which ended in a draw after a lot of runs were made. I got 65 and 29.
>
> It seems almost wrong to be playing cricket while all this is going on, but I have not put off the other matches yet.[16]

Wastage of human life

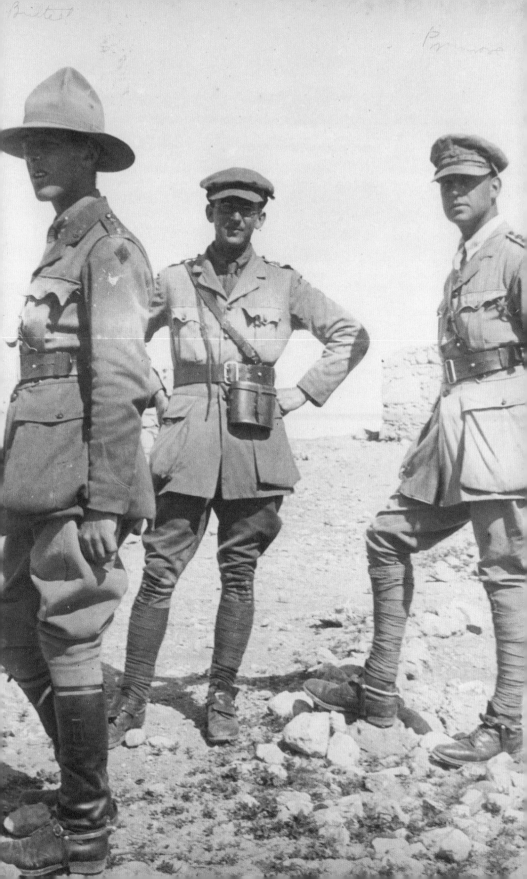

CHAPTER OPENING
In uniform: Anthony (centre) and
his cousin Neil Primrose (right)
with fellow officer.

ABOVE
Training in East Anglia:
Anthony (left) and Evelyn
(centre), 'soldiering'.

Within days of the war breaking out, Anthony and Evelyn had formally joined up and been mobilised with the Royal Buckinghamshire Hussars Yeomanry. The next eight months of training proved a time of often frustrating inaction, largely based in rural East Anglia and giving full scope to Anthony's critical faculties, as a detailed wartime correspondence got under way with his parents:

> At present as far as I can see our duties are mainly those of glorified but very inefficient grooms. (*18 August*)

> ...three months of this job – I won't call it 'soldiering' – have taught me anyhow not to think about anything! (*15 November*)

> Life is not particularly exciting in this village and my chief occupation is scratching the insect bites from which I am again suffering, not for the first time since we started these wanderings. Apart from that the great object of the day is to get to bed as early as possible, especially as I find it almost impossible to settle down to read anything. I am in such a state of unrest that I cannot even look at a sensible book. Can you find any shilling-shockers or anything really foolish and thrilling to send to me? They would be most welcome, but I fear that failing all else I shall have to make an effort to pull myself together and study philosophy or something equally desperate and equally foolish or possibly even military tactics!
> (*23 November*)

> One sees such strange people on these jobs and certainly gets an insight into the way the other half of this country lives. It is quite *disgusting* however to find everywhere... either that the people wish to make as much money as they can out of us or that they frankly don't want us [at] all and [are] not in the least amiable. Such is the patriotism in this country & it makes me wish the Germans would come. (*8 December*)[1]

In the New Year, he and Evelyn were brought to what Anthony called 'a state of angry mutiny!' by developments after an inspection: 'The Colonel, as usual, lost his head and his temper and was grossly insulting to all the officers of the squadron and above all told a d — d lie to all the officers of the regiment about us and spread it generally.' One favourite activity offered some consolation. 'We went for a hunt today,' he noted in February, 'and had quite a good longish run but over a vile plough: still it was a very enjoyable change from drill...'[2]

A few weeks later, the word was out that the 1st Bucks Hussars were likely to be heading for action in the Dardanelles. 'I can't say that I altogether appreciate the prospect of a three weeks voyage on a crowded transport,' was Anthony's initial somewhat grumpy reaction; but soon afterwards he was looking, though still unenthusiastically, at the larger picture:

I believe helmets have been ordered for us, so if we go I suppose our destination is Egypt but why I cannot make out, as using it as a jumping-off place [i.e. for the Dardanelles] seems to combine every disadvantage and as far as I can see has no redeeming feature. In the first place it will waste a great deal of time. Then there will be a terrible lot of wasted labour in disembarking and embarking again, also a great wastage and loss of horseflesh and also the hot climate will certainly do the horses a lot of harm.

'I hope everything will go alright at New Court and that you will be able to keep the peace,' Anthony wrote to Leo in early April – an unmistakable reference, days after Natty's death, to tensions between Lionel, deputed as Leo's eldest son to help mind the shop during the war, and his cousin Charles – shortly before (on the 9th) the Hussars sailed from Avonmouth on the *Menominee*, an old coal-burning cattle ship.[3] 'This boat is on the whole considering everything good especially for the officers, but the men are very crushed and horses also,' Anthony reported after a few days. 'We get a daily bulletin of Marconi news from which we have gathered that nothing startling has happened. We have all decided that whatever our present destination may be, we must find some other return journey, in fact are determined to ride home.' And soon afterwards, near Malta: 'I must say that the torpedo boats did not accompany us very far and when they left us after less than 100 miles we were practically helpless and must have been a very tempting bait to any submarine.' On the 22nd, after more than 100 men had died because of septic pneumonia, they reached Egypt. 'One could not help looking back and thinking of all the history of the ancient world, and how much of its fate was decided by or rather connected with this country...'[4]

The regiment initially encamped just outside Alexandria, at El Zahira, whose Mohamed Aly club attracted the officers for its gambling facilities. The challenge soon became to beat a renowned local card player. 'Tony was an exceptionally good card player, although he did not really care for cards and would seldom play,' remembered his fellow-officer Fred Cripps. 'We founded a syndicate among a few of our officers and challenged him to play against Tony. The Levantine lost a tidy sum of money and, at the end of the session, remarked: "I was the Napoleon of Picquet, until I met my Wellington."' In Alexandria itself, the social whirl did not stop because of war. 'There are a good many Greeks and other cosmopolitan travellers about here, who have met you at St Moritz and also know various French members of the family,' Anthony told his father in early May. 'I was taken to one smart reception and dance – I felt very strange amongst the smart people in dusty hobnailed shoes [and] dirty slacks (I had not known what I was in for, tho' as a matter of fact, they are my best clothes) ...' The same day, his letter to Marie touched on Churchill's unfolding disaster in the Dardanelles: 'I am afraid I must secede to you the justice of many of your criticisms about Winston: there seems to be no doubt that if the matter had been properly worked out and the fleets had waited till the troops were ready, the whole

thing could have been carried through with much less loss...'[5] Much of the next few months, largely spent in or near Cairo, was a case of marking time:

> It is just the same story here again as it was in England: nobody seems to want us at all, and our horses are a great nuisance and no use to anybody.(8 May, to Leo)

> As a matter of fact I am partly attempting to banish all military matters as much as possible from my head, and am trying to settle down into proper tourist mood. I have bought second hand books on Egyptian art etc including a Baedeker, in spite of the war. Every time I take it out of my pocket, I expect to be arrested as an ill-affected person or even a spy. (8 May, to Marie)

> Everybody is wondering what will happen in Italy & we also try to make out what is really happening in Flanders. Here there is a perpetual stream of wounded and I fear there was disgraceful lack of foresight, so that there was no adequate provision. Of course everything possible has been improvised and I suppose by the time this reaches you, it will have been remedied, but there ought to be an inquiry as to who is responsible. There are practically no medical orderlies and nearly all the wounded arrive here with their first field dressing on, without its having been touched for the 5 or six days it has taken to get here. As a result even quite slight cases are sometimes serious. There is no Hospital in the [Gallipoli] Peninsula, I believe, as the Turks shell anything with a Red Cross flag. I am not quoting any special case, but only repeating what is common knowledge...

> I don't write about New Court because I don't know what to say. I hope Charles will be amenable to reason: I must say I think it will be a great pity if the Refinery has to be sold... (14 May, to Leo)

> Nothing fresh here, and we are not doing much except trying to get our horses fit. As regards Gallipoli one does not hear much and that little is not good: we seem to have gained but a very narrow stretch of land along the coast and to be holding it at a great cost with difficulty. (21 May, to Leo)

> [General Sir John] Maxwell came to inspect us today: all generals are an infernal nuisance as they keep one in barracks and give a tremendous lot of work and they hardly take the trouble to look. (26 May, to Marie)

> I hope you are well and not doing too much at New Court. It is not worth bothering about Charles. Remember that nothing makes any difference. (1 June, to Leo)

Anthony remained in June thoroughly unenamoured by the powers that be. 'We are "enjoying" another heat-wave, in spite of which the generals etc are still busy trying to train us in infantry work and long dismounted attacks.' And: 'At the present moment there are over 50,000 cavalry horses in Egypt and pretty truthfully no use for any of them' – a situation attributable to 'an incredible lack of foresight'. By

early July the troubles at New Court still concerned him – 'Lionel will have to make himself really useful and busy,' apparently in the context of Charles wanting 'radical alterations' – while at the same time he was composing in his head an imaginary article on the prospects for the war at large:

> On the one hand as regards the length of the war [he summarised to Marie], we have deliberately set ourselves, though unprepared and untrained, to crush and destroy the strongest foe we have ever fought, who has been preparing for forty years: this task you have been told by your friends is *impossible*, and anyhow must be a long one... on the other hand there is the wastage of human life & material which is on a vastly bigger scale than ever before and which is the only factor that may bring the war to a rapid conclusion... The article would require much developing and many pages of turns and contradictions, and in the end you would find I'm sitting on the fence, beautifully balanced with extraordinary skill and adroitness.[6]

Over the rest of the month, Anthony wondered aloud to Leo about the Dardanelles ('They say that we are really doing very well in Gallipoli and that great happenings may soon be expected: I only hope this is true') and noted the continuing Eton v Harrow annual match in his absence ('It is sad to think that I ought to have been shouting myself hoarse at Lord's today, and eating ices to my heart's content'); while to Marie he described nocturnal practice at trench-digging ('when dawn came our efforts seemed to have been fairly successful, at least the trenches seemed to be facing the right way!'), expressed pleasure at apparently greater harmony in New Court ('they say that two negatives make an affirmative, so that between him [Charles] and Lionel there ought to be some hope!'), and expressed despair at the inadequacies of British politicians as war leaders (declaring it a good thing 'if all the strikers and the whole of the present government were to spend a month in the trenches').

Finally, in August, Anthony's real war began. 'What situation can have developed in Gallipoli, which would render the speedy arrival of 5000 dismounted cavalrymen of great importance?' he speculated on the 10th, after being told that 'we are going shortly on foot'. And three days later: 'They have rigged us out now with infantrymen's pack and equipment, and now we have to carry on our own backs all or nearly all that we have loaded on our patient horses during the last twelve months! It is really rather ironical that after a year's strenuous training as would-be cavalrymen, we should now make our first appearance in a different role.'[7]

Next day, Saturday the 14th, the Bucks Hussars – accompanied by the Dorset and Yorkshire Yeomanry, together forming the 2nd South Midland Brigade – left Alexandria on the *Lake Michigan* ('a v. uncomfortable boat with vile food'). They reached Mudros on the Tuesday morning, transferring there to two smaller steamers, on one of which, the *Hythe*, Anthony arrived at Suvla Bay in the early hours of Wednesday. 'If you ever send any comforts or food to the fleet,' he wrote next day to his mother, 'you might

remember the Hythe men and officers: they have v. hard work and were v. nice.' He also wrote that Thursday evening (from 'a stony hill-side!') to his father:

> Criticism or discussion of the whole expedition in general, or of any detail, is strictly forbidden, so I will merely say that anything I could truthfully and frankly write would give you no pleasure to read. As I write, they [the Turks] have just started their evening shelling and half a dozen shells have just dropped down by the landing stage, and now our ships lying down there are beginning to answer, and so it goes on with few intervals.

He continued on Friday afternoon:

> It got too dark last night, so I had to postpone the end of this letter. It was really very cold last night, and a strong wind sprang up, but the sun is still blazing hot by day and as there is no vestige of shade anywhere, one has to lie still and bake in the sun. Water is the great difficulty as there is none to be had, except what is brought in boats, so that it has all to be fetched in bottles and jugs, a very tedious process as it is quite a considerable distance to the landing stage.

> Just about 100 yds from where I sit is the main path or track going up to the hills and trenches behind, there is a perpetual stream of traffic both ways, particularly early morning and evening, mainly long strings of the Indian mule corps taking up water food and ammunition. Then there are the men coming back from the trenches 'brown, looking hardly human' like Enoch Arden stepping down from his mountain tracks, with a half dazed expression in their eyes.

'Yet with it all,' reflected Anthony, 'everything seems so very much like a passing show, one finds it very difficult to get used to the reality of it all and keeps rubbing one's eyes.'[8]

The following day, 21 August 1915, marked the centrepiece of Anthony's war, as his brigade was part of a doomed attempt to take Scimitar Hill, heavily defended by the Turks. During several hours of intense confusion and ineffective leadership, Lieutenant Rothschild was wounded in the arm, which bled considerably, even as many of those around him lay dead. 'I hear on all sides he did splendidly as cool as possible and always busy collecting men and leading them on and the Colonel has sent his name in,' Evelyn (not involved, but stationed quite nearby) reported a few days later to their mother; and indeed, he was duly mentioned in dispatches. Anthony himself at about this time sent home two detailed accounts of the 21st.[9] But it was a fortnight or so later, on 9 September, that a note received from Evelyn prompted him to write to his mother a remarkable letter, simultaneously vivid and reflective:

> He tells me also that the Col. sent my name in because of the 21st, which annoys me because nothing would have given me greater pleasure if it had been deserved, but the Col. never saw the latter part and I know personally

that at the critical moment I was no use. Difficult I know and a high standard, but one that *you* would certainly always choose.

As you may imagine I have been through every moment of that afternoon a dozen times in my imagination in all its details. My first feelings were curiously detached as though I was only an onlooker at some glorified military tournament and I wished I could have sketched the busy scene behind the cliff. Then as we moved over the sky line, one almost gasped for breath at the wonderful panorama in front of us: the scene was very like (mutatis mutandis) one of those old miniatures of battle-fields *and* from that distance *and* in that security it was war in all its magnificence with none of its horrors.

From when we moved down into the plain, everything seemed to go on mechanically. As we came to the shrapnel zone we passed the casualties of the regiments that had gone in front. I remember we first passed a dead Warwickshire yeoman and it struck me as we caught a fleeting glimpse of him, what a great big man he was ...

This advance was really surprisingly easy (though we are very proud of it). I did not know how many men we had lost till we counted up later. One's mind was working hard the whole time, but in a kind of mechanical fashion that I cannot quite find the expression to describe. We were all getting very blown and were all purple in the face when we got to the haven of the hill side, where we all congratulated ourselves on having got through and hoped – little did we know what was in store for us – that the worst was over. I think the chief sensation of being under fire is one of helplessness: always in life till then 'spoilt and favoured' individuals like myself can reckon on the help and assistance of their fellow-men in any difficulties, and here one found oneself just up against it and very much the opposite going on. We then got our orders to move on but lay down again a few yards further on where a man on either side of us was hit by a stray shrapnel. After that the advance began...

Going up the hill in the last charge my foot caught and I fell: as I got up and struggled through the burnt gorse I remember distinctly wondering which side of particular bushes I had better go and what a toss up it was. I don't know whether it was from weariness or darkness, but I could hardly see when we got to the top and one was almost dazed by the din.

Then when I was hit, I was a hateful, horrible, coward because it did not hurt at all, I only felt a jet as of warm water passing down my arm. I remained where I was till the line moved back, because I did not see how anybody could possibly cross the hill top alive and I was wondering when it would be quite dark. Just previously I had seen some poor soldier come running up to the front line: then I saw what seemed to be a star of fire

go through his chest (a red-hot bullet I suppose), he fell throwing up his arms just like all those pictures one sees, but managed to crawl away.

One pathetic incident I had almost forgotten: as we lay against a bank some 50 yds before we assembled for the charge an officer came running up enquiring for any officer so I answered him. He said 'I am ready to charge now: I have none or hardly any of my men left but I will come along with what there is'. I sent him along to the Brigadier close by. That was all that was left of the Enniskillens, that had attacked the rear hill earlier in the afternoon and this officer was hit in the body as he got up to move forward.

'I am afraid this is a very egoistical letter,' Anthony concluded, 'but I thought perhaps it might interest you to hear some of my recollections and impressions.'[10]

<p style="text-align:center">* * *</p>

'Our journey here was very tiresome and prolonged, as they kept us waiting for a long time mainly for no purpose,' he wrote at the end of August to his parents from Field Hospital No 17 in Alexandria. 'I believe that between Aug. 6th and 22nd there were at least 30,000 casualties, luckily a very large proportion only slightly wounded, and I am afraid the result was that the ordinary soldiers who were walking cases, were herded and driven about like cattle.' On 8 September, two days after leaving hospital, he sent separate letters: to Leo, warning against his regiment's generally despised commanding officer, Cecil Grenfell, now on his way to England ('he will probably be very effusive and sugary, but I should not believe a word he says'); and to Marie, telling her he had been reading Patrick MacGill's *The Children of the Dead End*, a searing novel about the plight of the rural poor in Ireland and Scotland. 'I wonder whether men will be prepared to go back to that kind of life after the war or rather tolerate its possibility for others. I hope not.'[11] Barely a month later, having just about recovered, he was back in Gallipoli.

Within days Anthony was letting off steam:

I hear that Vere [Vere Ponsonby, future 9th Earl of Bessborough, a friend of the family] was very speedily summoned to Headquarters, I suppose for a staff job: I imagine they wanted to muzzle one M.P. At any rate, they have got more out here than they like and when they spend some time in the trenches they are apt to show an unwanted tendency towards speaking out and writing the truth, and H.Q. cannot face too much daylight in their organisation with any equanimity.

In the event, Anthony was in the Gallipoli trenches for only about a fortnight, before on 2 November the regiment withdrew to the greater comforts of Mudros, a move only partially assuaging his discontent with the conduct of the war:

The only hope is that there is but a limited amount of bungling and incompetence in the world, and if that is the case that has certainly all been used up here! (*4 November, to Marie*)

It feels quite strange and stuffy to be under canvas again. I don't know what it will be like if we get into houses. (*5 November, to Leo*)

The English papers are certainly not cheerful reading, and it is extraordinary how slow the Cabinet have been in everything, always adhering to a policy of drift. (*11 November, to Marie*)

I think I am going off for a walk this afternoon to a village, where one can get a hot bath from a natural spring, a luxury in which I have not indulged since I left Egypt. A piece of my tooth came out in the trenches, I ought to say from eating hard ration biscuits, but truth compels me to admit that it was caused by munching the n'th handful of sweets sent by Papa... (*13 November, to Marie*)

By early December, with the whole Gallipoli campaign having almost conclusively failed, Anthony and the regiment were back in Egypt. An early stop was Shepherds, the famous Cairo hotel; and there, he and his cousin Neil Primrose (son of Lord Rosebery) 'ordered a dinner that was worthy of Lionel!'[12]

For almost the next year, apart from a period of summer leave when he went home, Anthony was based in the Middle East, mainly Egypt and Palestine. These months included some early action, as part of the Western Frontier Force's campaign against the Senussi, a pro-Turkish religious order in Egypt and Libya; but they were largely attritional, provoking in his letters a fresh series of complaints, whether about local conditions or larger matters:

Really in many ways this show is like a comic opera, but one of the generals at least would never even have been credible on the stage or in the Chocolate cream soldier [a reference to Shaw's *Arms and the Man*] ... (*30 December 1915, to Marie*)

I hear a staff officer was recently given a D.S.O. because he discovered a wrong move of a division from Cairo to Alex, in time to prevent it, and not as usual half way through. This is the first time any staff officer has shown such intelligence! (*27 February 1916, to Marie*)

This camp [Sidi Bishr] is 12 miles out of the town [Alexandria] and it is very tiresome going in so far, especially now the authorities have started these disciplinary restrictions as though we were school-children. (*19 April, to Marie*)

Here everything moves very slowly, including the hands of the clock: I think the sand must have got into it. I am afraid that a holiday in England is not a good preparation for a stagnation in the desert. (*12 July, to Marie*)

Life is very tiresome here [Palestine] and I am a confirmed grumbler, so that I was almost envious of the beautiful photograph of Philip Sassoon, which

I saw in the Bystander. It is certainly a bad sign for us that we have lost a Brigadier, because this looks as though we [the regiment] shall remain split up, stagnating here indefinitely and whenever the Great War may end, this Greater War [in the Middle East] cannot possibly end for another five years at the rate at which it is progressing. (21 July, to Leo)

…Otherwise there is nothing to record except the stupid empty routine, which seems so rotten when such big things are afoot elsewhere and it seems utterly wrong to grumble at anything or complain of all those petty daily troubles and friction, which are nevertheless very harassing. I am afraid I am very dissatisfied, tho' I should find it hard to justify myself to an impartial outsider, but I cannot stand it indefinitely. (21 July, to Marie)

I am sorry that Eton beat Harrow, but to my mind it is one of the most horrible and depressing results of the war that I can no longer raise proper enthusiasm about this, and the worst of it is that I know it can never really come back again as it was. (31 July, to Marie)

We still remain very comfortably dotted about the fringe of the desert, totally useless for the purpose of preventing any traffic or trading with the Oasis if such existed or indeed if it mattered that it did, in the end it all makes so little difference. However I am not grumbling, only manufacturing some comments on the only topic that is available: you will [be] pleased to hear that I am gradually preparing to give up grumbling. You will note however that by the cautious way I express myself, I reserve to myself the privilege of enjoying 2 or 3 very complete grumbles before finally abandoning the habit. (25 August, to Leo)

Well, I am afraid our inspection today, like most of them in the past, was a tragedy: we had not polished our buttons or equipment sufficiently and I suppose the frantic labours of the last few days were not enough, strenuous though they were, to remove the dust accumulated during many weeks in the desert! (1 September, to Marie)[13]

Anthony continued to read when he could, including Robert Tressell's hugely influential The Ragged Trousered Philanthropists. It had, he told his mother, 'the inevitable fault of books of that type that it merely retells the old tale of evil, denounces the present system, which is admittedly bad, but has nothing to offer instead'. An increasing preoccupation was Zionism, in the context of potentially momentous developments afoot about the future of Palestine, still an Ottoman region with a small minority Jewish population. 'I have always said that the English Jew of today is an anomaly, though it may be an anomaly which it is very convenient and pleasant for us to continue,' he wrote to Marie in late July. 'That is where I agree with Weizmann [Chaim Weizmann, the leader of British Zionism and in time the first President of Israel] though whether I would wish or be ready to translate this into the logical

Best wishes for Xmas 1916.

From Anthony

To Papa.

The artist had one pair of your gloves and was very grateful. I gave the chief medical officer the other pair, should be well looked after.

action that should follow – one way or the other – on this belief, is quite another proposition.' Then a month later, an article in the *Spectator* on Zionism led to a full exposition of his views not only on that question, but on religion more generally:

> Of course I have no doubt that what you [Marie] say about Zionism being so irreligious is true, but disappointing though this is in one way, and though it may alienate your sympathies from the movement, it does not really affect the question or the argument, because if a Jew is merely a man holding the Jewish faith, he can well be the citizen of another country and this is the practical interpretation of the problem, according to which we Jews of England live today making however according to an adverse criticism too many sacrifices of principle and if one goes as far as Weizmann one would say that such Jews are morally bankrupt *etc etc*: that depends on the point of view but the strong arguments in favour of Zionism or some development of that sort is that it is admitted on all sides that it is impossible for the 4 to 5 millions of these Eastern Jews to live this kind of life: it is not open to them, even if they wished it. There is the beginning of the vicious circle, they do not wish it, to them Jewry is not merely a religion but Judaism is a race and a nationality with ancient traditions over and above it being a religion. This separation of religion from their life's ideal is only accidental and incidental to the times in which they live, and indeed it is in keeping with all the history of the Jews who, under the influence of some great leader or prophet at special times, have always been noted for this failing.

> Weizmann, it seems to me, brushes aside the religious standpoint and bases his position on the idea of a nationality to be developed once more in the future by means of a living Hebrew language and by an adherence to many ancient customs, which seems to us out of date and retrograde. It is to be hoped that when this movement does develop, as I imagine it must in some direction or other, there will be some one big enough to infuse the vitality and purity of religion into what otherwise can only fail of its highest object, being soulless and purely materialistic. It may be strange to write it at times of war, where might is all that counts, and yet I think the lesson stands out more clearly every day to those that can read it that ideas are greater than facts and that hard facts even still are futile in the end with all their apparent force and destruction and that it is the Spirit alone that counts.

Meanwhile, more mundanely, Anthony was pushing for something new in his military life. 'I am very vague at present in my ideas, except for a wish to get away and have a change,' he had written to his mother a few weeks earlier about his intention soon to request a new posting, 'but I am quite determined *not* to go on any staff, if it was offered me which is unlikely, and if Papa does suggest writing to his friend to ask

for anything or mention it, please dissuade him at all costs.' By October his desire not to be given a staff job remained unabated:

> In the first place [he explained to Marie] there is no doubt that the human element, which is *the* real value of military life, disappears almost entirely when one leaves regimental duty and inevitably one loses touch with the individual. There can no longer be the *same* equality in the sense of dangers and labours shared: apart from or perhaps by reason of the unpleasantness of these, there is no doubt that they both bring out to a wonderful degree all that is best in the majority of people and that without them there is never such a perfect and lovely friendship and spirit of companionship.[14]

Soon afterwards, he was posted to France – as a staff officer.

Once there, Anthony served over the following months in a variety of capacities; but the new situation inevitably made his correspondence less revealing. 'The little one knows or hears one is not allowed to write,' he told Marie in November. 'Previously there were all the happenings and events of one's surroundings which could be written because they were so unimportant but now it is different.' Instead, the focus was necessarily more on external issues, including in December his welcoming of how the arrival of Lloyd George at No 10 had led to a more meritocratic choice of ministers: 'The so-called aristocracy who go to the public schools do not work nearly hard enough or on any system.' And he looked forward to a post-war world 'when there will be no "idle rich" to patronise the public schools so that they will have to provide something better, and really cheaper, because it leads to something I have always hoped that this will be the development of a school like Harrow, which does not want to and cannot compete with Eton.' That was to Marie, and three days later he was on a similar tack to her, arguing that the problem with 'the public school man' was that 'he is essentially an Amateur, and that just as the Americans taught us at polo and other games that this is no longer good enough, the Bosh is teaching us in the science of war...'

Leo was by this time palpably failing, and Anthony seems to have made a particular effort to write to him:

> I have got little news for you from here except that everybody now seems to receive optimistic reports from England and the story is going the rounds everywhere that the Germans are ready to accept peace on practically any terms. I am afraid this is one of those unreasoned bursts of optimism, which recur from time to time, but anyhow it is more agreeable than the recently prevailing pessimism. (*26 December 1916*)

> It has been snowing here today and somehow it struck me that it made all the country, ghastly and utterly disfigured as it is, even more wretched

and desolate than ever, and it must have been horribly depressing for all
the poor devils shivering in the trenches. (*11 January 1917*)

I wonder what you are doing at New Court in order to induce your clients
to subscribe to the [War] Loan. I am quite prepared to pawn my securities
if this is any use... (*13 January*)

I don't think you are sufficiently optimistic as to the difference which
America's intervention would make. (*6 February*)[15]

An unexpected boon came soon afterwards, when Anthony (by now a major) started
working for a more senior officer. This was Adrian Carton de Wiart: one-eyed; a holder
of the Victoria Cross; probably one of the two chief models for Evelyn Waugh's most
memorable military character, Ben Ritchie-Hook; and Anthony immediately admired
him, not least for the way he led by tireless example. It was the start, indeed, of a life-
long friendship.[16] But at Ascott, the news continued to worsen. 'I can only wonder,'
Anthony wrote in late April to his mother, 'how Papa is getting on: when the time
does come that you wish me to try to come home, you had better say nothing about
it to him till the last moment as everything is so uncertain...' Soon afterwards, he was
given compassionate leave and arrived home at the start of May – in the event, some
four weeks before Leo's death on the 29th. Eleven days later, Anthony left England
to return to France. 'Yes,' he wrote to Marie on 13 June,

I know that feeling that one can no longer look for that interest and advice.
It was so invariable and always given so freely that one almost took it for
granted and now —.

I suppose the only thing to do is to look back on it as the enormous asset it
has been, and then daily from one's knowledge of him to inquire and create
for oneself the advice and interest that he would have given as each thing
crops up little or big: this is easier from the certainty that the interest is still
there and stronger than ever.[17]

<div align="center">⋆ ⋆ ⋆</div>

'You can always write and ask me what I think about anything and it really does not
take very long to get an answer,' Anthony went on in the same letter, 'and I hope that
you won't avoid sending me things that might worry me because really it worries me
far more *not* to hear everything. Besides they are a distraction, and for the moment
I don't look like being very busy.' Over the next five months, he wrote almost more
frequently than usual to his mother; and New Court, the war, politics, Zionism and
literature were all recurrent themes:

I sometimes fear whether I was right to run away and leave all of you with
all these difficulties to face and whether the burden is not unduly heavy

for Lionel. It is hard to say but I did not decide so for pleasure's sake nor I honestly think for selfish and personal reasons. (14 June)

I have just read in the Times the account of Walter's speech at the Board of Deputies and I must say it makes me fairly boil with anger that he should have the impertinence to talk like that and misquote Uncle Natty...The best thing to do would probably be to write and tell him how glad we were to see that he was now taking a real interest in Jewish Questions and insist on his doing a fair share of the dirty work. (19 June, *about his pro-Zionist cousin Walter, now 2nd Lord Rothschild and generally regarded, by dint of his position, as the head of British Jewry*)

To my mind the worst feature is that they (i.e. Walter etc) are joining together to turn out the best leaders of the community, which it is a matter of indifference to them who takes their place, as the object for which they are doing it is purely extra Anglo-Jewish. I am not at all sure that in view of Walter's attitude, the time has not come for the family name to appear on the other side... I don't think it would do much good for Evelyn [on leave in England] to see Weizmann, but I have always agreed that the practical part [i.e. of Zionism] is the stumbling block in this scheme and after all that is the most important. (20 June)

I am afraid that E. [Evelyn] has found New Court as heartbreaking as I did. The worst feature of all is that then the difficulties will be enormously enhanced as soon as the war is over, because then there really will be a lot of different points to decide and it will be the moment on which a great deal depends. (5 July)

Personally I have never thought of anything of that sort [i.e. standing for Parliament] for many years to come, if ever. I really don't think you can honestly say that I am considering it as I am sure I do not want or intend to go into politics at present. There is a great deal to be done at New Court... Above all I want to see how parties are going to shape and what the different lines of policy are going to be. Personally however much I may criticise Asquith & L.G. etc I still consider myself a Liberal if not a Radical... (11 July)

I feel sure it is wrong and that in the end it will bring about L.G.'s downfall. (20 July, *about Churchill – two years after the Dardanelles disaster – returning to the Cabinet*)

I dare say Winston will be fairly subdued to start with but afterwards he is bound to cause trouble. Besides it is such an abominable principle for public life that as long as the mistakes you make are big enough and you are high enough up you are bound to come back again whilst out here nobody has any sympathy for the wretched subaltern, who makes mistakes which only affect a handful of people. There is no wonder that politicians are held in such contempt. (22 July)

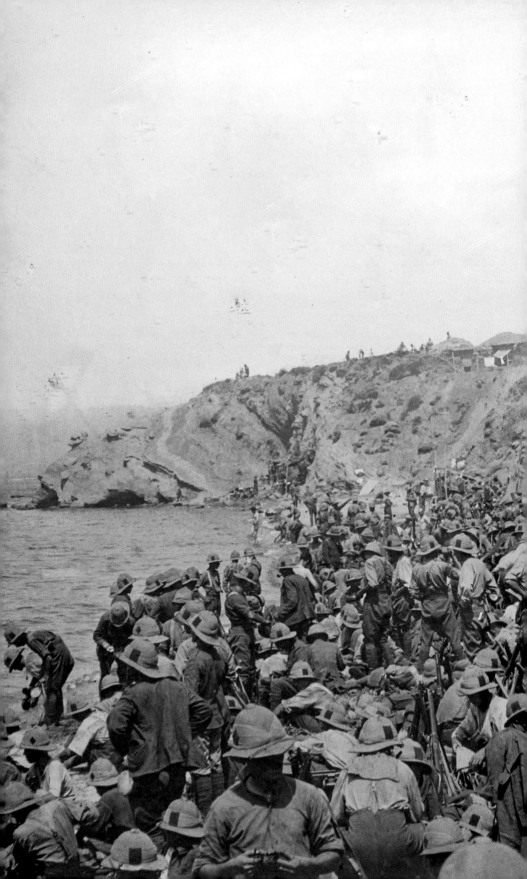

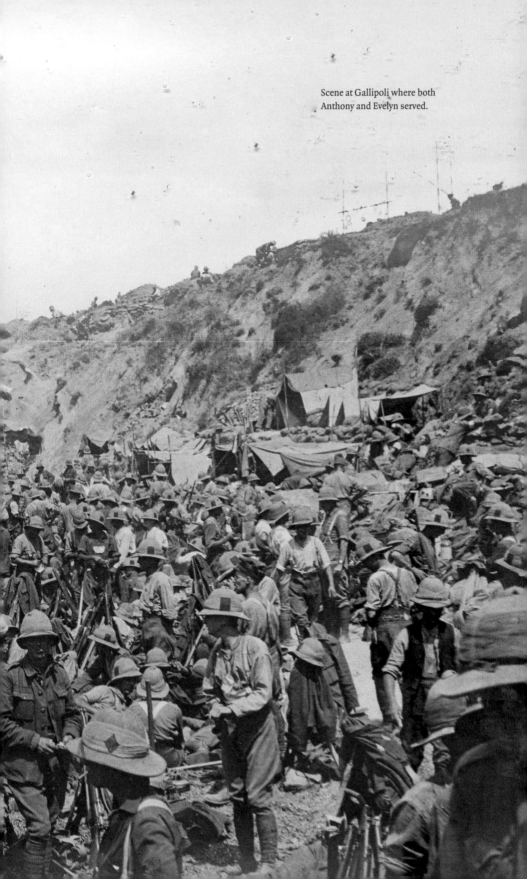

Scene at Gallipoli where both
Anthony and Evelyn served.

I must say that Winston does stick in my throat, and I am wondering
what John Bull [the jingoistic magazine run by Horatio Bottomley] will say
about it: however scurrilous it may be, it will hardly be adequate. (24 July)

I wonder whether you have seen the Cornhill [magazine] with Mrs Asquith's
story in it: it is absolutely typical of her, and just the way she talks, but to my
mind absolutely unfit for publication, so undignified. (3 August)

The news is really wonderfully good from all quarters, and I have the
greatest hopes that the happenings of the next two months will teach the
Hun the greater portion of the lesson he needs to learn. (22 August)

Yes, I am depressed too at Evelyn's having gone off so far again [to the
Middle East], somehow it makes everything seem so much longer and
the idea of having to wait at least another year before seeing him again
is dreary. One cannot look back because there is the impenetrable wall
of Aug 4th 1914 and one dare not look forward. (24 August)

I do resent their [the Jewish Chronicle] calling Walter the head of the House
of R and thought of writing to tell them so. (28 August)

There is no doubt that the Zionists have given people all sorts of ideas that
do not fit in at all with the existence of English Jews, so that as far as it goes
Weizmann is making his case there, but I still stick to my opinion that when
it comes to practical politics, the air will be cleared a good deal. (31 August)

If during your 'rest' [Marie was staying at Woodhall Spa] you hit on a light
novel, which would entertain me, send it to me, but not unless you recommend
it strongly nor another 'South Wind'. (1 September, a reference to Norman Douglas's
highly stylised novel, reviewed admiringly by Virginia Woolf in the TLS in June)

I am sure the less one thinks about peace for the moment the better.
Let the Hun do that and long for peace, and then he may come to a less
truculent frame of mind. (6 September)

I see the Hun has been very active in England again with his bombs etc,
and I am afraid that all the Russian news will encourage all the civilians in
Germany. One can only hope that the American tightening of the blockade
will make them all very hungry during the winter. (7 September)

I went to a service [for the Day of Atonement] for a couple of hours this
morning, but otherwise have not been able to spend the day as I should have
liked so that I have not had time to think and dream and ponder. (26 September)

I am afraid Dilke's bon mot about the family no longer holds good.
(29 September, a reference to the celebrated assertion in 1879 by the politician
Sir Charles Dilke that the Rothschilds 'all quarrel with one another, but are united
as against the world')

... most annoying, but I think the attitude and articles of the Daily Mail are disgusting tho' only what one might expect. (*30 September, in the context of that paper's ferocious attacks on people with German names living in England*)

I shall be curious to hear whether you met Walter: I hope not, as personally I know that I cannot be friendly to him and don't want to. (*5 October*)

How do you like the idea of Chequers going to the Prime Minister, and of having Lloyd-George as a neighbour? You will have to ask him to play golf at Ascott. (*6 October*)

Many thanks for the book on Chinese Pottery ... I look forward to the day when I can study those things again and dabble in them to my heart's content. (*13 October*)

I wonder whether you still study Literary Supplement [i.e. the TLS]: I read the last number but one rather more carefully than I usually do nowadays and thought the article on [Horace] Walpole was very good, quite in the pre-war style and up to the standard of the first article in it in those days. I see Buckle is producing another volume [of the Monypenny and Buckle biography of Disraeli]: what a lot of leeway I shall have to make up when the war does end. (*16 October*)[18]

Soon afterwards, Anthony was in England for about ten days, returning to France on 2 November. A week later, he pointed Marie to the current issue of *Punch*, where she could 'read on page 312 "The Great Man" which is I fear a caricature of myself by the learner in this office and one which does not altogether please me'. This was a semi-humorous sketch by a subaltern called 'Jack' of an unnamed 'General Staff Officer, third grade', to whom the writer was attached in order 'to learn how he does it (whatever it is)'. It took the form of a letter to a friend or relative in Ceylon called 'Dickie':

He is very good to me. He rarely addresses me directly, except when short of matches, but he often gives me an insight into things by talking to himself aloud. He does this partly to teach me the reasoning processes by which he arrives at the momentous decisions expected of a G.S.O.3, and partly because he values my intelligent consideration.

This morning, for instance, furnished a typically brilliant example of our co-operation. 'I wonder,' he said, (and as he spoke I broke off from my daily duties of writing to Her) – 'I wonder about these Flares? Division say they want two thousand red and white changing to green – oh, no, it's the other lot; no, that is right – I don't think they *can* want two thousand *possibly*. We might give them half for practice purposes, or say five hundred. Still, if they say they want two thousand I suppose they do; but then there's the question of what we've got in hand. All right, *let them have them*.'

That was one of the questions I helped to settle.

'Heavens!' he went on, 'five hundred men for digging cable trenches! No, I don't think. They had five hundred only the other night – no they didn't; it was the other fellows – no, that was the night before – no, I was right as usual. One has so many things to think of. Well, they *can't* have them, that's certain; it can't be important – yes, it is, though, if things were too – yes, yes – *we'll let them have them.*'

You will note that he said 'we'. Co-operation again. I assure you I glowed with pleasure to think I had been of so much assistance.

I had hardly got back to my letter when we started off again.

'Well, that's my morning's work done – no, it isn't – yes, no, by Jove, there's a code word for No. 237 Filtration Unit to be thought out. No, I shan't, they really *can't* want one, they're too far back – still they *might* come up to filter something near enough to want one – no I *won't*, it's sheer waste – still, I suppose one ought to be prepared – oh, yes, *give* them one – give them the word 'strafe'; nobody's got that. Bong! That's all for today.'[19]

Fair or unfair? It is impossible to know. But it was hardly a crime to want to get things right, in a war in which the officer class almost systemically got so much wrong.

November 1917 proved a traumatic month. The lesser trauma was the instantly historic Balfour Declaration: taking the form of an open letter – dated the 2nd, and released a week later – from the Foreign Secretary, AJ Balfour, to Walter Rothschild ('Dear Lord Rothschild'), it declared unambiguously that 'His Majesty's Government view with favour the establishment in Palestine of a national home for the Jewish people, and will use their best endeavours to facilitate the achievement of this object'. It was, in Balfour's introductory words, a 'declaration of sympathy with Jewish Zionist aspirations'. In the immediate moment, Anthony's irritation was focussed less on the statement itself, more on his cousin's role in it. 'I am not altogether in agreement with you about the impression made by the letter being addressed to Walter,' he told Marie on 10 November:

> To the world which knows not facts but looks on him as the son of his father, it is not ridiculous and I am not at all sure that our remaining silent does not compromise us. However for the present I really look on myself as dissociated from all contentions of that nature but remain quite clear in my mind as to my personal relations with Walter and that is that I do not intend to speak to him.

Events moved quickly, with an immediate reaction to the Declaration being the formation of the League of British Jews, under the presidency of Anthony's brother, Lionel, and taking an essentially anti-Zionist position. 'I think it will have strong

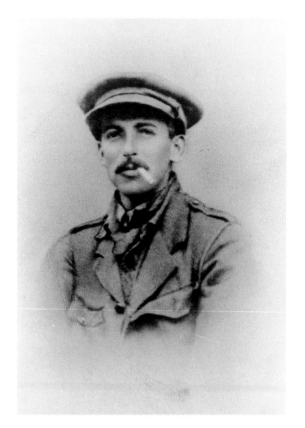

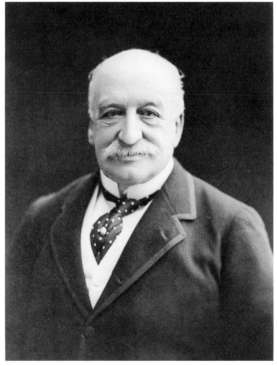

support from nearly all the most prominent English Jews,' Anthony predicted on the 15th; while three days later, he could not but reflect that 'there is something both comic and tragic in Lionel becoming President as a set-off to Walter'.[20]

The greater trauma, putting all this and everything else to the back of his mind, now happened: the news that Evelyn, having been shot through the head in the Royal Bucks' cavalry charge against the Turks at El Mughar in Palestine, had died in a Cairo military hospital. 'He did not survive the operation, but if he had he would never have been right,' subsequently recalled a fellow-officer. Anthony probably heard the news on the evening of 19 November; and next day he wrote to Marie, who had now lost a son – quite possibly her favourite son – so soon after her husband:

> I was terrified the moment I saw in the papers that the Midland Brigade had done great deeds, even more so than any day since they began to attack out there.

> I have received no letter from Evelyn since the first of this month and then this morning by some freak of fate the early post brings me one from him dated October 24th. It seems a cruel mockery, but one must try to believe that it is a message from him as he is now...

> Poor Papa, I am glad he was spared this shock.

> And that was really the only thing to which one was looking forward after the war and now —.

> I have sometimes thought that I have learnt many things since Suvla [Bay] in 1915 and was going to put them into practice with Evelyn. It has been unkind that since then fate has willed that we should hardly be together at all.

Another letter followed a day later:

> We must try to look back on the happy 31 years which we enjoyed together rather than think of the future with its unutterable void and we must believe with the poet that 'it is better to have loved and lost than never to have loved at all' but it is hard and I feel like a rudderless ship on a broad and stormy sea. There was not a plan, not a thought, not an idea for the future, which was not dependent on Evelyn.

'I can write,' he ended, 'no more: yes we must try to help one another in the future as we have in the past, but you must never be tempted to wish that I should not do my duty – when one can see clearly what it is.'[21]

In fact, days later, he was back at Ascott; and there he seems to have stayed, comforting his mother, until the following May, when he started a London-based posting at the War Office. This not only lasted until the end of the war, but gave him enough time to be an active presence at New Court, where as a new partner he could help Lionel in the double context of their Uncle Alfred – last of the older generation

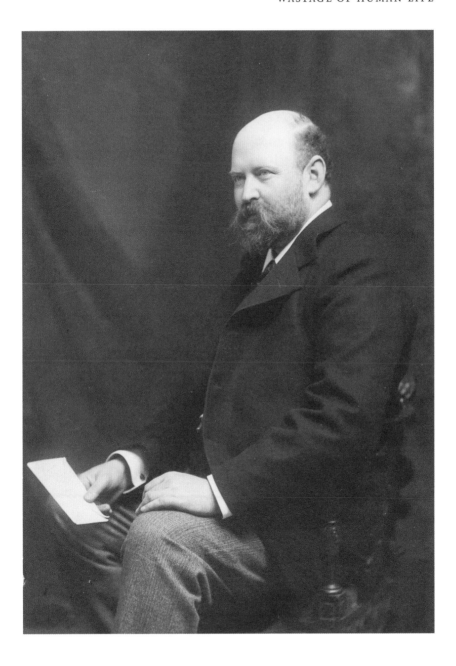

Walter, 2nd Lord Rothschild,
to whom the Balfour Declaration
was addressed.

– having recently died and Charles being only an erratic, intermittent presence. His correspondence now resumed with Marie, but with rather less of the vitality it had once had. He described a dinner party at 'the Austen Chamberlains' where he had arrived 'in a black tie and short jacket' only to find 'everybody else in white ties and white waistcoats'; he recommended Lytton Strachey's 'very entertaining' *Eminent Victorians*; he dined with Lionel at the Savoy and was 'quite dazed by the unusual surroundings'; and, against the background of a threatened national strike, he asserted that 'the claim of equal pay for equal work seems very reasonable, and will surely have to be conceded'.

The war at last ended on 11 November 1918. Twenty-one years later, after another war had broken out, Anthony would remember its predecessor, with all its 'a thousand and one recollections all tumbling over one another as though it were yesterday or even today'.[22]

CHAPTER THREE

Very heavy payments

NEW COURT

The post-war years were not, taken as a whole, particularly easy ones at New Court: the three remaining partners – Charles, Lionel and Anthony – were still youngish and relatively inexperienced; the deaths of the older generation had led to a significant depletion of capital; and, more generally, the City of London was struggling to recover the ground it had lost during the war to New York as an international financial centre. Even so, Rothschilds were still centrally involved in a series of foreign loans which, under the broad supervision of Montagu Norman the legendary governor of the Bank of England, at least gave a passable impression of the old days – in the broader context of a valiant, historically underestimated attempt by Norman and other central bankers to bring about Europe's financial reconstruction after the economic catastrophe of the war.

It was the so-called 'Trinity' of Rothschilds, Barings and Schroders which sponsored these loans. They included in 1922 a major loan to Czechoslovakia, after that country's foreign minister, Eduard Beneš, had visited New Court and met Anthony; in 1923 a large-scale Austrian loan; and in 1924 a loan for Hungary, albeit needing some strong-arming from Norman before Rothschilds and Schroders agreed to commit to it. Also, later that year, when London was responsible for some £10 million of the huge 'Dawes Loan' seeking to put Germany back on its feet, Rothschilds participated secretly up to £1 million, though again after some gubernatorial persuasion.[1] Put another way, Norman at this stage still undoubtedly saw the famous name as continuing to lie at the very heart of the Square Mile's business and responsibilities.

It was not, unfortunately, a partnership firing on all cylinders. 'I hope Lionel has been getting on alright in the city,' Anthony wrote to his mother in 1919 while away, 'and suppose Charles has been there to help him occasionally!' But Charles had problems of his own. For some years he had suffered from chronic encephalitis, which eventually drove him to suicide on 12 October 1923. Rozsika, his distraught wife, immediately turned to the most reliable person she knew:

My dear Tony,

I want you to help me. Poor Charles died at 12 o'clock today – no one must know yet, I want you to keep all details out of the papers. His mother does not know and must not – pray only keep it quiet because I can only send for Victor [her son, away at boarding school] tomorrow...

The children here only know that he is dangerously ill.

Anthony at this moment of family crisis seems to have done all that he could.

'Thank you ever so much for your most kind letter for which I am very grateful,' the twelve year old Victor wrote soon afterwards to him. 'Mummy has told me how good you have been about everything. I hope that some day we shall work together at New Court and I will be of use to you.[2]

THIS PAGE
From an album of photographs
of New Court staff, 1937:
CLOCKWISE FROM TOP
Eve Icely; Samuel Stephany;
Henry Bevington; Ronald Palin.

E. H. Icely.

S. Stephany

R. Palin

Henry Bevington

What about Lionel, by this time in his early forties? Although very keen on motor cars and yachts, undeniably the dominant passion in his life was horticulture, especially once, soon after the war, he had acquired the estate at Exbury on the Beaulieu River in Hampshire. There, 'he planted an arboretum containing a specimen of every tree native to these islands and laid out the vast rhododendron and azalea gardens which in May, when they are at their best, offer one of the most entrancing spectacles to be seen anywhere in the Kingdom'. The words are from *Rothschild Relish* (1970), the enjoyable, fair-minded and informative memoir by Ronald Palin, who came to New Court in 1925. Sometimes aloof, sometimes affable, occasionally impatient, seldom concerned with financial detail – Palin's is a largely affectionate portrait of a classic high-spending merchant banker of the era who in business terms was, while never a negligible figure, not on the whole a big hitter either.[3] In other words, it was clear enough by the 1920s that, as far as the future health of New Court was concerned, much would depend on Lionel's more naturally industrious as well as serious-minded younger brother, respectfully though he would always treat his senior.

Anthony himself by these post-war years was undertaking a significant amount of 'pro bono' duties on behalf of causes close to his heart. President of the Jews' Free School in Camden Town; President of the Jews' Hospital and Orphan Asylum (renamed in 1928 the Jewish Orphanage) in Norwood; Chairman of The Four Per Cent Industrial Dwellings Company (set up in the 1880s by Jewish philanthropists, chief among them Natty Rothschild, to help relieve overcrowded housing in the East End and renamed in 1952 the Industrial Dwellings Society (1885) Ltd); Treasurer of Queen Charlotte's Maternity Hospital on Marylebone Road (thereby making him a permanent member of the hospital's board of management) – all these positions reflected his underlying conviction that the way to a better society was through patient, incremental work on the ground rather than the imposition of grand designs from above.

Typical was the way in which in 1921 he (in tandem with Marie) made available on the Ascott estate a 'cottage' (in reality a substantial house, complete with tennis court, kitchen garden and orchard) as a rural retreat for Basil Henriques, a fellow Old Harrovian much involved with boys' clubs in the East End for deprived Jewish children. He 'has allowed us without any kind of question whatever,' noted Henriques gratefully in 1937, 'to entertain as many boys or girls, or social workers, whom we may choose to invite either for a week's respite, or for a long period of convalescence.'[4]

Inevitably, the issue of Zionism did not go away. 'I had the temerity to discuss the Z. question with Mr Balfour,' Anthony told his mother in October 1919. 'He admitted most of our points & all the difficulties but professed optimism in the end without much reason for it except the great wealth & ability of the Jewish people, whereupon I pointed out to him that the Zionists had succeeded in alienating the majority of the most wealthy...' Then the following summer, Anthony met Weizmann – at the latter's request, with his chances of success lessened by how 'it is unfortunate

that W. always reminds me by his appearance of the last villain I have seen on the stage or elsewhere'. As to the substance itself, 'the purport of his visit was to find out whether I thought there was any chance of getting the *whole* community in this country to help financially the immigration of poor refugees into Palestine.' Despite Weizmann apparently emphasising that this cause was 'nothing political and has nothing to do with Zionism,' Anthony responded cautiously: 'I thought it extremely doubtful whether anything could be done.'[5]

The 1919 exchange with Balfour seems to have taken place on or near the links of the Royal & Ancient at St Andrews, where Anthony was enjoying a golfing holiday. Later that autumn, in a handwritten letter from Ascott, he had uncompromising words for John Heywood Lonsdale, Master of the Bicester Hounds:

> I have been out hunting today and have heard it said that you propose to draw the covert, 'Lionel's Thorns', with the Bicester hounds. I do not know if this report is correct, but in case there is any foundation for it, I am writing to you to ask you not to draw the covert as my father planted it specially for the Whaddon Chase hounds and always said that he did not wish it drawn by any other pack and under the circumstances I cannot allow any other hounds to draw it.

Another enthusiasm was fishing; and on three successive summers he rented for several weeks the same beats on Norway's river Laerdal, often called 'the queen of rivers'. At the end of one summer, his notes on accompanying equipment were typically methodical:

> Food as per Fortnum & Masons list of 1923 about right except honey not much eaten, less Worcester Sauce & less cheese required. Peas unnecessary. An alternative or supplement to tongue such as pressed loaf... Slightly more peppermints or other sweets.
>
> A reading Lamp.
>
> Make sure of rods & reels & bring spares & duplicates, possibly an even heavier line for trout rod...

And of course, 'A Knife with Scissors that cut ...'[6]

One activity above all dominated Anthony's sporting life: horseracing. 'A charming Home of the Thoroughbred: The Southcourt Stud, Leighton Buzzard' was the title of an illustrated profile in *Country Life* in August 1924, with the anonymous writer noting how Leo had created the stud about two miles from Ascott House itself, and emphasising Anthony's 'personal enthusiasm' – entirely understandable, trilled 'Philippos', given 'the tiled red-brick buildings and the cool, sequestered paddocks, with more ridge and furrow about them than I have seen in the acreage of any other stud'. That was a one-off visit, but another, more frequent visitor to Southcourt was the leading equine painter Alfred Munnings, commissioned by Anthony between 1920 and 1928 to paint nineteen of the horses there. 'He would see me settled in a peaceful

paddock with tall elm trees,' recalled Munnings about Kent the kindly stud-groom, 'painting in the company of well-bred mares and foals, a stud-helper holding one of the mares whilst another held a little foal.' Anthony himself, during weekends at Ascott, 'always wanted to know if I had everything I wanted, if I was being looked after, and would ask to see what I was doing'. While as for the financial aspect: 'Not only did the patron say, "Paint whatever you like, just whatever you feel inclined to do," but he afterwards paid for everything at my figure.' And Munnings remembered with understandable warmth going to see him at New Court and being 'given the largest and most generous cheque I had so far received for my work'.

The other part of Anthony's racing empire was the Palace House estate in Newmarket, which he had inherited from his father, and which included not only the house itself but also the stables, both of them closely associated with King Charles II. 'He is quiet and unassuming, and takes a great interest in racing,' observed one journalist in about 1925, the year that Anthony was elected to the ultra-exclusive Jockey Club. 'I doubt,' continued the writer, 'whether any owner is to be seen more often at Newmarket, and he is a familiar figure on his grey hack.' Anthony during these post-war years enjoyed two notable racing triumphs: in 1919 when his Galloper Light (bred by Leo) won the Grand Prix de Paris; and on the last day of April 1926, when his Pillion, a 25-to-1 shot ridden by Dick Perryman, won the One Thousand Guineas at Newmarket itself. 'Pillion came down the hill into the Dip well in front, and it seemed as if she only had to stay up the hill to win comfortably,' reported The Times's racing correspondent. 'The majority of the other runners who were prominent were now beaten, but Trilogy began to go up to the leader. Pillion was undoubtedly stopping, but held on sufficiently long to win by a length...'[7]

<p style="text-align:center">★ ★ ★</p>

Some six weeks and one general strike later, Anthony was a married man. His bride was Yvonne, eldest daughter of Baron Robert Cahen d'Anvers, a French banker (and Old Etonian) whose family had been associated with de Rothschild Frères, the Paris house, since the 1850s. They had met at a dinner party at the British Embassy, where the Marquess of Crewe's wife, always known as 'Peggy', was a daughter of Lord Rosebery. Yvonne accepted his proposal at the end of March. 'The answer is "yes" which seems very wonderful,' Anthony wrote to his mother from Paris. Also keeping Marie in the picture was a contemporary of hers called Edith (probably Lady Wolverton) who had known Anthony as a 'fascinating small boy' and now in mid-April met the couple at the Embassy. 'I liked the look of her so much,' she told Marie. 'I do not think one could say that she is really pretty, but she has such a nice refined face, & such nice blue eyes ... a very nice slim figure & a quiet voice – and absolutely natural manners.' Altogether, 'it was delightful to see Tony looking so pleased & happy, & I feel sure he has chosen

wisely'. Another endorsement came a day or two later. 'The Prince of Wales passed through Paris yesterday and Peggy insisted that I should be at the Embassy with Yvonne to meet him and for her to be introduced,' Anthony informed Marie. 'He was very amiable and looking very well but too shy to congratulate us which he did through Peggy and according to her he said many nice things about Yvonne.'[8]

The wedding took place on Thursday 10 June at the Temple Israélite on the rue de la Victoire, the day after the civil marriage had been celebrated. The *Jewish Graphic* devoted two and a half small-print columns to wedding gifts received, whether in Paris or London. 'As can well be imagined, the very long list of presents were costly and beautiful,' began the inventory. 'A Rolls-Royce, pearl necklace, diamond bracelets, a sapphire ring and bracelet, and a silver fox fur were given by the Bridegroom to the Bride...'

The 10th itself may not have been the easiest day for Anthony. 'It was a great relief to get away from all the bustle and tension of Paris and be peaceful here and lazy,' he wrote the following week to Marie from the honeymoon in Italy; but it was a passage earlier in the letter which carried the greater emotional charge:

> Your few words on the Thursday morning at the Embassy took me by surprise so that I did not know what to answer or rather more accurately my answer was not ready. It is quite simple and true. Comparisons are particularly odious: I do not love you any the less nor any differently because I am married nor is there the shadow of a reason for you to think that there has been anything which you have omitted to do these last years.

A seemingly delayed reaction came some three weeks later, in early July. 'I enclose a letter written 3 years ago to show you what I felt then and have felt ever since and tried to convey to you on the day of your wedding,' Marie wrote to her son. 'I am thankful that I *have not* spoilt your life and that you have found the happiness I so ardently longed for.' The enclosed letter was from January 1923:

> I have nothing to add to my will and requests, but I want to thank you for all your affection and love. What I should have done without it, I cannot think. If I have been selfish and spoilt your life in any way I beg you to forgive me. I often worried dreadfully about you and wondered whether you were happy and would have done anything – but I did not know how.

In 1926 itself, the honeymoon ended with Anthony and Yvonne starting their London life – initially in his mother's house in Hamilton Place, where Anthony on weekdays had been largely based since the war. During those years he had been collecting Chinese ceramics assiduously, and Yvonne would later tell their son that on arrival there she had discovered the collection dotted around the rooms, some of it even hidden away in the bathroom.

Dick Perryman, in Rothschild silks of blue
and yellow, riding Anthony's horse Pillion
to victory in the 1000 Guineas Stakes, 1926.

ES 1926.

PILLION 1.

That son, Evelyn, was the third of their three children, born in 1931 and following on from Renée (1927) and Anne (1930). Was it a happy marriage? The only negative evidence comes in the diary of James Lees-Milne, who in 1949 recorded the art dealer Colin Agnew having told him that 'after their marriage she ran away but after much woe was received back magnanimously and rehabilitated'.[9] Perhaps that was an early blip, for overall one's fairly firm impression is of a marriage which may not have been one of the great passionate romances, but was nevertheless a largely contented and companionate union of two intelligent, cultured and sufficiently like-minded people who treated each other as equals. Yvonne spoke perfect English; she was interested in current affairs; she possessed a distinct egalitarian streak, possibly stronger than Anthony's; she had an equally strong sense of duty; and together they made a life.

Entering a whole new phase, what impression did Anthony make on others at around this time? Our two fullest pen portraits come from very different vantage points. Yvonne's mother was Russian, born Sonia Warschawsky in St Petersburg in 1876; and almost a century later, in 1972, she published *Baboushka Remembers*, a perceptive and atmospheric autobiography full of interesting detail. His 'generosity and anonymous way of helping those in need,' his 'tremendous sense of humour,' the way he would say 'it is never too late to learn more,' his love of poetry (including each spring reciting aloud Wordsworth's 'daffodils' poem 'I Wandered Lonely as a Cloud') – she clearly admired and indeed loved her son-in-law:

> By nature he was a silent man, very reserved, keeping to himself his inward thoughts and feelings. Deeply cultured and knowledgeable, interested in history, art, literature and possessing a wonderful memory, his brain worked so rapidly and methodically, that like a jig-saw puzzle, everything fitted in the right place at the right time! And this no doubt is why, in spite of his so full and busy life, he surprisingly managed to find time for so many and varied activities.

> And with all that he was the most modest and unassuming person, and also so broad-minded. He had a deep sense of duty and of his responsibility towards how the fortune entrusted to him had to be used. A generous philanthropist, he not only contributed large donations to various institutions, hospitals etc, but took personal interest in their activities.

'Nobody ever knew, except those working closely with him,' she repeated, 'the anonymous help he gave to private cases.'

For Ronald Palin, by contrast, the perspective was necessarily that of a dependant in what was still a quasi-feudal – albeit paternalistic and often caring – set-up at New Court. His depiction emphasises how Anthony, for all his various expensive tastes (racehorses, porcelain and fine claret among them), also had a distinctly ascetic aspect: on his way home to Ascott after a day's work, he invariably insisted on taking the tube from Bank to Euston; he was a non-smoker who disliked smoke

in 'The Room' (a purity of air only possible until the arrival of the cigar-smoking Lionel, who shared that sacred, inviolable space with him); and, to the despair of his loyal and long-serving secretary, Eve Icely, his indifference to clothes was such that he wore his shirts until they practically fell to pieces. Palin's first extended contact with Anthony came in 1930, five years after he had joined the firm:

> I entered The Room and stood before Anthony's desk; he invited me to sit down. Hitherto our encounters had been few and brief. I had never experienced his wrath, which in some men could induce nervous prostration; never been addressed as 'my friend', which to senior members of the staff in constant contact with him was the unmistakeable storm signal. But I had always found him formidable, aloof and slow to smile, often impatient and irritable. I had at least learned to appreciate his incisive mind, to understand his donnish and professorial manner, to be ready with accurate answers to questions that ought to be within my field of knowledge and to anticipate the inevitable supplementaries. Now a glimpse was vouchsafed to me, although naturally I could not have realised it, of that more genial and relaxed Anthony whom later I was to know and love, when the years had mellowed him and reduced a little the immense disparity between our relative positions.

On this occasion, Anthony informed Palin that he was sending him on a trip to New York and then Brazil, in order to accompany Stephany: 'You will help him with his cables, coding and so on, and I want you to take notes of all you see and hear. Show them to me when you come back. You will need some tropical clothes – it's very hot in Rio; see Mr Archer about that.' At which point, after Palin had thanked him, Anthony 'dismissed me with a friendly nod'.[10]

Of course, it is cumulatively through his papers – above all his many letters and more occasional diaries – that over the years one really builds up a full picture of the man. Here, just a trio of suggestive contemporary snippets, starting with Anthony in December 1916 apologising to his mother for what he had failed to say during his recent leave in England: 'I am always bad at the expression of an enjoyment or of an emotion because it seems to me that the attempt renders one self-conscious, and that this destroys the spontaneity and self-abandonment which are the quintessence of it.' Then, almost eight years later and again to Marie: 'Yes, I am afraid Gunnersbury [about to be sold and its family possessions dispersed] will give you a lot of trouble and bother, apart from all other feelings, but like most things once tackled they get finished somehow.' And finally, in May 1928, not a letter from Anthony but instead to him, as sent by Victor from Harrow: 'Thank you so much for your letter; lots of people have given me advice about my cricket but yours seems about the soundest. In the nets I play as well as anyone in the school. So Archie MacLaren [briefly coaching at the school] says, but out in the open I am a bundle of nerves.' No wonder that Victor a third of a century later – by now 3rd Lord Rothschild and, to put it mildly, a man seldom

Wedding day in Paris, 1926,
for Anthony and Yvonne.
Bridesmaids Rosemary (in
front of Anthony) and
Naomi (in front of Yvonne)
were the daughters of his
brother, Lionel.

given to effusive praise – remembered Anthony not only as possessing 'a first-class and incredibly quick brain', but also as someone who 'took an almost fatherly interest in my activities' and 'was very kind to me' throughout his youth.[11] A brain and (more often than not) a heart: hardly a unique combination, but arguably rare enough.

<p style="text-align:center">⋆ ⋆ ⋆</p>

'I know you do not expect me to write and thank you for looking after us so well at Hamilton Place,' Anthony wrote (on Claridge's writing paper) in November 1926 to his mother, 'but I do not care to leave there without giving you some sign that we are not unappreciative of all the trouble you took.' And he went on: 'Apart from the last few months [i.e. since returning from honeymoon], when we have found it so useful and when it made a great difference to us, it has been a home – and a very happy one as I think you know – to me for all these years and it has many associations for both of us which I cannot and do not forget lightly.' The recently married couple now or soon afterwards moved into 42 Hill Street, Berkeley Square (tel: Mayfair 7066), recently acquired from the shipping magnate Lord Furness, as their London residence. 'Yvonne is curious to know why you think she wants a "grander place,"' Anthony asked Marie in February 1927. 'She says Hill Street is quite enough for her!' It seems for quite some time to have been a work in progress. 'My library is now nearly finished,' he reported in September 1927: while five months later his correspondence with his surveyor, Percival Hawkins, was still ongoing:

> The long series of experiments [wrote Hawkins] which Waygood-Otis have made in the endeavour to silence the small motor used in connection with the lift indicators has, I am afraid, definitely failed and the hum which you objected to is still quite audible in the car.
>
> I have thought of another way of dealing with the matter, and if you will kindly approve I propose to move the motor into the enclosure in the Boiler House, which contains the other motors driving the pumps, etc., the noise of which does not seem to disturb you.

'As regards the suggestion for the Waygood-Otis indicator,' replied Anthony, 'I am doubtful whether all this is worth while, but I suppose as we have gone so far, *if it does not cause much disturbance*, it had better be done as you suggest.'[12]

The library was surely closer to Anthony's heart than the lift. Alongside Chinese porcelain, his main collecting enthusiasm since the war had been books, many of which he had acquired through the long-established booksellers Henry Sotheran. When, in early 1929 amid difficult circumstances, Sotheran's was formed into a company and badly needed shareholders, they looked hopefully to Anthony; he duly obliged by putting in £5,000, in effect a 10 per cent stake which was crucial in helping to ensure the concern's survival.

Elsewhere in his extra-curricular life, Anthony's involvement in horse racing deepened with his membership of the Racehorse Betting Control Board, i.e. 'the Tote', as it was known almost from the start. 'It is not quite correct to say that the tote will always be in funds if this system is adopted,' Anthony wrote in January 1929, several months before tote betting got going properly, to his fellow-member Sir Harry Goschen, after Goschen had made various suggestions. 'You should provide for the emergency in which the bulk of the losing bets are represented by vouchers and the winners all require cash, and it might be in the case of a day on which outsiders won, that is to say when the general public received and the professional backers lost, that the difference might represent a large sum.' Anthony's own horses continued to run, but there would be no more classic victories, with Torchere being denied by a short head in the One Thousand Guineas in 1930. 'Mr de Rothschild had many to sympathise with him in what must have been a sharp disappointment, though everyone who knows him is well aware that there is no better loser among our leading owners.'[13]

Horseracing matters by now dominated Anthony's dutifully frequent letters to Marie, but they still gave glimpses of other aspects of his life outside New Court:

We went and lunched with Berenson the Art critic ... (25 February 1928, from Grand Hotel, Florence)

Yes, I am quite well: I am afraid I only stayed at Newmarket to escape Adler's sermon and the atmosphere of the synagogue, also to see Renée. (26 September 1928)

We had quite a good day's hunting on Saturday and killed two foxes... (18 March 1929)

It was such a long way to go for a week-end that I got an aeroplane from the Imperial Airways Co & flew down. (10 September 1929, after a trip to Westward Ho!, where on Monday morning he 'played a round of golf before leaving & was in the office here [New Court] by 1.30')

I learn that they killed 8 cubs at Ascott, a terrible massacre... (13 September 1929)

We are going to Biarritz tomorrow for five days and then coming back here before we start off in the car to wander about the South (9 September 1930, from Pilat in the Gironde)

The weather was very bad at Biarritz: I played golf on the two new courses... (17 September 1930)

This afternoon we went to see Alphonse's house which is like a museum and has many wonderful things. What appealed to me most really were the sculptures ... However much one was prepared for it, one could not help being almost alarmed at the size of the house and the garden! (5 October 1930, from Vienna after visiting Alphonse von Rothschild)

It is hard not to feel, reading the letters and comparing them with the ones he had sent home during the war, that Marie had been displaced by Yvonne as the most important person in Anthony's life. And at odd moments, the relationship seems, however ultimately affectionate, to have been difficult. 'You misunderstood my remarks on the telephone,' he gently admonished her in July 1931, 'and I certainly never threatened you with anything!'[14]

In New Court itself, the general atmosphere remained through the 1920s and beyond almost defiantly old-fashioned. One moment above all stuck in Ronald Palin's impressionable young mind:

> 'This, my boy,' said George Tite, warming the seat of his elegant Edwardian trousers at the coal fire in the General Office, 'is the best club in London. We really ought to be paying a subscription instead of receiving a salary.'
>
> It was two o'clock in the afternoon. George, art critic, connoisseur and collector, a dandy, a clerk in the Correspondence Department of NMR and a rich man who had made a great deal of money by 'stagging' the firm's Russian loans which always opened at a premium – George was holding forth to a small group which was not excessively keen to get back to work. With his high collar and stock, his black jacket and narrow striped trousers, his thin cynical smile and his mordant wit, he typified the now [1970] vanished New Court dilettante.
>
> At his back the fire blazed brightly ...

Altogether less attracted to the club ethos, whether at New Court or anywhere else, was one young visitor in 1926. 'My first impression of that firm,' Siegmund Warburg recalled half a century later about the autumn months he had spent there, 'was that compared with the way in which one worked in Hamburg it was lazy, easy-going, and even sloppy.' His initial impression had perhaps been different, or perhaps he was just very tactful; for on ending his stint in 1926 itself, the twenty four year old could hardly have been warmer or more effusive to Lionel and Anthony about the great honour bestowed on him :

> You provided me with many opportunities to learn. I learnt quite a lot of details of business-machinery. But I learnt something also which will be far more important to me in my future life. This is the fine tradition of New Court which combines business with humanity without neglecting either. To learn such a combination is particularly valuable to somebody from the continent where so often humanity is killed by business. When one has stayed for some time at a certain place and felt more and more at home there, a feeling of attachment accompanies one after having left such a place. That will be very strongly the case with me towards New Court. I shall always think with great pleasure of the months I spent here ...

Four years later, the impending retirement of J.H. Archer the staff manager prompted Anthony to reflect on the need to address 'the weakness of the staff in Stephany's department'. 'I believe,' he told Lionel, 'we ought to try and build up fresh staff more from below and I should like to explore the possibility of getting from Cambridge in the next 2 or 3 years a couple of men of first class capacity who should be easy to train and should be able to pick up what is necessary more quickly than the average man.'[15] Hardly ambitious in itself, but it probably marked the start of the firm's gradual transition from being predominantly amateurish to being predominantly professional.

Anthony was writing to Lionel in a 'Partners Note'. Presumably such notes existed earlier, but for Anthony's time they have only survived from August 1929. They were essentially a means of the two partners keeping in touch with each other if one was away from New Court, with the great majority of these notes being written by Anthony, though in some cases one cannot be absolutely certain; and they enable us for the first time to get close-up to him in business action:

Schroders offered me a participation in a syndicate they are issuing for the Chase National Bank. I did not like to take it without consulting you, so thanked them very much and refused. (29 August 1929)

I was very much annoyed to find out that owing to a stupid mistake Harry [Lord Rosebery's son] never received a letter telling him of the transactions which were done on his behalf on Thursday, and this is all the more vexatious as by ill luck the Tintos were bought first thing in the morning and have been well below their price ever since. Of course, the report of what was done should have been sent to him immediately. (25 November 1929)

The Hungarians have not answered yet but we are promised a definite reply tomorrow morning. Naturally if they want to reduce the terms we will discuss it with Barings and Schroders but I am inclined to think it is not a question of bargaining about the rate and they must either take our conditions or go elsewhere. (9 December 1929)

I had a visit from young Schroder today to talk over the general coffee position [in Brazil], and I explained to him our criticisms and objections to their scheme; but they seem to be working on much less drastic lines than I should think necessary. But I particularly explained to young Schroder that I had not had an opportunity of discussing it with you and I did not therefore know what the official New Court view was. (20 January 1930)

Waley and Charlie Montefiore came in today about the Egyptian stock belonging to the ICA [Palestine Jewish Colonization Association] which they state they have had instructions to sell and, in what I thought a very patronising way though they did not mean this at all, they said they were

most anxious to be loyal to us as we were so loyal to them and would we get them therefore a bid from Egypt... (*undated, circa February 1930*)

It seems to me to be extraordinarily difficult, if not impossible, for us to give [Sir Auckland] Geddes the assurance about the finance of the company [Rio Tinto, of which he was chairman] which he requires before he is prepared to go on with the scheme of amalgamation [with Anglo-American Corporation]. It might not be essential to decide within a few hours but here again, as Geddes is quite clear on this point, it is very rash to go against him. You probably have more definite views on the whole matter than I have and I am prepared for you to tell Geddes tomorrow whatever you think best. (*3 November 1930*)

There is a meeting at Schroders on Monday [a possible Chile loan] and you might send me a message beforehand to say what you think. (*6 February 1931*)

Two months later, following Rio Tinto's annual meeting, Anthony received a visit from a partner of the stockbroking firm Crews & Co. 'He was very dissatisfied with the answers he had received and was very long-winded and discursive about the Rhodesian position,' Anthony informed Lionel. 'He left copies of the speeches he had made at the meeting and to which he said there had been no adequate reply. I am arranging for him to see Buchanan and Preston [both of them presumably at Rio Tinto], as although he made an unfavourable impression it is perhaps worth while trying to quieten him down.'[16]

During these years, the whole area of foreign loans became increasingly problematic, as Norman at the Bank of England attempted to walk a tightrope: on the one hand, seeking to reassert London's standing as an international financial centre and not entirely give the game away to New York; on the other, fearful of what an avalanche of foreign loans would do to Britain's chances of staying on the gold standard (to which it had returned in April 1925), given that a high Bank rate was by now political dynamite. His sometimes cryptic diary shows him in action, the Pope of the City encouraging self-denial, not least at New Court:

2 Rothschilds...?Loan to Poland for Tobacco Monop & Exch. I say in confidence that they shd avoid all such transactions: not even worth discussion at present. (*2 December 1925*)

2 Rothschilds... £6m Loan for Vienna. Officially nothing agst Issue here. Privately: a Socialistic city: an uncertain future... (*22 April 1927*)

A de Rothschild... He protests bitterly agst continued embargo on French Loans ... (*4 October 1928*)

Almost a year later, in September 1929, two possible foreign loans were in play. On the 12th, Anthony was visited by Sir William Goode, a senior civil servant, and

told him that, in the context of a putative Hungarian loan, 'it was not likely that any foreign loan could take place in London this year,' but that he would check with Norman. 'I am seeing the Governor today and am also going to talk to Schroder and Barings,' Anthony next day informed Lionel, 'but personally my own feeling is that it will not be good policy to force a Hungarian loan this Autumn, because it could only be done with difficulty, and unless such a loan is going to lead to the purchase of English goods, it would be deservedly most unpopular.' That afternoon he was indeed in the governor's room: '4.15. A de Rothschild. Hungary waterworks. No Loan possible here this year...' 'Moral suasion' was the technical term for this sort of guidance from the Old Lady, and as Anthony further reported to Lionel, it was given 'most emphatically'. A week later, and Anthony was visiting Norman again: '4.30. A de Rothschild. Brazil cables for £8m long or short loan. I say any public issue or placing here impossible in any form.'

The following month saw the Wall Street Crash, the start of a long period of deflation and general economic dislocation, making the world of international finance, including the free movement of capital, even more difficult than before. 'I went to see the Governor this morning,' Anthony told Lionel in January 1930 (the start of the devil's decade), 'who was very friendly and said that a long loan [to Chile] was completely discouraged but suggested we should do £2,000,000 Treasury Bills, which seems to me quite a reasonable alternative. He says this will not provoke any unfavourable criticism and they ought to be quite easy to place...'[17]

Inevitably the New Court focus began to shift, at least somewhat, towards domestic corporate finance, in other words for the British economy. Among the firm's clients during these years were some of the London Underground companies, as well as the brewers Charrington & Co. One intriguing might-have-been occurred in the autumn of 1929. 'Everybody here is v. excited about Hatry & I think it is pretty bad but the chief losers are the big jt stock banks so people don't mind so much,' Anthony wrote to his mother on 20 September; while on the same day to Lionel: 'There is a great deal of talk in the City about Hatry's companies... There have been some very strange doings.'

Hatry was Clarence Hatry, a hugely ambitious financier with plans to take over and rationalise the British iron and steel industry, but who had just crashed amid ugly and justified rumours of serious fraud. Almost a fortnight later, on 2 October, came Norman's intriguing diary entry: '4. A de Rothschild... Steel Industries. ?go into the Hatry position with idea of purchase of control. I advise him to go slow: complicated: management difficult: personal troubles: part of larger question. He will consider.' That in practice seems to have been the end of the matter, though in the 1930s the firm would be closely involved with the iron and steel makers Dorman Long.

Meanwhile, if Hatry was a financier on the way out, that certainly did not apply to Philip Hill, the self-made son of a West Country cab proprietor who during the

1920s emerged as a significant figure, first in the commercial property market and then in company finance generally. His links with New Court became quite close, including in 1930 enabling Rothschilds to float the London & National Property Co. Some sort of personal crunch seems to have arrived that December. 'It was quite obvious that it did not interest him to bring business here and always to be dealt with entirely on a commission basis,' reported Anthony to Lionel after a visit from Hill, who wanted instead 'some formula in which he could get an established position'. And:

> He frankly admitted that he was most ambitious and while he recognised New Court's special position he wanted to gain some of the kudos for himself for being associated with it in some of the industrial business which he might bring our way ... He wished to find some way in which he could be brought into the picture without spoiling it ... I said that I hoped as business developed it might be possible to find some formula which would satisfy him, but I purposely left it very vague... He quite realised that although we should be interested to have the pick of his business, there are many types of business in which he is interested which would not suit us.

Ultimately, Hill would go wholly his own way, so that by the mid-1930s Philip Hill & Partners, forerunner of the merchant bank Hill Samuel, were a very active issuing house in their own right. But before then, in 1931, it was Hill who effected the introduction that led to Rothschilds making in June a £9.36 million offer for sale of shares in the Woolworths retail chain. It proved a dramatic few days: initial huge enthusiasm on the part of small investors; then swirling negative rumours about the company's future; and finally, a desperate all-night allocation process, with staff from Barings being drafted in to help those at New Court – crucial assistance owing at least something to Anthony's close and trusted friendship with Arthur Villiers of Barings. Eventually there was a chance to draw breath. 'After talking it over with Bevington I suggested to Arthur that it would be nice to give something to the members of Baring's staff who helped us,' Anthony told Lionel on the 19th. 'He asked his partners and I am accordingly sending them 50 cigars each, which I hope will please them.' Significantly, Anthony added in the same note: 'I have been thinking a great deal about the I.C.I. issue and the more I think about it the less inclined I am to do it in our name. I asked Arthur casually what he thought about it and I gather that he is very strongly of this opinion, that at the present time it would be a mistake to associate ourselves with this company.'[18]

Anthony's phrase 'at the present time' concealed a wealth of meaning. 'I think the list is a good one and it just depends on whether the Committee prefer a longer dated security than the shorter ones,' Anthony had written barely six weeks earlier, on 7 May, after receiving a list of possible changes of investment from a fellow-member of the Finance Committee of Trinity College, Cambridge. Four days later,

on the 11th, the 1931 financial crisis was under way, as it became known that Credit Anstalt was in serious trouble. It was Austria's largest commercial bank, it was chaired by the local Rothschild house (SM von Rothschild of Vienna), and one of the foreign banks most heavily exposed was, almost inevitably, NM Rothschild & Sons. Anthony himself was perhaps not wholly surprised – back in October 1929 he had warned Lionel that 'the Credit-Anstalt certainly seems to be taking over a difficult position' after it had swallowed Austria's second-biggest bank – and in May 1931 itself, on the 15th, he told Lionel that 'I have been considering the question of the Credit Anstalt very carefully and think it would be a good opportunity to terminate the arrangement by which we take money from the National Bank [of Austria] for them'. From a London perspective, matters remained in limbo for an agonising fortnight or so. 'We [i.e. Anthony and Lionel] have been busy all day with the Credit Anstalt position: it is all extremely disagreeable and dangerous,' he told his mother on the 26th. But within days, helped by a strong push from Norman, an international committee of foreign bankers, chaired by Lionel, had been established. 'The Credit Anstalt has been taken in hand,' Anthony was able to report to Marie on the 31st, 'and there seems a reasonable chance that it may all be arranged but it must be a long job.' So indeed it proved over the coming weeks and months, even years, with Sir Robert Kindersley of Lazards the merchant banker most to the fore in achieving on 16 June 1931 the First Credit Anstalt Agreement, by which the foreign creditors agreed to maintain all facilities outstanding with the Credit Anstalt (as of 28 May) in return for the Austrian government guaranteeing repayment in two years' time. Although he attended, usually with Lionel, several meetings in late May and early June with Norman at the Bank of England, Anthony's overall role in all of this seems to have been relatively limited, certainly compared to Lionel.

For the London house generally, the whole episode represented a significant blow but not a fatal one. Arguably, it could have been much worse – if, at the most critical moment, the partners had not been able to call on Charles's Hungarian widow, Rozsika, described by her daughter Miriam as 'a brilliant business woman'. 'Both Lionel and I appreciate very much your attitude and your readiness to help in this way,' Anthony wrote to her on 29 May, after visiting her the previous day and putting her in the picture – a visit which prompted Rozsika to put a significant amount of her stocks at the firm's disposal so that it could if necessary borrow money on them. 'I only hope,' added Anthony, 'that it should all turn out to have been only an unnecessary precaution, but it is wise in these days to expect nothing good.' It was timely assistance. 'Thanks entirely to your advice and help we have weathered the storm,' Anthony apparently told her a year later. 'I – we – can never express our gratitude sufficiently.'[19] Back in 1923, after Charles's death, should he and Lionel have considered making her a partner? There is no evidence, though, that with her son Victor seemingly destined for a life at New Court, they even thought about the

possibility – at a time, after all, when the very notion of a female merchant banker would have seemed all but heretical.

In 1931 itself, the City's mood continued to darken through those summer months, especially from mid-July as first the German banking system almost buckled and then gold started to flow out of London at an alarming rate. 'Generally I explain our parlous internat position,' noted the increasingly beleaguered Norman after seeing Lionel and Anthony on the 28th, not long before a nervous breakdown. Two days later Anthony was one of the nine signatories to a joint appeal from clearing and merchant bankers to Ramsay MacDonald's Labour government, demanding 'a sound budgetary policy' in order 'to restore confidence both at home and abroad'; while next day the much-anticipated May Report likewise called for major cuts in government expenditure. 'Everyone wonders very much what the Government can do about this economy report,' Anthony wrote to Marie on 2 August. 'It will be so unpopular that it cannot be done unless all parties agree, also the general opinion is that if you try to do it they will also have to do something about the rate of interest on debentures etc, either a special tax or a reduction.' Anthony implicitly conceded, in other words, that all parts of society had to do their bit – notwithstanding that, as The Times's City editor famously put it not long afterwards, '"equality of sacrifice" has an ominous sound in the ears of the investing classes'.

It fell to Anthony during these weeks to hold the fort. 'I am afraid all this does not make very cheerful reading,' he wrote to Lionel on 18 August after summarising the latest state of play (not just dire financial straits in Britain and Germany, but also 'far from encouraging' news from Brazil), 'and I almost hesitate to send it to you on your holiday, as you really ought to have three weeks more rest, but perhaps it is better to keep quietly in touch with what is going on rather than have too much of a cold douche on your return.' It turned out to be a delayed return, even as sterling's position continued to weaken despite the formation in late August of a National government. 'I have received your letter,' Anthony told his brother on 7 September, 'and have just telegraphed to you that of course you were to stay on at Cadenabbia if you and Marie-Lou were enjoying yourselves there.'

Anthony's next missive, four days later, was the killer:

It may have been difficult for you to realise whilst you have been away all that has been happening and how much the situation has changed for the worse. A very large proportion of foreign balances have been taken away from London generally and it is difficult to say if and when they will return. I found out casually in conversation that Glyns had suffered the same as others in this respect. I am sure therefore that until things improve they would not be prepared to fix a loan for a long period of time.

We have then to face the fact that at this time of exceptional difficulty we find ourselves dangerously illiquid with little prospect of improvement in

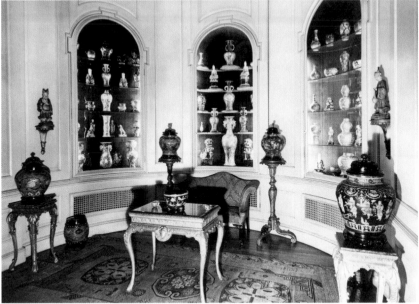

42 Hill Street, Anthony's London home. The tapestry depicting Moses striking the rock became a familiar sight for visitors at New Court after the sale of Hill Street.

Anthony's collection of Chinese porcelain is now on display at Ascott House.

the near future. I know that Rue Laffitte [home of de Rothschild Frères] have done the work of giants in helping Louis [Louis von Rothschild, head of the imperilled Vienna house] and that they have also taken enormous participations in the English credits and loans. Robert [de Rothschild, brother-in-law of Lionel] wrote that in view of what they had already done he hoped very much they would not be asked to help in any other direction, to which I replied that I quite appreciated this and that we would do our best. I have been thinking it over continuously ever since and have been examining the whole position. I am quite certain that unless you are prepared to run a dangerous risk, it is essential that you should ask for their assistance now. I am therefore writing this letter in such a way as to make the position clear if you care to show it to them.

'Very heavy payments,' Anthony emphasised, would need to be made over the next five weeks, adding that 'I have asked Hill to find out if the National Properties [i.e. London & National Property Co] would care [to] leave some of their money on deposit for a longer period'. And he added: 'His mother [Rozsika] tells me that Victor agrees to leaving his money on deposit here for a period of years from October 31, when he comes of age, in which case there would also be further monies available from the same quarter if the position justified it.'

Over the next week or so it became ever more doubtful that Britain would be able to remain on gold. Sunday the 20th found Anthony temporarily relaxing at Ascott. 'It has been a lovely day here & the Sun has been really warm,' he wrote to Marie. 'Yvonne [three weeks after giving birth to their son Evelyn] has been sitting in front of the house sunning herself. I went round the Stud this morning and played a few holes of golf this afternoon...' By the end of the day it was known that Britain on Monday would be coming off the gold standard, symbol of that old, irrecoverable pre-1914 world in which London had reigned supreme as an international financial centre – the golden years for its merchant banks. 'Things have moved so rapidly since I wrote to you that one knows even less where one is,' Anthony on Tuesday confessed to his mother. 'Everything is very quiet in the City and it will take some time for things to settle down.'[20]

A clear and limited objective

'The City is on the whole steady & in some directions markets are better,' Anthony wrote to his mother almost exactly a year later, in September 1932, 'but everybody is waiting for a trade improvement which does not exist yet.' Nor indeed did the world economy start to pick up for a while longer; and though the 1930s had for some in the City its positive aspects, for most – including at New Court – it was largely a case of holding tight and hoping for better days.

A new arrival there in 1931, just as the Credit Anstalt crisis broke, was Michael Bonavia, a young Cambridge graduate whose tutor had recommended him to Anthony following a request if he knew anyone suitable 'to learn the business'. Bonavia was at New Court for four and a half years, before becoming an administrator at the University of London; and his attractive memoir, *London Before I Forget*, gives (complementing Palin) a nice sense of life there:

> The heart of Rothschilds was the Partners' Room, separated from the General Office by a door with a glass upper panel. Staff communications were simple. Each partner had a row of bell-pushes with the names of each head of department beside them. The buzzers sounded frequently in the General Office, and heads of departments slid off their high stools and made for the Room. Entry was obtained by pressing one's nose on the glass window until one of the partners looked up and beckoned one in. When the partners did not want to be disturbed, or had gone to lunch, they drew down a green blind and became invisible from the General Office. In the evening, the drawing down of the blind and locking of the door by a messenger signified that both partners had gone and a general cry of 'Who goes home?' rang through the General Office together with the banging of desk lids.

> It was a rule that one partner would see all the morning's letters, passed across to him in rapid succession by Max Aeschlimann – and every letter that went out, however trivial, was signed by a partner provided one was still in the building. Aeschlimann would be summoned by buzzer in late afternoon and would take in a huge pile which would be signed at incredible speed with a hieroglyph that presented – if one had sufficient imagination – the words 'NM Rothschild and Sons'. Occasionally, in this quick-fire process, something would be thrown out for Aeschlimann to answer a query; but not often...

What about the partners themselves by this time, sitting 'at huge mahogany desks', one at each end of that large room with its 'two vast fireplaces and massively-framed oil paintings on the walls'? '"Mr Lionel" looked rather like the conventional image of a City financier,' recalled Bonavia about his first time there. 'He was plumpish, grey-moustached and smoked a large cigar. "Mr Anthony" was greying, clean-shaven, relatively slender, obviously an intellectual type. He fired questions at me, appeared satisfied with my answers and the interview was rapidly terminated.'

Their approach, Bonavia fairly soon discovered, was also different: '"Mr Anthony" wanted to give Rothschilds a more modern image,' whereas '"Mr Lionel" was more relaxed', liking 'the traditional ways of New Court and not always enthusiastic about innovations.' It was Anthony who in about 1932 'decided that New Court needed an Information Department, similar to that possessed by most banks'; and it was Anthony who was 'rather less popular than his partner owing to his habit of staying late.'

In practice, to judge by the Partners Notes, the brothers seem to have rubbed along harmoniously enough, with little if any sign of friction or riding roughshod over each other. 'I know that you have very strong views about Australian finance although you were inclined to modify them this summer,' Anthony wrote to Lionel in October 1932 in the context of a possible £2 million loan for Sydney, 'and before committing New Court in any way to examining this business I should like to hear from you that you have no objections.' Or, for a more personal touch, take two years later: 'I hope that you [Lionel] are already feeling better for your "cure" and that you are rapidly losing the requisite number of pounds; or is it stones?' One suspects that Anthony was not unhappy to be doing the lion's share of the work and bearing the heavier responsibilities; and if he had a serious complaint, it was perhaps that Lionel did not quite share his strong streak of caution, referring explicitly in 1937 to his elder brother's incorrigible 'dislike of being a bear of anything'.[1]

Anthony during the 1930s may have been a mild moderniser at New Court, but in his approach to doing business he was firmly a City traditionalist. 'They know where we live,' Palin would remember him saying of potential clients. 'If they want to do business with us, let them come and talk to us.' A telling episode occurred in 1937 when Brendan Bracken, buccaneering friend of Winston Churchill, brought along to lunch a representative of the shipping magnate Sir Thomas Royden, apparently dissatisfied with his company's 'present banking connection' and having it in mind to go to either Barings or Rothschilds. 'I explained the etiquette in the City,' recorded Anthony, 'and that as soon as they had definitely broken with Lazards and/or told them so, we should be very pleased to see them and do our best to give them the right advice.'

The City in general was still as hierarchical and status-conscious as ever, perhaps even more so, and relations between Rothschilds and Philip Hill remained delicate. 'Erlangers and Hambros are doing the Covent Garden issue for Hill and have adopted his formula which we refused,' noted Anthony in October 1932. 'Hill's representative offered us some underwriting through Sebag [stockbrokers Joseph Sebag & Co], which I declined for obvious reasons.' A break seems to have occurred the following year, before in October 1936 Hill visited New Court for 'a long discussion' with Anthony. After touching on Woolworths as well as 'a very large and ambitious insurance scheme,' the conversation moved up a gear:

CHAPTER OPENING
Yvonne de Rothschild.

ABOVE
Anthony's brother Lionel,
whose death in 1942 left Anthony
as sole partner at New Court.

> He [Hill] then went on to say that nothing would give him greater satisfaction than if he could co-operate with us in any business that might arise in the future and he was confident that there would be a number of different openings for profitable business, to which I replied that the same conditions applied as had prevented the continuation of our relationship some three years ago on our side at any rate, and I imagined that he had not changed his point of view. He agreed to this but he said none the less he would be very glad if we and Barings cared to take a silent participation in any business of sufficient importance as would justify it. I answered that we were not accustomed to taking a share if we did not pull our weight in the business and the chief thing we could bring to the common cause was our name.

Hill, reckoned Anthony, 'is obviously very anxious to get associated again with New Court so as to improve the standing of his company'.

But if Anthony remained top dog in that on/off relationship, he could hardly hope to be the same with Montagu Norman, who through the 1930s continued to lay down the law to his many visitors, including in September 1938 when he summoned Anthony to 'discuss' the gold situation and, specifically, the firm's services to the Bank of England:

> He [Norman] said he thought it had been getting very big and rather congested and it was probably a mistake to keep it all in such a narrow range. I asked whether we had failed in any way and he said no: there were no sins of omission or commission; but they had been thinking it over and thought it might be a good thing for their purpose if sometimes in the afternoon, when there were large dealings, the Bank could deal direct with other parties. He particularly emphasised that there was no dissatisfaction and no wish to interrupt relationships and on no account was there to be any change made until after the fixing; but he repeated that it was desirable not to keep it all in one hand. I could do nothing but accept his statement and asked to be told if at any time there were any faults on the part of our office to carry out their wishes.

Anthony seems in general to have learnt to bite his lip; but in March 1940 – still four years before the end of Norman's marathon governorship – he would reflect privately that 'I have always thought there was something devilish about him with a cynical assumption of superior knowledge to himself', an attitude on Anthony's part surely influenced at least to a degree by Norman's well-nigh-overt anti-Semitism.[2]

The Partners Notes are full of detailed examples of actual or possible business transactions. Again and again, one sees Anthony in essentially circumspect mode. Entirely typical was when in September 1934 Churchill's ally Robert (Bob) Boothby, at this stage of his life a stockbroker as well as an MP, sent Anthony a letter 'about possible

developments in the cinema industry,' leading to him coming round to New Court and having 'a preliminary discussion'; but 'although the reasoning is sound,' continued Anthony in his report to Lionel, 'the business is very complicated and it looks to being a long way from being fit for us to take up'.

Even so, it would be wrong to imagine that Anthony in daily practice was *wholly* cautious, never taking advantage of a possibly advantageous situation or offer. Take these extracts from a January 1937 note for his brother:

I am rather disturbed by Firth's [i.e. Sir William Firth, chairman of the steel maker Richard Thomas] altering the underwriting arrangements again, as it was arranged quite clearly in this room that he should give up £250,000 underwriting of the debentures and I think it is for you to decide whether you wish to accept this change or to insist on what was settled here. I think there is a definite limit to what Firth may be allowed to do in this way and you must put your foot down somewhere. I am rather inclined to think that it is not worth offering Barings or any of the others stock firm, as after all we can always give them any allotment they want. If you should give any underwriting back to the brokers, I think you should reduce the amount we take firm.

I think it would be interesting for us also to take a participation in the share syndicate which Vickers [stockbrokers Vickers, da Costa & Co] and Sebags are getting up, as it means having these shares at 14/-.

Hart-Davis [Richard Hart-Davis of stockbrokers Panmure Gordon] is very sarcastic about the new Anglo-American company and thinks it is a very bad omen for the future: a great deal depends on the price of issue. I imagine we shall be offered some.

Otto Schiff [of stockbrokers Bourke, Schiff & Co] is trying to buy a large line of Mineral Separation shares and he has arranged with [Auckland] Geddes that if he does get them to offer half of them to us and half to Geddes. I said we should be interested at about £7.

That, overall, probably gets the balance about right. And later that year – even as he told one stockbroker (Claud Serocold of Cazenove's) that he did not want to get involved in a syndicate buying Richard Thomas shares if they were 'pushed up and then down again as a Stock Exchange manipulation' – he was becoming a significant stakeholder in an exciting new venture. 'Tony said to me one day at New Court,' recalled his cousin after Anthony's death, '"Victor, you are a scientist; you ought to be interested in a new Company whose shares are just coming onto the market. It is called Polaroid; shall I buy you some?", to which I replied, "Yes, if you think it is a good idea." I did and I can truthfully say it was the only good investment I have ever made.'[3]

A welcome solid earner for Rothschilds through the 1930s – helped by Britain coming off the gold standard in 1931 and gold bullion returning in large quantities

to London, seen as a safe haven – was the Royal Mint Refinery (RMR), near the Tower of London, that it owned and managed. In early 1932, in the context of the Bank of England scrutinising RMR's fees not only for the treatment of gold but for administering the sale and distribution of the refined gold, Anthony positively let himself go in an internal memo to Clement Cooper, head of the Bullion Department at New Court:

> Gold is a goddess and in this country the Bank of England is her chief priest. Since the war the Goddess has become more remote from this workaday world and her chief priest, having surrounded Her with increasing mystery and austerity, would I am sure frown on any attempt to cheapen her service. You will remember that before the war anybody could take gold to the Mint and in due course receive an equivalent amount of gold in minted sovereigns. If one did not wish to wait for 'due course' one could take the gold to the Bank of England who would forthwith deliver sovereigns there against, deducting about $1^1/2$ per cent for this facility (to cover costs of minting and interest for the period). The facility has, alas, gone but the charge of $1^1/2$ per cent remains. If the Chief Priest considers $1^1/2$ per cent a proper charge for merely handling gold, what will he think of a mere acolyte like NMR reducing their already miserable commission of $^1/4$ per cent? I do not know who has suggested commission reductions but I am sure that if you agree it will be at the cost of offence to the Bank of England.

It is unclear whether Norman got himself involved on this occasion; and in the event, notes Michele Blagg in her authoritative account of the RMR, Rothschilds 'continued to receive the fixed rate, which remained unchanged until it was later abolished in 1967'.

Anthony himself took a close interest in RMR matters, perhaps closer than earlier partners. 'Cooper wanted the use of a little gold in the Refinery in order to treat more of the Canadian gold that comes over for platinum,' he told Lionel in October 1933, 'and after discussion with Stephany we have taken over twenty bars of the Guarantee Trust gold which is sold forward to Barings, and which gives him £50,000 of gold to play with without our being speculators in gold in any way.' Typically, in April 1935, he personally inspected 'the new building at the Refinery' and noted 'the distemper on the walls, which gets very dirty and which should if possible be protected by some varnish or similar material capable of being washed.' Two years later, though, something was clearly amiss:

> The new plant at the refinery [he informed Lionel in August 1937] has been very slow in coming, especially the rolling mills, and in order not to be behind with the Mint we are giving some to Mattheys to roll and some to the Sheffield Smelting [Johnson Matthey and Sheffield Smelting being the other two gold refineries in London]. Except for the colour, some of the first

samples have proved satisfactory, and Kimpton now thinks that we shall be able to complete the order by the date agreed. The whole organisation at the refinery has been rather creaking, especially whilst Smith has been away on a holiday, and definitely needs strengthening.

'I have had long interviews with Smith from the Refinery,' he added a few days later, 'and tried to impress upon him the necessity of accepting New Court control and help.'[4]

It was probably a couple of months later that Victor, who had recently succeeded his Uncle Walter and become 3rd Lord Rothschild, began working for the family bank. He was approaching his late twenties; he had won two years earlier a Fellowship at Trinity College, Cambridge for his scientific work on fertilisation; and, with echoes of Anthony a quarter of a century before, it was quite likely that he felt he had to be seen by the family to be giving a chance to banking, even though it was not what he saw himself as doing for the rest of his working life.

During his relatively brief spell at New Court, his main involvement seems to have been with the Refinery – starting with a letter from Anthony in October 1937 in which he explained to Victor that, with the Bank of China wanting a large amount of silver refined in London, the RMR was now committed, in order to compete with Johnson Matthey, to increasing its weekly output to 2 million ounces, in effect a doubling. After explaining that this might involve weekend working, something that Anthony was very reluctant to introduce, especially for a long period of time, the letter ended: 'I cannot help feeling that you will think it somewhat Irish or peculiar first of all to make a definite offer to produce a definite amount of fine silver per week and then, afterwards, to set to work to find out if and how one can do it; but that is the way things happen at New Court – perhaps also elsewhere.'

A month later, having got his feet under the table, Victor asked Anthony whether, when writing to him about the Refinery, he should send duplicates to the senior partner. 'You need not bother,' replied Anthony, 'to send copies of your letters to Lionel.' But the following August, with Anthony away, it was to Lionel whom Victor wrote, about possible rebuilding work at the Refinery and the question of cost. 'Consequently, before taking this step,' he finished, 'I think we should give it some thought, and wait four or five days. Personally, I should like to talk it over with Tony.' Victor himself seems shortly after to have left New Court and returned to academic life; but he had probably done a good job, with Anthony in September 1938 noting that 'the figures for the first half year of the Refinery ... appear very satisfactory'.[5]

During the 1930s one country was on most people's lips, certainly those of leading figures in the City. In August 1933, exactly seven months after Hitler had come to power, Anthony listened at lunch to the Bank of England's Harry Siepmann:

> He was very unfavourably impressed by his brief visit to Germany last week and found an indescribable state of tension and disciplinary measures; everybody whispering, uncomfortable and obviously dissatisfied without

daring to say so ... In any other country but Germany he would have concluded that there would certainly be a great conflict or flare-up before the end of the year, but the Government appeared so all-powerful that he did not think this was likely in this particular case ... Siepmann admitted that it came as a very unpleasant shock to him as previously he had thought that there was at any rate some good in this movement, but now apparently the underlying brutality of the people has come out and is in evidence everywhere.

Did Anthony *ever* see any 'good' in the Nazis? Almost certainly not, quite apart from the anti-Semitic aspect. A year after Siepmann's visit, in August 1934, he read in The Times a letter from Thomas Moore, a particularly right-wing Scottish Unionist MP, who lamented how 'rarely do we read anything of the social, educational, or even moral achievements of the Hitler administration', listed a range of 'humane and progressive measures which have so altered the face of modern Germany', and urged that Hitler now receive 'the friendship of Britain'. Anthony, writing to his mother, flatly called it 'an incredibly stupid letter'.

Over the next few years, a series of luncheon guests at New Court gave him vivid but conflicting accounts of the state of political and economic conditions in Germany, prompting Anthony to reflect to Marie as early as August 1935 that 'I am afraid the outlook in Europe is very black at the moment and I don't see any way out, except a bad one!' In August 1938, after the Nazis, immediately following the Anschluss, had imprisoned Louis von Rothschild and demanded a huge ransom for his release, Anthony was adamant that 'New Court would on no account contribute to blackmail'; while soon afterwards, with the Czech situation darkening by the hour, he told Lionel that 'after consultation with Stephany I agreed to take additional money from the Bank [of England], so as not to be obliged in case of necessity to go to them in a hurry if a crisis comes.' That phase culminated with the Munich Agreement, averting war and hugely welcomed by the City. 'Anthony Rothschild believes that out of this crisis will come a rejuvenation of England,' recorded his friend Robert Bruce Lockhart a few weeks after Neville Chamberlain had returned to England waving his piece of paper. 'He agrees with me no use cursing and blaming; at same time he is against the frightful complacency of the Chamberlainites and wants a strong line.'

By the following summer, following Hitler's occupation of the rest of Czechoslovakia and Britain's guarantee to Poland, war seemed sufficiently inevitable, with the accompanying bombing of London, for Rothschilds to have opened a new refinery on the site of the old Silk Mill on the family estate at Tring. 'They seem very busy and have a great number of orders in hand,' Anthony reported to Lionel in late July. 'The die casting is developing and it will be necessary to take a decision before long as to whether we are to build on the cottage site and whether it is worth while, besides, having some possibility of further expansion elsewhere if it is a success.' By 10 August, Anthony had given the go-ahead: overall expenditure of £15,000, but a likely annual profit of 16 per cent if the

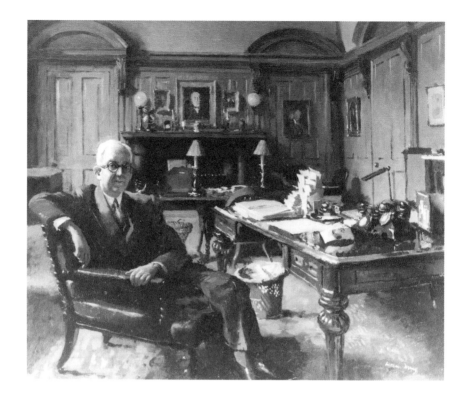

ABOVE
Anthony seated at his desk in
'The Room'. By William Dring (1948)

plant was fully occupied. Around the same time, late July and early August, a technical decision was needing to be taken about Brazilian bonds. Albert Pam of Schroders put forward a plan for dividing them and issuing fresh ones; Anthony disagreed with him ('I am convinced,' he informed Lionel, 'that the physical objections to an exchange of securities should be decisive'); and in due course, after lengthy discussions, the Council of Foreign Bondholders came down on Anthony's side.

What about the most pressing matter? 'Here we continue to have an anxious time,' Anthony wrote on 3 August to his man in Buenos Aires, 'and we are naturally very uneasy as to what the developments may be over the next 3–6 weeks, but it is not possible to form any reasoned judgement on what turn events will take.' Sadly, Anthony's voice then goes largely silent over those next few weeks; but in the City at large, the mood by the end of August was accurately caught in the diary of a Stock Exchange jobber, Roy Sambourne:

> Alas after a good start – & the usual St Ex optimism – we get a bombshell. Evacuation of children – calling up of Navy – practically complete mobilisation. Prices begin to fall & intense gloom prevails. The Stock Exchange to be closed tomorrow. Still one or two optimists still are to be found. I have practically – God help me – given up all hope.[6]

<p style="text-align:center">★ ★ ★</p>

Anthony during this decade remained one of life's philanthropists. He continued in his various positions, mainly for Jewish causes but also as treasurer of Queen Charlotte's Maternity Hospital, for which he played a leading part in a big City fund-raising dinner in November 1935 to enable it to move the main hospital to a new site in Hammersmith; he carried on giving generously to a wide range of institutions and individuals – the former often being hospitals, the latter including in 1937, a typical year, Mrs LC Armstrong ('widowed daughter of a carman formerly employed at N.C.'), WJ Cable ('Sec. of Soc. of Friends of Foreigners in Distress'), Mrs AR Dunham ('wife of poultry farmer helped since 1903'), S Harrison ('incurable invalid'), and Miss M Spear ('governess formerly in Belgium; without means'); he was increasingly the go-to person to act as an executor in the wider Rothschild family, for example for his Aunt Emma after her death in 1935; two and a half years later he moved decisively, in tandem with his old tutor John Tarver (by now managing the Ascott estate), to sort out the finances of Sotheran's the booksellers; and in 1937 he gave Van Dyck's 'The Abbé Scaglia adoring the Virgin and Child' to the National Gallery, enabling it to be publicly exhibited for the first time in almost forty years. There was, perhaps, one significant disappointment. The most loyal of Old Harrovians, he was always willing when approached to give financial advice to the school's governors; but because it was still assumed (mistakenly in fact) that the statutes of 1871 had debarred non-members of the Church of England, he was never asked to become a governor himself.[7]

A member by this time of the Oriental Ceramic Society, Anthony during the 1930s expanded further his collection. A full appreciation awaited a *Country Life* article in 1950 by Arthur Lane (a leading pottery expert) on 'Outstanding Chinese Ware'; but almost certainly what he saw at Ascott then had been largely acquired by the time war broke out. Lane noted 'a Tang grain-jar of heroic proportions', as well as 'a numerous assembly of the Chün wares'; but it was 'in a particular class of wares made during the Ming period (1368–1644) that Mr de Rothschild's collection far excels any other in this country.' These were the 'so-called san ts'ai wares', whose 'glazes have a rich depth of colour not found in any other class of Chinese wares'; and, continued Lane, these 'three-colour' wares ranged from 'the big sturdy jars and barrel-shaped garden seats to the tall, elegant vases and smaller more exquisitely modelled pieces for the writing table.' Taken in all, it was a collection revealing 'an informed and remarkable individuality of taste'.

It also revealed, Lane might have added, Anthony's almost unerring eye for – and attention to – detail, characteristics that emerge again and again in his papers. 'This reel was never satisfactory, as I found it could not be adjusted to the correct rate of pull: it was apt to be too light, and the next catching point seemed to make it too heavy,' he wrote in September 1936 to the New York firm William Mills & Son about the latest fishing tackle he had bought from them:

> However, it worked fairly well until I was playing a large fish, which took practically the whole of the line out and in so doing, presumably, must have strained part of the mechanism, as afterwards when the fish made short runs the reel repeatedly over-ran. When I tried it later after re-setting it, it seemed to start all right at the beginning of the day's fishing, but was inclined to work loose and over-run for no apparent reason.

Mills duly sent him some replacement equipment. 'I should be glad to know whether the reels require any oiling,' Anthony wrote after acknowledging its safe arrival (and enclosing a cheque for $148.50), 'and particularly whether any oil should be put in the little keyhole on the outer side of the reel covered by a protective piece of metal, which slides to one side, and what the purpose of this is.'[8]

Horseracing remained an important part of Anthony's life, albeit for religious reasons he never allowed his horses to run on Saturdays. In 1932, for example, he had at Palace House in Newmarket twenty-three horses in training, ranging in age from two to four, as well as twelve yearlings; while at Southcourt Stud, in 1937, he had one stallion, nineteen brood mares and over a dozen yearlings (a mixture of colts, geldings and fillies). A notable episode was Anthony's close involvement in 1932 in the creation of a British syndicate to ensure that the ten year old Solario, a champion thoroughbred and influential sire, stayed in England after the death of his owner, Sir John Rutherford. That July at Tattersall's sale paddocks at Newmarket, the syndicate paid a record 47,000 guineas, thereby narrowly managing to outbid an American syndicate. 'All the while the excellently-

mannered Solario was showing what a perfect-tempered creature he is, not worrying about the strangeness of the scene, but placidly following his old friend and stud groom, Hammond,' reported the *Daily Telegraph's* 'Hotspur' about a dramatic day. It proved a successful investment for Anthony and friends, as Solario proceeded to sire a series of winners of big races.

Elsewhere, a snatch of correspondence from July 1936 is suggestive of how he operated as a racehorse owner, in this case in relation to Tom Cannon, who for almost half a century had ridden or trained for the Rothschilds, first Leo and then Anthony. By this time he was feeling his age and wondering about retiring. Anthony, on hearing about the 'pain and discomfort' he had suffered the previous winter, urged no delay:

> I am afraid your present lot of horses are disappointing and on looking at them from an unprejudiced point of view I do not think they are likely to be very profitable next year, those of them that is to say that one might decide to keep. All things considered I do not think there is much use in sending you a few yearlings for their first season, especially as the ones that might come to you appear to be backward and likely to want lots of time.

> The result of all this is that it seems to me much the best in all the circum-stances that you should definitely decide to retire at the end of this racing season. I understand from you that your expenses are likely to be heavy in the intervening period and that there are charges such as tithe etc. to be met, but I would willingly go into this matter with you and see whether I could make a contribution to bridge over this time.

Even so, there was still some of the present season left; and barely a week later, Anthony was writing to Cannon again:

> I think on the whole Praxiteles had better run at Chepstow though I think the storm at Newmarket very likely prevented him showing his form.

> As regards Monocle I am wondering whether he would not do better with a jockey like Perryman, who might ride him quietly and give him time to settle down. I know up to now he has shown no form and therefore it was difficult for Sirett to avoid making the most of a good start, but I doubt whether a horse of this temperament is likely to show his best when ridden like that. Therefore the next time he runs I would suggest your telling the jockey to try and let him settle down and then come out to win at the right moment.

Best-laid plans ... Praxiteles indeed had his next outing at Chepstow, in the Great Western Maiden Stakes on 3 August, but finished an 'also ran'; as did Monocle, the following day at Birmingham in the Midland Plate, though some seven weeks later he did come home in the Midland Nursery at Leicester.[9]

Through much of the decade, Anthony continued to shuttle between his three homes: Ascott, Palace House and his Mayfair residence at 42 Hill Street, where an

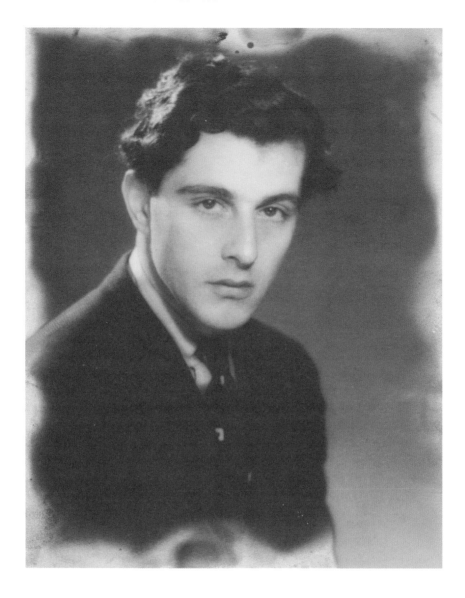

Victor, 3rd Lord Rothschild
aged 20, photographed by Man Ray.
© Man Ray 2015 Trust / DACS, London

undated list, probably from the late 1930s, shows a well-staffed household of nine servants (five men, four women) as well as kitchen staff (Chef + 1st Kitchen Maid + 2nd Kitchen Maid + Scullery Maid). After April 1937, when Marie died, Anthony was increasingly focused on Ascott, which he now inherited and where he and Yvonne, in the words of a modern guide, 'embarked on a total renovation, removing much of the house and many of its outbuildings, and remodelling the interior to create a series of lighter, simpler rooms, with modern central heating and bathrooms.' Over the next year or two, he was in considerable correspondence – sometimes friendly, sometimes less so – with George Muntzer of Muntzer & Son, a London-based firm of builders, decorators, upholsterers and furniture makers:

Mrs Rothschild has shown me your letter and I am glad that you have had an opportunity of seeing the wisteria at its best, so that you realise that it is worth doing all we can to avoid damaging it, though, of course, it is very important to get more light into the bedroom window upstairs. (11 June 1937)

The date in the doorway: there is a small fragment of an old beam with what, presumably, was the original date of the house in the lintel of the entrance door. This must certainly be preserved...

As regards the library: I shall require the maximum possible room for books, consistent always, of course, with the main decorative scheme, and place for, say, a couple of pictures. (26 July 1937)

I have been thinking a good deal of your remarks yesterday, when you said you had come to the conclusion that the work at Ascott would not be finished until October or November at the earliest. If within 3 months of starting they have already lost 2 months of their time table, I imagine that according to this calculation we shall be lucky if we are in by this time next year. I would remind you that the contract says that the work shall be finished by the end of August, and, in fact, that is allowing the builders extra time beyond the figure upon which the contract was awarded to them. I am therefore not prepared to accept any suggestion that there need be any delay at all ... I look to you to continue to exercise pressure to keep them up to their time table and to insist that they take the necessary steps with this in view. (7 March 1938)

I do not know exactly how much room there will be for mottos, but I give you the following and should like them used in the order in which they are written: –

1. Love me love my dog.
2. Strike while the iron is hot.
3. Faint heart ne'er won fair lady,
4. A soft answer turned any wrath.
5. Enough is as good as a feast.
6. Silence gives consent. (1 September 1938)

By the following summer, Anthony was in a state of extreme dissatisfaction with the high running costs of the hot water and heating installations. That August, replying to an extenuating letter from Sulzer Bros, he took time off from the international situation to insist that their original advice to him ('that the system ultimately installed would be relatively cheaper than any other') had proved far from the case:

> The results are lamentable. You have alleged that certain factors, namely the increased cube of the house, the increase in the cost of coal, the alteration in the division of the wings in the house, including the amount originally allocated to the respective divisions, the addition of towel rails, etc, and the additional temperature range, are responsible for the increase in running costs.

> All these factors, except the cost of coal, were known to you and fully considered by you before I gave an order for the plant ...

While as for the aspect of their recent letter about how it might be possible to improve the situation, 'you have merely made a number of suggestions which would materially interfere with the running of the house and largely nullify the advantages of the system, apart from which they were obviously not a part of the original scheme.'[10]

Marie was still alive when, in September 1933, Anthony and Yvonne went on their holidays. 'We have had the Anthony Eden's staying here for a week & they left yesterday,' he wrote to her from a family home in the small seaside town of Pyla-sur-Mer in south-west France. 'He has to meet Daladier in Paris on the 17th to recommence the disarmament conversations. They seemed to enjoy their stay here.' Later that month, he was writing from Madrid's Hotel Ritz:

> Lord & Lady Lee of Fareham are staying here: he has come chiefly to examine a small Raphael in the Prado of which he claims to have an earlier version, & he introduced us to the Clarks a v. nice young couple. He [Kenneth] is at present curator of the Ashmolean Museum and becomes director of the National Gallery in January though he is only 30. He has been v. helpful in telling us when things can be seen, as this appears to be v. uncertain in this country. Yesterday we went to the Escorial & came back quite tired. I have had a good morning in the Prado and a short moment yesterday, but today I have resisted the temptation of going there on the Day of Atonement! I nearly convinced myself by Jesuitical reasoning that the contemplation of the pictures would really be the best way of 'atoning', but I resisted & have stayed quietly in the hotel, except for a walk in the sunshine.

Three summers later it was an altogether less grand holiday – and perhaps not quite Anthony's natural milieu – that he was telling his mother about. 'The children approve of Frinton, which is the important thing & have settled in well,' he wrote from Hollywood, Esplanade, Frinton-on-Sea. 'The place is very full & swarming with children!'

The Central British Fund for German Jewry
WOBURN HOUSE, UPPER WOBURN PLACE, LONDON, W.C.1.

Contributions should be sent to:—

Messrs. N. M. ROTHSCHILD & SONS, NEW COURT, E.C.4

and envelopes should be marked "APPEAL"

I enclose my cheque value

Kindly acknowledge receipt

NAME

ADDRESS

BOTTOM
'An appeal to the community
inaugurated by the Rothschilds
would be heeded by all sectors.'
(Amy Zahl Gottlieb).

TOP
A retreat at Ascott: the library before
Anthony's renovations of 1937.

Of Anthony's own children, the surviving correspondence suggests that his primary focus was his son. In March 1937, when Evelyn was only five, Anthony was putting him down for full membership, in due course, of the Bath Club (in Dover Street); while two years later, the larger situation saw him in detailed correspondence with ACW Hodgson, headmaster of Egerton House, a day prep school based in Dorset Square. In April, shortly before Evelyn arrived there for the summer term, he was telling Hodgson that, should war break out and the school remove to a site near Brackley, then Evelyn would not be attending ('I have talked this matter over [with Yvonne] and we think that Evelyn is too young to go to a boarding school, and though he will be in the country near my country home not very far away, I doubt whether the petrol restrictions would allow of his going backward and forward'); in May he was giving Hodgson a term's notice, even if there was still peace in the autumn ('under present conditions it is probable that in any case after the summer he will be living down in the country and therefore unable to continue to go to your school'); and then in late July: 'Unless war breaks out during the holidays, we propose sending Evelyn back to your school next term if you have room for him.'[11] Whether as a parent or as a banker, it was now the age of uncertainty.

* * *

'We feel that the time has come when a Special Committee should be established to deal with the problems which have arisen, and will arise, in relation to the economic and social welfare of our German co-religionists during the continuance of the present policy of discrimination,' two prominent British Jews, Neville Laski and Leonard Montefiore, wrote on 24 April 1933 to Lionel. 'We hope that you and your brother will consent to act as joint chairmen of this Committee,' they went on. 'It is impossible for us exactly to define the scope and functions of this Committee, but generally speaking it will deal with questions of constructive work for the assistance of our German co-religionists and the raising of any necessary funds.' Lionel responded positively ('all efforts to ameliorate the conditions of our co-religionists in Germany must have the sympathy of every member of the Community'), on behalf of Anthony as well as himself; a meeting was held at New Court; and by 18 May the Central British Fund (CBF) for British Jewry had been established. 'Lionel de Rothschild and his younger brother Anthony, both pillars of the community, were unreservedly the best qualified of their peers to call Anglo-Jewry to action,' notes Amy Zahl Gottlieb in her history of the CBF. 'Their family name commanded respect; its munificence was legendary. An appeal to the community inaugurated by the Rothschilds would be heeded by all sectors.' Following a series of luncheons given by Lionel and Anthony at New Court to potentially supportive bankers, businessmen and others, an appeal to the Anglo-Jewish community was duly launched on 26 May; and by late 1933, to quote

Gottlieb again, 'an impressive sum of almost £250,000 had been donated to the CBF, an amount which proved to be proportionately more than the total donations to the American Jewish Joint Distribution Committee and the United Palestine Appeal in the United States in the same period.'[12]

Given what was going on in Nazi Germany, and to some extent elsewhere, it was understandable that Jewish affairs now began to play an increasingly prominent part in Anthony's life. 'I have been very busy with all these schemes for Palestine,' he told Marie in August 1933; and indeed he had been earlier that month, as Sir Robert Waley Cohen (a physically huge industrialist, with a choleric temper) sought to get other leaders of Anglo-Jewry behind him over an ambitious plan for German Jewry to start life afresh in Palestine. 'I do hope you will be able to have this out with Tony,' he encouraged Otto Schiff, 'and that he will agree with us as I feel sure he will, because he is always so sound, but his genius for friendliness sometimes I think submerges his judgement...'

Anthony himself from the first urged caution and realism. 'I think for this purpose it is absolutely necessary that we should have a clear and limited objective and deal with the various suggestions on business lines,' he wrote to Israel Sieff of Marks & Spencer, specifically about the ambition to launch a development company in order to create greater prosperity in Palestine. 'I therefore venture to think that a great many of the ideas expressed in your memorandum do not at the present stage arise.' Or as he put it the same day to Lord Reading, the former Sir Rufus Isaacs: 'I think that the proposal to raise the money by the flotation of a public company can only be carried out if we have a strictly limited objective in view and that we must avoid all sorts of vague generalities such as appear to be dear to the heart of Mr Sieff.' A few days later, Anthony had Sieff to dinner and, he told Marie, 'we reached a tentative agreement'.[13]

Where exactly did Anthony stand by this time on the larger question of Zionism itself? Miriam Rothschild claims, in her biography of her uncle, that 'Walter and Rozsika, by their joint efforts, eventually persuaded both Lionel and Anthony to modify their attitude and learn to live with the Balfour Declaration', but perhaps that is a stretch. A revealing moment came in December 1933 when, following an informal meeting between them, Chaim Weizmann took the trouble to write to Anthony at great length. 'I think you will have realised that the suggestions which you made, no doubt on behalf of others, could not but leave a very painful impression,' he wrote, before going on, in effect, to accuse Anthony of having listened too much to misleading versions by others of conversations they had had with him (Weizmann). And – whether for the sake of the record, or in the hope of persuading Anthony, it is impossible to know – he stated his core conviction:

It is obvious that our identification with the non-Jewish inhabitants of the country in which we live goes to great lengths – but it does not go quite all the way. There are points in our life which separate us distinctly from the others, and any attempt at a denial of this obvious fact, any submerging of

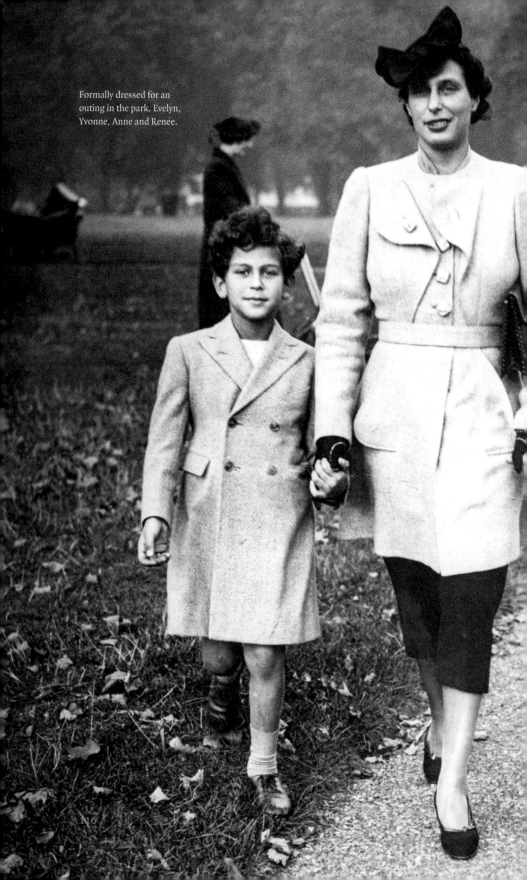

Formally dressed for an
outing in the park. Evelyn,
Yvonne, Anne and Renée.

116

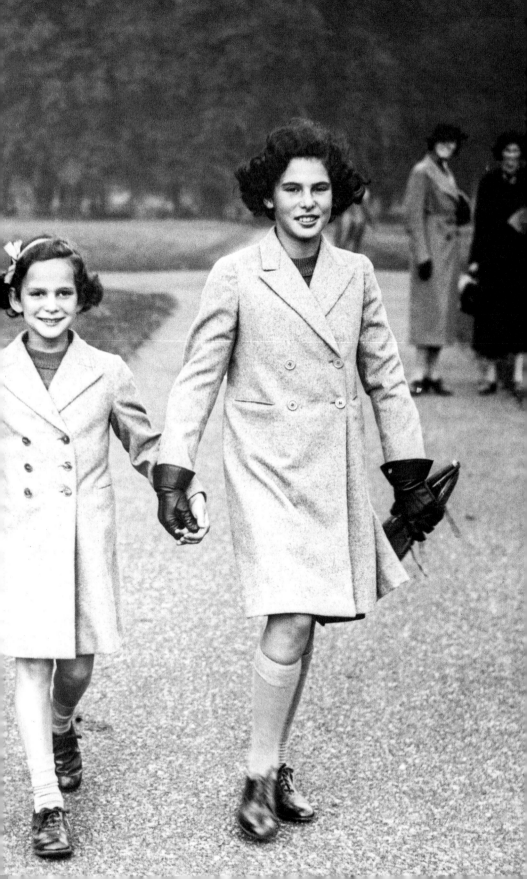

one's individuality in the majority (as practised by a great many of the so-called 'assimilated' Jews, who reduce their Judaism to a mere shadow – an empty formula) is as repugnant to me as I believe it to be to every thoughtful non-Jew.

Next day Weizmann told Max Warburg's daughter, Lola, how 'thoroughly fed up' he had become with the British non-Zionists. 'Whatever lip service they may do to Palestine, in their innermost they are either indifferent, or in the majority of cases hostile, and will always let us down at a critical moment,' he declared. 'They cannot do otherwise, as they are utterly hollow and frivolously superficial, and hopelessly stupid! And then – they don't care! I have had a tussle with friend Anthony, who is about the best. I have written him a long letter ...' It does not seem that the best of the non-Zionists replied, not at any length anyway, to Weizmann. But a suggestive (if not necessarily trustworthy) footnote to this episode occurred in October 1934. 'I just happened to run into Mme. Anthony de Rothschild in the George V Hotel [in Paris],' Weizmann told his wife. 'She admits her Zionist convictions, but is scared stiff of her husband.'[14]

Over the next few years, Anthony would need all his qualities of patience and diplomacy. During the winter of 1934–5, when the question came up of financial support for Jews in increasingly anti-Semitic Poland, he successfully argued to his fellow members of the CBF Executive, meeting at New Court, that while the CBF had 'done a very great deal to alleviate the position of the German Jews', the issue of helping Jews in Poland was 'quite another proposition', to be seen as still essentially economic rather than (as in the case of Jews in Germany) essentially political; in December 1935, 'the Jewish meeting on Monday was interminable and we decided nothing very definite', he informed the absent Lionel, adding that 'Waley Cohen was as usual impossible and made many outrageous statements'; a month later, reporting on Lord Melchett coming to lunch and talking big – 'he has tremendous Zionist ideas and wishes to stir up the British Government so as to get them to insist on Palestine taking in very large numbers each year, and in this way he thinks you should deal with the whole European situation, that is to say, Roumania, Poland, etc., and not only Germany, on a very large scale from now onwards' – Anthony mildly noted that his response had been to say that 'in many ways I differed from his policy'; in August 1936, with Max Warburg in London pushing hard for the City to back an issue of bonds to make it more possible to get Jewish money out of Germany and thereby put pressure on Hitler not to tighten the screws further on Jews there, Anthony consented to come in – though not until it was clear that at least two 'Christian firms', Schroders and Lloyds Bank, were in also; the following July, after 'a long Jewish meeting' at which it was agreed to 'put into the minds' of certain British politicians 'the idea that it was not yet too late to make an agreement between the Jews and the Arabs, so that the Government might state that in this event they would accept it and not force a partition', he added wearily that 'all the old questions about the status of Jews outside were repeated ad nauseam without anything very definite coming of it'; and in March 1938, soon after

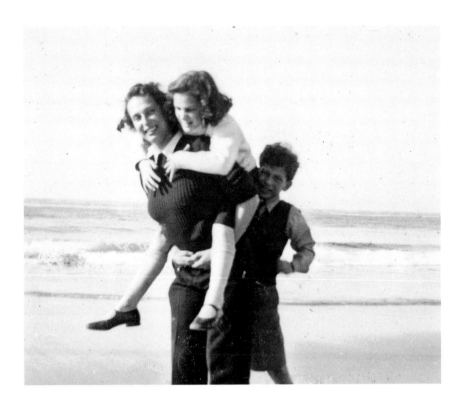

Yvonne, Anne and Evelyn on
holiday at Pyla before the war.

the Anschluss, Anthony recorded how 'the usual crowd' of prominent British Jews had assembled at New Court to discuss aid to the Jewish community in Vienna and had agreed to send a regular weekly sum 'to help the soup kitchen, which is apparently the only Jewish institution left open except the cemetery'.[15]

With funds not infinite, even after Anthony had helped to secure a loan of £356,000 from the Prudential that was guaranteed by Rothschilds, and with the international picture worsening almost by the day, it was increasingly a time for calm, dispassionate thought. The umbrella British organisation in relation to the emigration of German Jews was the Council for German Jewry, to which Anthony sent in January 1939 a carefully considered memo on the options for future policy. Emphasising that 'there cannot be sufficient funds available to meet all demand', he argued that 'some decision must be taken as to which claims should have priority over a period of time', decisions which would involve 'a proper budget' and 'a common policy'. He then put a series of pressing questions. 'How far is the Council prepared to give further support to communal institutions in Germany and Austria?' 'What funds are available as a contribution towards the maintenance of refugees in other countries such as Belgium, Holland and Switzerland?' 'How far is the Council able to provide additional funds for the children's movement?' 'What other reserves are necessary to enable grants to be made for training schemes, etc, in this country?'

A very specific matter, reaching Anthony's in-tray at about this time, was the proposed settlement of refugees in parts of Africa. 'The question was raised as to how these schemes both in Rhodesia and elsewhere would be worked; whether Christians and Jews should be sent together or whether they would be separated,' he noted after a meeting in February. 'The Chairman [i.e. Anthony himself] replied that there would be no discrimination, the deciding factors would be the suitability of the settler and the funds available.'[16]

It was probably towards the end of 1938 that Anthony put his Palace House Stables (also known as the Trainer's House) in Newmarket at the disposal of the British Homes for Refugees; by the following summer, on the eve of war, some twenty-five Jewish adults and a couple of children were housed there. Among those refugees were Fritz Ball and his wife Eva. Fritz's story had been an emblematic one: a lawyer in Berlin until in 1935 the Nazis barred all Jewish lawyers; arrested in November 1938, the day after Kristallnacht; sent for a period to the infamous Sachsenhausen concentration camp; their younger children leaving Germany on the Kindertransport; and at last, in May 1939, he and his wife managing to get out of Germany, with just two suitcases and two cellos. Soon afterwards, Fritz and Eva reached Newmarket. The next few months, before war broke out and official-cum-local attitudes hardened, were (recalled Fritz long afterwards) 'an oasis in the desert of years of bleak life'.[17]

CHAPTER FIVE

One can only hope and pray

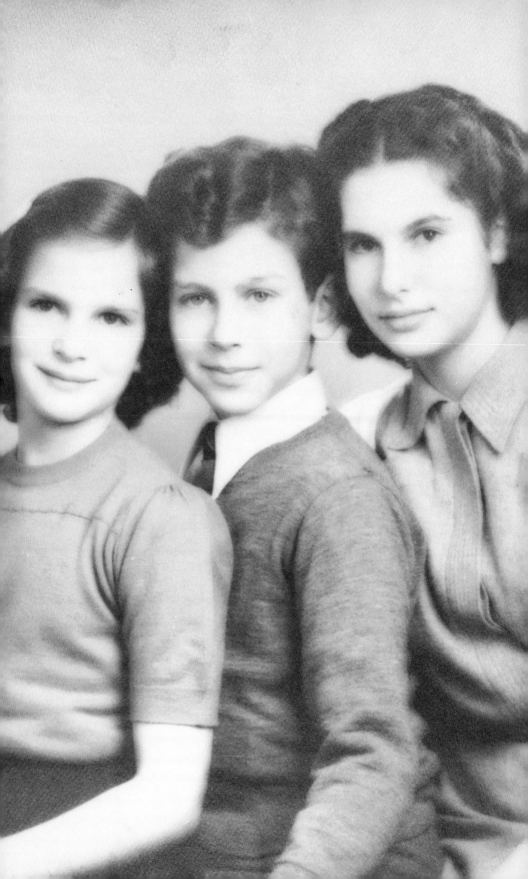

'The Germans invaded Poland this morning, hence the beginning of this diary!' Anthony wrote on Friday, 1 September 1939, starting his wartime diary in the same book in which, twenty-eight years earlier, he had broken off his previous journal. He was writing at Ascott after a busy day in the City and elsewhere. At New Court he had had 'several talks' with the staff manager Henry Bevington 'about the staff & arrangements to be made' for the 'very difficult time ahead', in which 'it is essential we should cut down everything possible so as to be able to keep our heads above water'. How serious was the bank's position? Anthony was just about sanguine: 'Provided credit is not curtailed & the N.P. [probably London & National Properties] truly does not do the dirty I believe our many positions will work out better than could have been anticipated at one time...' After New Court, and presumably with his staff manager in tow, he had 'motored down to Tring [where the bulk of the Refinery had already decamped] where I deposited the bullion books & had a talk with Bevington: everything seems to be working smoothly...' He had then gone to Ascott itself. 'The household here is creaking along & of course now the staff is too large except in the kitchen ... Am considering what can be done but the large proportion of men are over 40 & it will be difficult to cut down as it should be done. Is there any chance of being able to live here after the war in any case?' Saturday was the day of waiting for the formal start of the war. '200 children arrived in Wing [the village nearest to Ascott] today & the distribution went off smoothly. They looked a nice lot with good clothes, came from Willesden. One child was ill & sick & one other tried to throw herself out of a window, but otherwise everything went off smoothly.' Finally, on the sunlit Sunday the 3rd, Britain was at war with Germany. 'Chamberlain's broadcast was cold and curiously unmoving,' recorded Anthony. 'The King's broadcast was adequately good without quite rising to the occasion...'[1]

For Anthony as for almost everyone, major change and disruption lay ahead. 'Yes, Hill Street is all moved down to Ascott with the exception of what is stored at Sotheran's and elsewhere and the house is virtually empty,' he would tell an Old Harrovian friend in December 1939; refugees were housed at both Palace House and Southcourt Stud; while also at Ascott, not only was the cricket pavilion used for storing many of the main treasures of London's synagogues as well as some forty cases evacuated from the London Museum, but once the Royal Hospital in London had been bombed in 1941, a sizeable cohort of Chelsea Pensioners, many of them injured, came to live in the main house – where apparently they had a free run of all the rooms except the library, for which Anthony himself held firmly on to the key. As for wartime New Court, it was, in Ronald Palin's words, 'a fortress manned only by a small garrison of men whose presence in the City was necessary to keep the place going':

> The young men had been called up; the women and those of the older men whose jobs could be done conveniently in the country were evacuated to the mansion at Tring where the 2nd Lord Rothschild had kept his entomological collection. In the Dividend Office coupons and drawn bonds were still taken

in over the counter but were then immediately conveyed to Tring for processing. Brooks remained staunchly at the helm during the day and commanded the fire-watchers by night. During the daylight alerts we descended to the basement and sat on tin boxes in the stone-flagged passages until the sound of the 'all clear'.

'The efficiency of the New Court fire brigade,' adds Palin, 'saved the building from destruction by incendiary bombs,' even as roughly one-third of the square mile was bombed into rubble.[2]

Anthony's diary for the early months of the war gives a good feel for what was, one way and another, an unsettling, discombobulating phase in the life of this particular fifty two year old:

Spent the afternoon going round flats of the 4% [i.e. the Four Per Cent Industrial Dwellings Company providing housing in the East End] in order to consider ARP arrangements which have been sorely neglected by the borough council. Talked to a number of tenants, some of whom were very pleased with letters about their children from reception areas, and I tried to create the impression that the matter was in hand...

It seems clear that there cannot be a great deal to do at New Court and an hour or two daily for supervision would suffice save in exceptional cases if there is any important question of policy in connection with the Refinery... It is clear, therefore, that if the War Office do not require me [he had applied earlier in the year to work in military intelligence in the event of war], I must make myself useful in some other way. (5 *September 1939*)

We wrangled a bit on the usual lines... However much one may dislike his views & think him fundamentally wrong in thought, he is certainly stimulating to meet, what Berenson would call in a picture life-enhancing. (6 *September, after running into Weizmann at the Dorchester*)

I feel very old today ... It seems utterly wrong not to be able to find at once some useful work to do. Last time one was so proud & pleased to be in it from the first & doing all one could. The complete change of life made it all more real and was in a way satisfying. Today the opposite just holds good and it is intensely irritating to go along fussing about unimportant trivialities. (7 *September*)

The restrictions certainly make all normal business impossible: one can only hope that it will be equally effective in checking German activities. (8 *September*)

We have now been at war a week and it seems a hundred years: the government estimate on the conservative side is to prepare for a three year war, while I have a sneaking hope that it may end this year by internal collapse in Germany. My real estimate is that it may finish before Xmas 1940 ...

Have not yet grappled with the problem of reading under present conditions & do not know what to choose yet! (*10 September*)

...Victor actually contemplates the possibility of our defeat... (*12 September, after dining with his cousin the previous evening*)

From all sides I am told the Ministry of Economic Warfare is a gigantic muddle & advised to keep out of it. Where then can I make myself useful? (*18 September*)

Thinking over my conversation with Anthony I find it extremely disquieting as there appears to be no really strong direction with proper study of strategy, also the conversation of what one has heard about the relative strength of the air forces is far from satisfactory. It looks as though there are bad times ahead. (*20 September, after dining with Anthony Eden, Secretary of State for Dominion Affairs, but not in the War Cabinet*)

After dinner [at Ascott] listened to Winston's broadcast which was excellent. (*1 October*)

Uneventful day in the City, but Lionel arrived really chastened by the Budget and for once was beginning to come down to earth. (*2 October*)

... a meeting of the Accepting Houses Committee which I weakly agreed to join at 11 & it lasted till 12.30 with Walter [probably Walter Gibbs, 4th Lord Aldenham] in the chair groping about backwards & forwards on the same ground. (*4 October*)

...for once found him even more black than I am and it has at last dawned on him. He sees no future. (*5 October, after discussing 'further drawings' with Lionel*)

Discussed reduction in building staff [at Ascott] but it is horribly difficult with men who have been here so long. (*21 October*)

To the Refinery [at Tring] which is a hive of activity & the government inspectors said they were satisfied while the forewoman of the girls thanked me for the new accommodation arranged for the women. (*25 October*)

A most unfortunate & chastening half an hour with Yvonne in the morning, which made me most unhappy. Somehow I upset her & she lost her temper with me & proceeded to 'slang' me most unmercifully. If only 1/100th of the home truths I hear are true, I am an even more odious creature than I had suspected in my most humble moods! And I had not suspected this: of course like everyone else her nerves are rather on edge... (*29 October*)

Listened to Halifax's broadcast which was good if on rather a high level for the ordinary mortal, but that was its chief strength. (*7 November*)

First-class fighting broadcast from Winston which ought to get under the Hun's skin. (*12 November*)

ADDRESSES

by

Miss ELISABETH BERGNER

and

Mrs. ANTHONY DE ROTHSCHILD

In Aid of the
Women's Appeal Committee for
German and Austrian Jewish
Women and Children.

On Tuesday, December 6, 1938

at

42 Hill Street, Berkeley Square, W.1

Edmund de Rothschild, Anthony's
nephew, in service during World War II.

Down here [Ascott] by train & we actually had lights by which we could read in the carriage. (17 *November*)

This house [42 Hill Street] is getting emptier & emptier and sadder & sadder, depressing to see its passing. (21 *November*)

Listened to the P.M.'s broadcast which was good for him but he can never be an inspiring leader. (26 *November*)

Supper at Quaglino's, which was full of people in uniform ... and society folk, very noisy & uncongenial. (28 *November*)

The last night at Hill Street, the end of a chapter & the extinction of something we had made which was, although I say it, beautiful & to which we had devoted ourselves ... Yvonne likes to cherish the idea that some day we may come back but I have no illusions. No use having vain regrets & it is perhaps better to have enjoyed it & finished with it than never to have had it! (30 *November*)

...found Y. had had 62 women all knitting for the Navy. (15 *December*, *returning to Ascott after a week in London where his temporary base was now a house in Charles Street*)

'Played squash with Arthur [Villiers].' Anthony noted on Christmas Eve, '& he beat me easily; I have not played for 6 months & he has been playing this term, but I was unnecessarily bad & therefore could not compete with his technique of drops etc.'[3]

One activity above all gave Anthony a sense of purpose during this early part of the war: primarily on behalf of the Central Council for Jewish Refugees (as the Central British Fund for German Jewry had been renamed), a close involvement – in increasingly urgent and desperate circumstances – in the raising of funds. In November he and Lord Bearsted (chairman of Shell Oil Company) cabled Lewis Strauss of Kuhn Loeb, the New York bank closely associated with Rothschilds over the years, asking him to persuade American Jewry to give the Council a major infusion. They hoped for $1,000,000, but in the event got only $100,000 (half as a contribution, half as a loan). 'I must admit that I find it unbelievable & showing a lack of tact & understanding that one would not have expected,' reflected Anthony privately about 'the miserable American offer'. Or as he put it to Strauss two months later after little further progress, 'I will not disguise from you the fact that your response to the appeal which Bearsted and I sent to you jointly was so disappointing that there seemed no point in responding to your last letter to me.' Another possible source of funding was the British government, and Amy Zahl Gottlieb in her account of aid to victims of the Nazi regime gives the story of detailed negotiations with the Home Office over the course of the winter, including Anthony at one point 'assuming the driver's seat'. Eventually the government did agree to give some support on a regular basis, with Anthony becoming joint chairman of the committee created to administer the moneys assigned. The third source of possible

funds was, of course, Anglo-Jewry itself. At a formal launch at Woburn House (the Council's home) on 6 February 1940, in a speech praised by Sir Charles Seligman for the 'eloquence' of its oratory reaching 'a very high standard indeed', Anthony pleaded for the community to raise £400,000, as well as going out of his way to praise the help of the Rev. Henry Carter in persuading government officials that Anglo-Jewry was justified in claiming that it could not do it all on its own. The appeal – assisted by how Anthony, in Gottlieb's words, 'solicited contributions from refugees whom he knew had established themselves, as well as from banking associates' – proved broadly successful: almost £200,000 pledged within a month; and contributions for the year finally amounting to some £387,000. Through all this, the mood music was not quite as favourable as Anthony and his colleagues might have hoped. 'One hears on all sides rumblings of growing anti-Semitism largely because not enough Jews have enlisted,' he noted in January 1940. 'We discussed today at Council how we can bring pressure to bear on men under 40 who have not enlisted in pioneer corps. Somehow we must take drastic steps.'

There were other difficulties. 'The Marks & Spencer group appear to have shirked their share!' Anthony observed in October 1939 with funds rapidly running out to support Jewish refugees; while in early 1940, with Anthony busy persuading his relations and friends to subscribe privately before the appeal went public, family tensions surfaced. 'I was very disappointed to get your letter and am sorry that you do not understand the needs of the situation,' he admonished one in January:

> We are all in exactly the same position as yourself, inundated by appeals and we all prefer to give to individual cases which interest us or to special charities, but in this particular case there is a duty imposed upon all members of the Jewish community, especially as the Government has offered to help us provided we can raise sufficient funds to enable us, in conjunction with the Government contribution, to keep these co-religionists of ours from falling on the rates, which would do a lot of harm and undoubtedly cause a spread of anti-Semitism in many parts of the country.

There was also the Victor problem. That same month, he paid a visit to New Court and, noted Anthony in his diary, 'started asking all sorts of silly questions'; at which point, Anthony 'let fly & told him exactly what I thought of him and rudely too!':

> Lionel was shocked & silent & eventually went out to pacify Victor who avoided lunch. I have since written a line to Victor saying I was sorry I had lost my temper, but the worst of it is I really meant all I said in view of his failure to understand the whole question and that one had just done all one could!

A month later, Victor's sister Miriam was at New Court, in order to discuss their participation in the family contribution. 'She is obsessed by the idea of having only a small surplus and does not realise what little difference a donation will make if she

signs a covenant,' recorded Anthony. 'Victor has apparently poured out his heart to her about my explosion!'[4]

Generally, Anthony tried to keep going as much as possible the New Court luncheon parties where he could pick the brains of his guests. The day before he saw Miriam, they comprised Brendan Bracken, Reginald McKenna (who had been Chancellor of the Exchequer during the previous war and was now chairman of Midland Bank) and the prominent diplomat Sir Robert Vansittart:

> Reggie McKenna [Anthony told a friend] knew, of course, exactly almost to
> the day how long our economy could stand the strain of the war and, as might
> have been expected, was pessimistic in this direction, but I remember well that
> it was reported in the last war that he stated England could not go on beyond
> the summer of 1916, so I have a pretty good idea that his opinion this time is
> equally wide of the mark and even he says that we can last two years.

'Our guests seemed on balance to think that Hitler would not be able to sit still,' added Anthony, before mentioning their expectation that Holland would be attacked first. 'I pass you on all this gossip and hope you have been able to listen to Haw-Haw as I thought he was quite entertaining last night and recently, having previously been off his form.'

Anthony had, though, more practical concerns – doing his bit and using his connections to try to create effective wartime arrangements – than either table talk at New Court or goading broadcasts from Berlin. Soon after that lunch, he sought to bring pressure to bear on Herbert Crocker, a retired lieutenant-colonel who later in the year became a member of the Home Security Executive:

> I heard by chance yesterday that the Newbury Racecourse are in a great hurry
> to turn the soldiers out who are now billeted there, not because they are doing
> any damage to the course but because they want to sow the lawn so that it
> may look pretty for the first meeting – and strange as it may sound this has
> the support of the War Office, but it does not create a very good atmosphere
> with the G.O.C. of the Division who is actually favourable to racing. Surely at
> a time like this the convenience of the billeted soldiers could be considered
> and they could be given time for the Authorities to make other satisfactory
> arrangements, when it is only a question of whether the Club lawn is covered
> with a fine coat of grass or not.

A few days later, his focus was on the Jewish Orphanage at West Norwood – specifically, how it had been brought to his attention that (he informed the vice-president, Sir Isidore Salmon, a Conservative MP) 'children are to a great extent billeted in houses where the lodgings are usually let for the summer season, which provides revenue for the whole year; therefore if the children remain on, the householders will be largely deprived of their annual income'. Accordingly:

This will cause great dissatisfaction and also may lead in some cases to the householders attempting, successfully or otherwise, to turn the children out, in which case it may not be possible to find alternative accommodation for them. The Headmaster suggested we must be prepared for this eventuality and ready to find other billets, which of course seems to me impossible. The same situation, of course, must arise in nearly every other seaside resort throughout the country and I should be glad if you could find out whether there is any Government policy on this question or whether there is anything that Norwood should do.

A particularly heartfelt episode occurred in late March. Dr Lutz Weltmann, a German theatre critic who had taken refuge in Britain the previous year, seems to have been complaining about the failure to find him suitable work; and even though Weltmann was apparently 'Yvonne's protégé', Anthony did not spare his feelings:

It is not easy during war-time to find suitable occupation for men of your type, but please remember that is not the fault of Bloomsbury House [home of the Jewish Refugees Committee, with which Anthony was closely involved]. The fault lies with Hitler and his associates, who made war inevitable.

I remember well how during the last war I myself and many of my friends who were not accustomed to military duties and had joined up found at first a great deal of the work irksome and boring, but we were the whole time trying to make ourselves efficient so as to be able to do our share whenever the opportunity occurred.

'I am only sorry,' he ended, 'that I am too old to try again'. In the event, the thirty nine year old Weltmann served for the next three years in the Pioneer Corps.[5]

Anthony meanwhile had been continuing to keep a diary through the early months of 1940, and as usual one gets closest to him through it:

... as things are at present, the acceptance houses are losing the whole time in their status & will be completely squeezed out. I urged as strongly as possible that we should assert ourselves. (2 January, *after attending a meeting of the Accepting Houses Committee, i.e. of the merchant banks*)

Somehow I never seem to have time at New Court & today was a continuous rush. (5 January)

... back from France where he had been greatly impressed by the Maginot Line ... (9 January, *about Victor being among those at lunch at New Court*)

Most invigorating speech from Winston. (20 January)

Amongst serious thinking people there is strong belief that there can be no serious improvement without change in P.M. It also looks as though country requires a shock in order to galvanise it into greater efficiency.

Surely this should be possible by common sense instead. This is a black picture ... (22 January)

A harassing day [dealing with refugee issues] & supped off bread & cheese before reading [Arthur] Bryant's book on Germany which is a distortion of the facts & patently Anti-Semitic. It is a pity that a man who has written such readable books on Pepys should lend himself to such an exaggerated misrepresentation. (24 January)

Arrived at New Court [after a meeting of nearly three hours at Bloomsbury House] just in time for lunch; only Waley-Cohen & Sebag-Montefiore & Lionel rushed off immediately after. I believe he felt he had made a great sacrifice by being there in the morning! (26 January)

... he is convinced that in the last six weeks there has been great deterioration of situation in Germany, in fact great criticism of Hitler by generals ... (5 February, after Siegmund Warburg, whose New Trading Company had the previous autumn been enabled by Anthony to act as intermediary between British importers of American goods and a consortium of acceptance houses, calling in at New Court)

Quiet day in the City, but markets are inclined to be weak, particularly New Court specialities, & the position is already substantially worse than Jan 1st ... (14 February)

Long meeting of the 4% after lunch & somehow each day now seems fully occupied & then on to Woburn House for a long sitting of the executive. (28 February)

Squash & then dined at the Turf, almost empty (11 March, by when Anthony's London base during the week was the Bath Club)

The changes in the Cabinet are announced and are really ludicrous as a contribution to the war: even the Times is sarcastic to a degree. (4 April)

Went to see foals at Southcourt, but I find it difficult to take an interest ... (13 April, with news from Norway still uncertain)

A fortnight later, on the 28th, Anthony noted not only his struggles trying to learn Norwegian ('I seem to make little or no progress, mainly I fear because I do not settle down to any: I have lost the knack'), but also that he had been reading 'some of my old letters during the last war', presumably his letters to his parents. The experience made him 'depressed to find how much I have deteriorated & grown old since those days & how little I seem to have done in the intervening 23 years except to live selfishly in luxury & grow soft & good for nothing, whilst then I could do a job & now —?' In the world at large, events in Norway were rapidly shifting the political dynamic at home:

The P.M. gave a strangely inhuman account in the House, still apparently complacent & quite inadequate. (2 May)

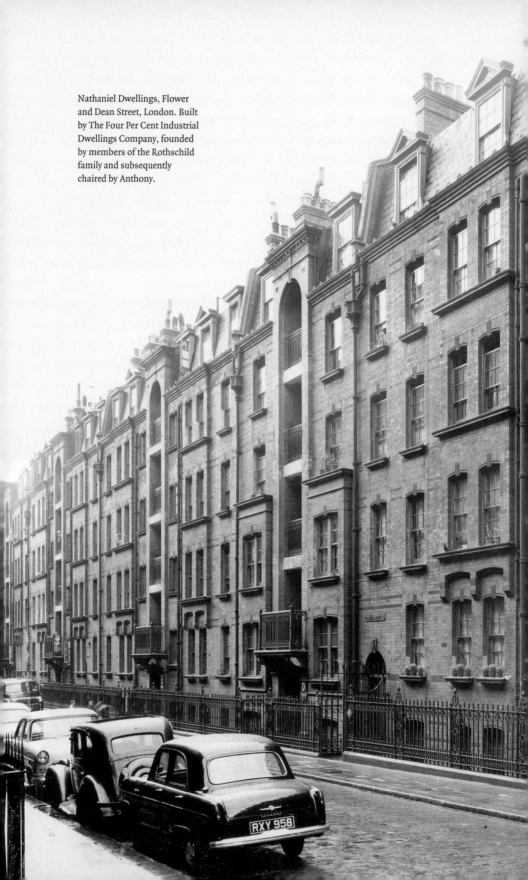

Nathaniel Dwellings, Flower and Dean Street, London. Built by The Four Per Cent Industrial Dwellings Company, founded by members of the Rothschild family and subsequently chaired by Anthony.

The Government seems to have had greatly reduced majority, which is perhaps the best one can expect for the moment. A change is surely necessary. (*8 May*)

Momentous day. Woken up to hear news of invasion of Holland & Belgium & have accordingly been hanging on the wireless all day [at New Court] ... It is all nerve-wracking & one can only hope & pray ... Drove down here [Ascott] with Y & then at 9 heard the PM announce his resignation – marred by his usual incredible egotism in the making. So Winston is PM at last: many people will have grave doubts as to his sound-ness & wisdom but at the moment it was probably inevitable. (*10 May*)[6]

At which pregnant point, just as things were about to get really interesting, Anthony decided – for reasons unknown – to end his diary, apparently never to return to it.

<p style="text-align:center">★ ★ ★</p>

Over the next year or so, Anthony engaged fully in the increasingly key question of when at last America would abandon its quasi-neutrality and start effectively helping the British war effort against Nazi Germany. His main links there were with Kuhn Loeb, and he did what he could to push the buttons. 'Here we are all in very good fettle and very satisfied with the developments in Albania and Africa,' he told Lewis Strauss in December 1940. 'When the supply of planes from your side really gets going I believe that the turn in the war which has already taken place will become apparent even to the Germans.' And two months later: 'We are all now anxiously watching the political developments in your country and hope that it will be possible for your President to accelerate production, but it always seems rather to be a question of never jam today and always jam tomorrow.' Eventually there was a breakthrough, but Anthony's tone was hardly ecstatic. 'Of course we all appreciate,' he wrote in March 1941 to one of Strauss's partners, William ('Willy') Wiseman, 'what a great turning point is marked by the passing of the Lease-and-Lend Bill, though it has seemed to us such a long time coming and therefore perhaps it does not make the impression that it should ...' Three months later, Hitler made his fateful decision to go east. 'Here we are all watching with intense interest the campaign in Russia,' Anthony wrote in July to Strauss, 'and are doing our best to understand what is happening without too much wishful thinking.' While on the same day to Wiseman: 'We are trying hard not to do too much wishful thinking on this side but there is a general feeling of confidence and expectation that things are definitely on the upgrade.'[7]

We have odd glimpses of Anthony continuing more generally to do what he could. 'Mr de Rothschild says that you may certainly let the officers have bed linen if they should ask for it,' his secretary Miss Icely in June 1940 informed the housekeeper at Palace House after a query about the latest batch of soldiers arriving there, 'and also that the covers may be put on the chairs and settees.' Later that summer, in the context

of delays about the installation of a telephone, he explained to G.P.O. Telephones that 'I am handing Ascott House over to the British Red Cross Society as a Convalescent Home at the end of this month [August] and have arranged a flat for myself and Mrs de Rothschild over the stables.' 'You will, I am sure, understand,' he added, 'that it is absolutely essential for me to have a telephone at my private residence.' A fuller glimpse comes in October 1941, when Anthony wrote to The Manager, Ministry of Labour and National Service, Leighton Buzzard, asking to be allowed to retain the services of his housemaid, Mrs Coleman:

> My house is now occupied by a number of Chelsea Pensioners and I am living in some rooms in the stables where I also have an evacuated old lady of over 70. My personal household staff, besides Mrs Coleman, consists of a cook, aged 55, and a man servant, aged 58, who is also in charge of one of the Lodges. I have myself to attend to the business of my bank in London every day besides serving on a number of committees and being a member of the Home Guard. My wife is engaged upon war work as a member of the M.T.C. [Mechanised Transport Corps], in which capacity she drives for the Home Guard, and she is also a member of the WVS and does ARP work at Linslade [a small town near Leighton Buzzard].

> In these circumstances, which preclude both my wife and myself from giving any additional time to domestic affairs, it would be extremely inconvenient if we were to lose the services of the one housemaid.

Yet the chances are that what Anthony really wanted to do, in terms of contributing to the war effort, he was denied. After his pre-war request to the War Office to be appointed an intelligence officer if war broke out had seemingly got nowhere, he tried again in January 1941:

> I am employed in business, as previous returns which I have made will show, but I am available for any special work for which it may be considered I am specially fitted in view of my past experience and training. I do not however wish to be considered for any ordinary routine work as in the circumstances I think I am more useful in my present occupation.[8]

Again, as far as one can tell, no joy – so New Court and miscellaneous activities it would be for the duration.

Inevitably, war meant parental preoccupations as well as all the others. During 1940 Anthony's three children were each, for reasons of safety, evacuated to America, where Strauss and Wiseman appear to have had overall responsibility for their welfare and education. That December, after thanking Strauss for 'the care you are taking of the children', Anthony touched on an important matter:

> I hear that you have interested yourself in getting someone to come and give them religious teaching once a week, which I think is a very good thing,

especially as I imagine that the person you have chosen, like yourself, belongs to the liberal part of the community. I should like to stress this particularly so that the teacher should not in any way feel it necessary to give them an orthodox teaching. I should like their lessons to be biblical and on general grounds and of course you know I am an assimilationist and not a Zionist, which I believe applies also to you.

A fortnight later, after their letters had crossed, Anthony wrote again, this time in reflective rather than assertive mode: 'I hope the young man you chose will turn out a success and will teach them on the right lines, whatever these may be. I am afraid I am now getting to that period of life when I am not so certain as I was 30 years ago.' The following summer, the nine year old Evelyn seems to have been sent to school. 'We [i.e. Yvonne as well] shall be very anxious to hear how he gets on with the other boys,' Anthony wrote in July 1941 to Mr Hoban, presumably the headmaster, 'and hope you will not find him too much spoilt and that he will respond to such discipline as is necessary.' While two months later he was reporting to Wiseman: 'We have had an excellent letter from Mr Hoban about "Adrian", telling us about his life in camp, though it has not improved his handwriting!' 'Adrian' was the name that Evelyn had now temporarily accorded himself, in order to stop teasing about a name sometimes assumed to be a girl's name only.

What about the girls themselves? 'It is most important under present conditions,' Anthony instructed Wiseman soon afterwards, 'that their education should be carried through as efficiently as possible and that a school should be chosen which will stimulate their intelligence and their interest. This in our opinion is much more important than social conditions, which sometimes weigh in the selection of a school.' He also had a very specific suggestion. 'In these days,' he told Wiseman in October, 'it is necessary for all girls to work and to learn if possible something about domestic economy and kindred subjects.'[9]

It was probably the London Blitz (which in 1941 would take out 42 Hill Street) that had persuaded Anthony and Yvonne to send Renée, Anne and Evelyn three thousand miles away – a bombardment which had begun in earnest on 7 September 1940 with a concentrated attack on the Docks and the East End. The Refinery was not hit, but its man in charge of air raid precautions, Arthur Hunt, was part of the rescue party trying to haul people out of the rubble of the nearby Peabody Buildings on the Whitechapel Estate. He subsequently collapsed with exhaustion; and Anthony, on visiting the Refinery and seeing what state he was in, immediately sent him to the mansion at Tring for some badly needed rest. In the City itself, air raids persisted for much of the autumn, before on 29 December a night truly of devastation, with eight of Wren's churches razed to the ground, much of the area around St Paul's destroyed, and likewise most of the buildings in Cannon Street. Just off Cannon Street, in St Swithin's Lane, the home of Rothschilds got off relatively lightly. 'Virtually every

piece of glass here was broken last night,' Anthony wrote next day to a cousin, 'and I have been sitting in a room with my coat on, but we are extremely lucky that it was no worse.' Among visitors to New Court that day were the writing team Mr and Mrs Robert Henrey, Rothschild relatives regularly being given lunch by Anthony as they compiled a book based on the letters of a nineteenth-century Paris informant to the London house. 'On this occasion the steps were covered with broken glass and a messenger, wearing a top-hat and carrying a rolled-up umbrella, was brushing the dust from his coat,' she recalled. 'Mr Anthony led his guests to a small room below stairs where he often slept during the air raids and where the housekeeper served them with cold tongue and chutney. There was no coffee because the gas was cut off.' Over the next few weeks, while repairs were carried out, Anthony saw the bigger picture. 'Although the weather is rather unfavourable for open air banking,' he told Wiseman early in 1941, 'it does not matter very much.'[10]

With the business ticking over (albeit very quietly), Anthony's main concern during most of this phase of the war was probably the rising threat – as he saw it – of Zionism. In December 1940, 'on behalf of myself and all my friends', he wrote in a spirit of protest to Professor Selig Brodetsky, President of the Board of Deputies of British Jews, who in recent speeches had argued strongly that the persecution of Jews in Nazi Germany had demonstrated that assimilation was no longer a viable policy generally. Whereas, according to Anthony:

> Assimilation to English life seems to us – that is to say to me and to all my Jewish friends and, I believe, to the great body of English Jews – to be the civic ideal. We desire to see Anglo Jewry sharing to the utmost in the life of the country, contributing all they can to it, and, especially as a religious Community, enriching its spiritual treasury in a way only possible to those who feel and show themselves to be completely 'assimilated,' i.e. identified in their aims and in their secular life with their fellow-citizens of other creeds.

Brodetsky's unyielding reply to this prompted in February 1941 a further riposte, again on behalf of others as well as himself. 'It is indeed a tragedy that Nazi tyranny "has engulfed" – to quote your words – "about four million Jews" and, incidentally, a great many more million non-Jews,' wrote Anthony. 'It is impossible to formulate a policy on the assumption that Nazism will prevail.'

The closing months of 1941 were especially active in the ongoing and increasingly urgent controversy. 'Dr Weizmann lunched yesterday,' Anthony in mid-August informed Lionel Cohen, his closest confidant in these matters. 'I believe that the Colonial Office has moved in his direction,' he went on in pessimistic vein, 'and he says that for financial reasons in any case it is absolutely necessary to have the authority of a State. I think that he is as determined as ever and just as dangerous, as he is concentrating on one objective alone, but all this is too long to write.' Soon afterwards, on Weizmann's initiative, Zionists and non-Zionists gathered at New

Court to see if they could find common ground. In early September, days before that meeting, there was still disagreement within the Rothschild family, let alone the non-Zionists as a whole. 'He of course is strongly of opinion that there should be some Jewish fighting unit, either Air Force or something of the kind, which could then be produced as evidence that the Jews have played their proper part in the battle,' Anthony told Cohen about the 'long talk' he had had with 'my cousin Jimmy', i.e. James de Rothschild, at this time Parliamentary Secretary to the Ministry of Supply. 'I told him that I was completely opposed to any such unit except in so far as it was a Palestinian unit for those living in the country. I do not think either of us made much impression on the other. I do not see how the existence of such a force will reduce anti-Semitism after the war ...' The summit itself on the 9th seems to have proved predictably inconclusive, with Anthony pushing for 'a spiritual home' in Palestine rather than an actual Jewish state.

Over the rest of the autumn, the non-Zionists concentrated on sending a formal letter to Weizmann – a letter to be sent by Anthony on their collective behalf, and which underwent several drafts before being finally dispatched on 3 December. 'There is in our opinion no necessity for the creation of a Jewish State,' it insisted. 'To found a State on race or creed is fundamentally wrong and indeed is the antithesis of one of the principles for which this war is being fought. We cannot imagine any basis for a Jewish State which is not wholly inconsistent with the principles of the Atlantic Charter.' To this, the letter added that such a development 'must accentuate the difficulties in the way of arriving at friendship and co-operation with the Arabs without which nothing can be achieved', i.e. if the British government was to achieve 'the fullest immigration into Palestine on satisfactory terms'. Anthony and his more or less like-minded non-Zionists then stated what was perhaps their core objection:

> A Jewish State would also prove disastrous to the best interests of the
> majority of our co-religionists throughout the world and especially those
> living in the countries of Eastern Europe. Such a concept will inevitably
> play into the hands of those who put forward the alleged dual allegiance
> or nationality of the Jews as a cloak to justify their own efforts to refuse
> them equal rights of citizenship. An advantage gained for the few at the
> expense of the well-being and happiness of the many can render no lasting
> service to Jewry.

'The letter to Weizmann may appear to you in some ways to blow hot and cold,' Anthony explained later in December to Morris Lazaron (of the American Council for Judaism) in a note accompanying a copy of the letter itself, 'but this comes from the fact that it had to please quite a number of individuals and reconcile somewhat divergent views.'[11]

By now, though, the future of NM Rothschild & Sons was weighing heavily on this younger brother's mind. 'He was genial, friendly, interested in me personally, a very

different Lionel from the aloof and formidable figure of earlier days,' remembered Palin about a conversation in around July 1941 with the older brother. 'But he was also unusually quiet and subdued.' Some five months later, in fact the day before the letter to Weizmann was sent, Anthony was in the governor's room. 'Seems overwrought & worried: Lionel seriously ill & future uncertain,' recorded Montagu Norman. There was already in place Rothschilds Continuation Limited, a holding company designed by Anthony to ensure the bank's survival in the event of either him or Lionel being killed by a bomb; but Lionel's illness (lung cancer) brought the reality home that Anthony sooner rather than later was going to be the sole partner. That was the case from 28 January 1942; and among the many letters of condolence to him on Lionel's death was one from Arthur Kiddy, doyen of City editors:

> Your own high courage & fortitude & love for your Firm will I know sustain you in this trying hour and I believe you will also be sustained not a little by the evidence you will have of the affection and sympathy of so many in the City & the assurance you will have of the City's confidence in your carrying on & fully maintaining the great traditions of your House.[12]

<p style="text-align:center">★ ★ ★</p>

'My father had lived in great style,' Lionel's son Edmund (always known as 'Eddy') would rather ruefully recall over half a century later. 'It turned out that he had run up a considerable overdraft at the bank. Consequently, by the time he died I was saddled with a debt to the bank of about £500,000, and on top of that I needed to borrow a further £200,000 to pay the estate duty. Tony helped me out with a further loan from the bank to settle the latter...' If these were difficult days in 1942 for Eddy, they were critical ones for Anthony. The precise financial position of Rothschilds at this time remains something of a mystery; but we do know that in April, two and a half months after Lionel's death, Norman told his protégé Cameron (Kim) Cobbold 'in all secrecy of R's dependence on Bk', i.e. the Bank of England. Then, that autumn, it seemed for a tantalising moment that 'the Trinity' of the 1920s might be about to be transformed into a single deity. Again, the source is Norman's diary:

> 8 September. Pam [Albert Pam of Schroders]. Why shd not Schroders, Rs & Barings amalgamate? Or why shd not Barings take over the other 2?

> 10 September. ERP [Sir Edward Peacock of Barings]. ?BB & Co + JHS & Co + NMR & S: he will consider.

> 2 October. ERP. BB & Co not willing after consideration, to join with JHS & Co, whose methods are impossible & unpopularity great – nor with NMR & S who are entirely a Jewish family concern.

Would it have been a runner? Would, among other questions, Anthony with his deep pride in his firm's history have conceivably allowed it to happen? Yet perhaps, given his dependence on the Bank of England at this stage, he might have had no alternative if Norman had insisted on it. As it was, the Jewish factor proved for Barings the knock-out one; and Norman would have understood. Over the next few months, the governor continued to receive regular visits from Anthony. Later in October 1942: 'He shows an improving position but has a long way to go.' And in January 1943: 'They must go very slow.' Slowly indeed, as over the rest of the war Anthony did all he could gradually to nurse the bank back to something like a position of financial stability. 'After the passing away of your uncle Lionel,' Eric Warburg (son of Max) would justly write to Evelyn after Anthony's death, 'your Father really had to carry on alone for quite some time, and I really admired the wise, unassuming and infinitely balanced way in which he steered the ship through waters which were not easy ones to navigate in.'[13]

Daily life continued, and a flavour of it comes through in a letter Anthony sent in June 1942 to Gilbert Cahen d'Anvers, Yvonne's cousin in Buenos Aires:

> Yvonne is working in the country, driving for the Home Guard and doing half-time in a factory, so that you can imagine that her time is fully occupied, but this has its advantages. Our house [Ascott] in the country is occupied as a hospital and we are living in some rooms in the stables alongside. Everyone is very busy both on the farm and growing masses of vegetables in the garden, and I come up to London every day as I am alone in the office now.

What about his customary world of committees? 'I suppose I must continue to serve on the Committee and you can therefore do as you think fit,' he had replied somewhat wearily in January 1942 to the Honorary Secretary of the Whaddon Chase Hunt; but in truth, Anthony continued during the second half of the war to be just as heavily committed to his various causes as he had ever been. To give just a handful of examples: he was on the executive committee of the Council of Christians and Jews that had been formed earlier in the war; in August 1944 he chaired a meeting at New Court about the establishment and re-organisation of Jewish voluntary schools in London; that same year he was elected chairman of St Mary's Hospital in Paddington; from late 1944 he represented it on the newly formed General Committee of the Voluntary Teaching Hospitals of Great Britain; and he was as involved as ever with the Jewish Orphanage – in relation to which he fired off, in December 1943, a stern rebuke to Basil Henriques for threatening to resign from the Norwood Committee:

> Quite definitely, I do not consider that, whatever may be your experience and knowledge in the education of children, you have a right to hold a pistol at the head of the Norwood Committee and I resent this very strongly. It is of course also essentially a stupid thing to do as my own reaction to such a threat is always to tell the person who throws his weight about in such a

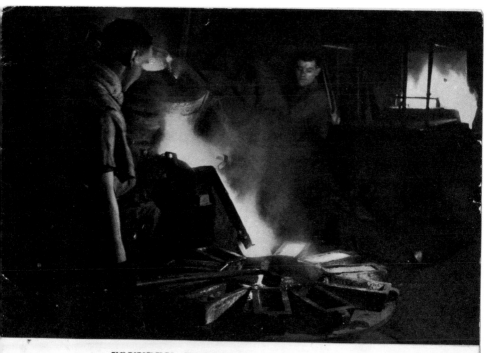

The Royal Mint Refinery's
marketing brochure from the
immediate post-war years.

way that he can go to blazes, whereas had the proposal been argued out in a reasonable way I have little reason to doubt that you would have had a good chance of carrying your point.

During this second half of the war, Anthony sent regular letters to his nephew Eddy (away on active service), including during the middle months of 1943:

> For my sins I have to go up to Leeds for a conference this week-end for refugees and even have to take the Chair. I am afraid I find the communal problems at the present moment very harassing as they never seem to make much progress, but after all they are small matters compared with what you have to meet over there [in north Africa] and it would be wrong to give you the impression that I think too much of them. (9 April)

> It seems strange to think of you so busy over there with so much going on, while over here one day is very much like another. (19 April)

> I have been working hard in the garden this last week to try and clear away the weeds so as to prevent them strangling the azaleas which your father gave me, and I can assure you it is quite a heavy job. (8 June)

> There is no special development in communal matters save that we continue to have committees of interminable length and I only wish I could send you there as my deputy, but this would not be doing you a kindness. (22 July)

> She [Yvonne] has been very busy with the harvest as she has been our intermediary in collecting labour all round and has been working very hard herself for the harvest. (23 August)

The following summer, in July 1944, Anthony related to Eddy what he himself called an 'odd kind of day', but that actually may not have been so atypical: in the morning, 'a long Jockey Club meeting at which I had to explain certain financial proposals for post-war racing' (even though Anthony had by about this time sold his own racing stock); then to Bloomsbury House for 'a refugee meeting'; and 'then to finish up with, Rex [probably the merchant banker Rex Benson] gave a dinner to discuss post-war trade problems.'[14]

With all three children still in America, Anthony was thinking hard by early 1943 about their future, perhaps especially that of the eleven year old Evelyn. 'If he does go to Harrow,' he wrote in January to Cyril Browne, a housemaster there, 'I would certainly prefer – if you had room – that he should go straight into your House, as I always feel, whatever the arrangements may be, that the time spent in a smaller house does not count in the same way if he goes into a large house afterwards: that at any rate is my recollection of 40 years ago.' Evelyn himself was by now keen on going into the Navy; but soon afterwards Anthony told him that he had been speaking to a naval friend, who had advised that it was best to go first to a public school, and

afterwards to the Navy by 'what they call special entry'. In the same letter, Anthony went on to give broader paternal advice:

> I must take this opportunity of reminding you of what I wrote some time back about your letters and handwriting, because I am sure that with a little trouble you can improve this a great deal, and if you wish to get into the Navy – or indeed get on at all now that you are growing up – it is high time that you began to work at this.

> I had the great pleasure of finding a letter from you at Ascott when I got back yesterday and was pleased to hear you liked the books which reached you safely, but reading your letter was rather like a crossword puzzle because in several sentences about every third word was left out as though you had been in such a hurry to get to the end of the sentence that you could not get all the words in, your thoughts running on faster than your pen. This is what a great poet, Browning, used to do – you will probably read his poems later on and will at first find him rather difficult until you get into the habit of understanding him, but for ordinary mortals it is not a very good principle and I am sure it is not an idea which will commend itself to examiners, so please try to work at this.

By the spring, arrangements were being actively made for the children to return home, prompting – after a discussion between Anthony and Yvonne – an urgent telegram to Wiseman in New York: 'WE DO NOT WISH CHILDREN ALL TRAVEL TOGETHER.' By the end of the summer they were all safely back. 'I don't think it will take very long for his twang to wear off,' Anthony in late July reported to Eddy about Evelyn, 'and he has not really startled us with any very extraordinary expressions, anyhow not yet.'

Evelyn began at Harrow that autumn; while by early 1945 the educational focus was on Renée, about to start at Westminster Tutors. In January, after noting that Renée had 'done very little history in the U.S.A. and has therefore not got sufficient background for the work she is trying to do now and has not yet learnt how to digest and make use of what she reads,' Anthony told Miss Freeston there that, accordingly, 'it would seem to me, as at present advised, a mistake for her to attempt the Newnham exam.' The situation, however, changed over the next month. 'Spoke to Miss Freeston on telephone, who said Renée would be very disappointed if she were not allowed to try for Newnham College Entrance Examination, though there did not seem much chance of her succeeding,' recorded Anthony in February. 'Her history had improved considerably, but her French was surprisingly bad considering what it ought to be.' And then some five weeks later, he wrote to Miss Freeston thanking her for another update:

> I am glad to hear that Renée has improved. We are waiting anxiously to hear whether she is called to Cambridge for the interview as I think it

would be a very valuable education for her, even if she did not succeed, but she is prepared for a disappointment.

I quite agree that she should continue to work for her Higher Certificate and try to take it in July.[15]

In the event, Renée did not go to Cambridge, but instead read History at St Andrews University.

Anthony during these years was, like many people, trying to read the runes of what might lie ahead in a post-war world. The main recipient for his thoughts was an old Cambridge tutor, the constitutional historian Gaillard Lapsley, now living in America:

I am not at all sure as to how the public schools will fare after the war, as many of them, including Harrow, have had a very difficult time, apart from which there are all kinds of reform proposals in the air which, however, will take much longer to come to anything than the reformers like to think. (25 August 1942)

Yes, I think the general atmosphere in this country is certainly very much to the Left, but it would be unwise to prophesy as so much depends on how personalities in the political world develop and whether it is possible to continue the National Government for at least two or three years after the cessation of hostilities. (7 January 1943)

I must admit that I was very much disappointed in Burnham's book [James Burnham's much-discussed The Managerial Revolution] and did not think it merited in any way all the attention it received. To a great extent it seemed to describe in pompous fashion an evolution which started many years ago and which does not appear to be changing at a particularly rapid rate at the present moment. (23 March 1943)

The agitation against the Public Schools has for the moment perhaps died down and it looks as though it may not be so necessary for them to receive assistance from public funds as had at one time been thought likely as the numbers now in each case are already moving upwards. If this position can be maintained there will of course be no justification for interference on the part of the State, though all sorts of things may happen after the next General Election... (13 June 1944)

In a letter to Eddy that autumn, Anthony was also looking ahead to a post-war world, especially as it might affect Rothschilds itself:

As regards New Court, we are trying to keep our head above water and working to get into shape in order to take a part in such activities as may be allowed after the war. The financial controls will in my opinion be essential at any rate for some time, and probably even for a long time, but there is no

reason why, given the right ability and direction, New Court should not play its part in the reconstruction within such framework as exists.

'Apart from New Court proper,' he added, 'there is a lot to be done both at the Refinery and at the Silk Mill to fit them into peacetime economy on sound lines.' Indeed, the Royal Mint Refinery presented a potential post-war dilemma: in essence, whether to continue to operate not only from London but also from its newer base at Tring, where by the end of the war there were three main activities: gold and silver refining; armament work; and work for the Royal Mint, primarily the production of blanks, ingot casting and the making of moulds. 'Much of the machinery at Tring had been purchased with the help of the wartime scheme operated by the Ministry of Munitions where the purchase of machinery had been heavily subsidised,' explains Michele Blagg. 'RMR Engineering, as the Tring operation became known, was keen to take advantage of the opportunity that presented itself at the end of the war to buy out the Ministry and purchase machinery at discounted prices.' This would duly happen, with the Tring operation moving away from wartime needs and towards peacetime markets (such as lipstick cases), before finally being sold in 1971.[16]

Yet of course, in the here and now of the last two years of the war, most of Anthony's thoughts were less on post-war prospects than on the immediate situation and outlook. His correspondence shows him following events closely:

He is a wonderful artist in the way in which he presents his case and uses the different inflections of his voice to emphasise his points.
(2 July 1943, to Eddy, after going to Guildhall to hear Churchill speak)

The Russians appear to be making almost miraculous progress and had not the Germans slipped out of so many awkward corners in the past one would have great hopes of the whole lot being collared in the pocket, but even if the majority escape, and even from the Crimea too, the effects of the whole campaign must be tremendous. I like very much the pocket cartoon in the Express today which depicts two typical German officers driving along in a Jeep and one says to the other 'I don't wish to seem impatient Herr General, but how long shall we have to wait before the treacherous civilians stab our glorious army in the back?' (29 October 1943, to Adrian de Wiart)

The political crisis seems to have died down for the time being but everyone agrees that the situation in the mines is thoroughly unsatisfactory and even hard to understand as they all seem ready to come out [i.e. on strike] without any reason or grievance, and it looks as though there are underhand people at work. It is good to read in the papers today that the Government proposes to take definite action, which is very necessary. (5 April 1944, to Eddy)

Of course at the present time everything is over-shadowed by the great news of the last week and the great hopes which we all have as a result.

It does seem certain that the first week has been more successful at a lower cost than anyone would have dared to hope and we have already got past the more dangerous phase of a small and narrow bridgehead. (13 June 1944, to Lapsley, exactly a week after D-Day)

I always ask my guests at lunch when it [the war] is going to be over – obviously a foolish question – and to begin with they refuse to answer, but with persistence at the end I always drag something out of them. Yesterday four of them agreed to say that it might end tomorrow but possibly the more likely time was the end of September, which seemed to me to be reasonably optimistic. (28 July 1944, to Eddy)

One or two of these doodle-bugs have come quite near Tring and Ascott and I only hope that we get along [i.e. in the war] quickly enough to prevent V2 being launched, whatever it may be. (4 August 1944, to Eddy)

The tragedy is that they [the doodlebugs] have damaged so many houses of the working class in different parts of London, and at this stage of the war it is an added unhappiness to lose one's home and belongings ...

There still seems to be quite a section of public opinion in this country who are surprisingly soft and unrealistic about Germany and that in spite of the well-authenticated reports of the incredible horrors and murders committed by the Hun in many directions. It is quite impossible to understand how any human beings can have carried out on such a vast scale the atrocities in the murder camps near Lublin, as described in our papers. (1 September 1944, to Eddy)

I had the great good fortune to be able to go down to Harrow last week to hear the songs and the P.M.'s speech which all went off very well. After the performance I was conveyed in great style to Chequers, where we dined and saw a film, after which I was sent home, so it made a very pleasant evening. (6 December 1944, to Eddy)

The P.M. was naturally very optimistic and seemed to think the war might end very suddenly, so that there could be a General Election in June. (12 April 1945, to Eddy, after Churchill lunching at New Court the previous week)

All the time, whatever the ups and downs, the almost daily luncheon parties had continued. 'Lunched at New Court with Tony Rothschild, arriving scandalously late owing to the Cabinet failing to rise until 1.50,' noted Churchill's private secretary, John ('Jock') Colville, on 4 May. 'Lord Bennett [former Prime Minister of Canada], Sir Basil Brooke [Prime Minister of Northern Ireland], and Colonel Vickers were the other guests.' Three days later the war in Europe – the second in Anthony's adult lifetime – was at last over.[17]

Yvonne at a children's Christmas party at Wing.

No reason for not being an optimist

Once VE Day was over, the summer of 1945 had one dominant story, with Anthony continuing to keep the absent Eddy in the picture:

> The next excitement here will be the General Election ... You can guess as well as I what the result will be, but I am inclined to think there will be a big turn-over to the Left. (11 May)

> I try to get a Gallup Poll from everybody I meet in the train but am really not much the wiser. (8 June)

> I think the general opinion on the whole is that the Conservatives will come back with a reduced majority, but this is probably based on wishful thinking and I would not be at all surprised if there were a much bigger swing to the Left than has been generally expected. (6 July, the day after voting)

His instincts were sound, for later that month it turned out that Labour had won a landslide victory.

Over the next few years of considerable economic difficulty, the City's atavistic hostility to the new government could hardly have been greater – typified by Panmure Gordon's senior partner, Richard Hart-Davis, insisting that Clement Attlee was Chinese and invariably referring to him as A.T. Lee – but Anthony, even though his youthful desire for political change had long since abated, took a characteristically more reasoned view. After referring to 'an almost general shortage here', a January 1946 letter to Lapsley went on:

> It seems to take a long time to turn over to peacetime production and so far very little has shown itself ... Some people, according to their political faith, blame the Government and are full of criticism, but I doubt very much whether it would have been much different under any other government, and certainly had the Tories got in there would have been a much more aggravated labour trouble on quite a different scale.

Anthony was also aware that, in some more fundamental sense, it was now a different world. When a few months later Robert Henriques sent him the draft of something he had written about the history of Rothschilds, Anthony not only made a series of specific criticisms, but described 'the whole chapter' as 'distasteful to me'. 'You may think me unduly sensitive,' he added, 'but in these days I do not think it is a particularly good thing to stress the contrasts or to emphasise the fact that members of a certain family had at one time an undue proportion of wealth.' Times generally continued tough into the early 1950s, even after Churchill had returned to power in 1951 promising to end austerity. 'The budget here seems to have given markets quite a shock and of course everyone is asking whether really it is drastic enough and will straighten things out,' Anthony in March 1952 wrote to Adrian de Wiart in Ireland. 'I do not see how anyone can tell for quite a long time and I would not be inclined to be over-optimistic.'[1]

What about life at New Court? There were some signs of change during the first ten years after the war – growing numbers of staff, a higher proportion of women, the increasing use of machines, less personal methods of recruitment – but on the whole, in these and other areas, the greater pace of change awaited a future generation in charge. One thing that did not change was the luncheon ritual. 'At 1.00 p.m. precisely, a blind would be drawn down over the glass panel in the door between the Partners' Room and the General Office, signalling that Tony and I had gone to the Partners' Dining-Room,' recalled Eddy, who had returned to the office in late 1946 and become a junior partner the next year. 'Lunch itself, invariably preceded by a glass of dry sherry, lasted for one hour exactly, no matter whom we were entertaining. My uncle's guests were a mix of people (usually between two and six of them) from the worlds of finance, politics and Jewry, with a sprinkling of his personal friends, and sometimes one of my own.' At the end, 'whoever the guests were, and however much they might have liked to linger, after the customary one hour Tony would get up from his chair and announce that it was time to return to work' – an appreciably shorter affair, in other words, than the City's traditional long liquid lunch.

More generally, New Court remained a place where the great post-war social revolution that was under way – albeit more slowly than has sometimes been assumed – only partially penetrated. In December 1949, on the occasion of Henry Bevington retiring as office manager, Anthony wrote revealingly as well as appreciatively:

> It is impossible for me to express at all adequately in a short letter, or for that matter at all, the appreciation of the firm for the services which you have rendered to New Court during the last thirty years. You have helped greatly with the reorganisation of the office and, while achieving a great improvement in the general efficiency with many necessary changes, you have succeeded in maintaining the old traditions of the relations between the staff and the partners, which are all-important...

What exactly did Anthony mean by those 'old traditions'? In his own mind, almost certainly, the Rothschild tradition of paternalism, in which the family took an active and benevolent interest in the welfare of those working for them. That was indeed the customary approach in the City at large in the 1940s and 1950s, but in few places more so than at New Court. Yet inevitably, the other side of the coin was an unquestionably – and unquestioning – hierarchical system, in which ultimately it was birth rather than merit which determined who got to the top. And here, the nub of the matter was the partnership – and above all Anthony's refusal to broaden it to people from outside the family.

The key example was David Colville: recruited from Lloyds Bank, renowned for his investment expertise, taking a seat in 'The Room', and described in 1950 by Anthony as 'thoroughly suitable' when proposing him for membership of Pratt's, he nevertheless had to wait until 1960, once Anthony had definitively departed the

New Court scene, before becoming a partner as such – the first-ever 'outsider' to receive that honour. He was joined in 1961 by Michael Bucks, thirty-seven years after coming to Rothschilds. 'There's not enough talent to go round,' Colville openly admitted on the occasion of this second break with precedent. 'To attract the right people, it's useful to point out that it's possible for partners to come from outside the Rothschild family.' Many family-based City firms wrestled after the war with the same dilemma; but undoubtedly, Anthony's conservative approach, in this respect anyway, made the bank less dynamic and less competitive than it might have been.[2]

Even so, one should not exaggerate, for the arrival of Colville in 1946 did in itself mark a certain opening up. During the first half of that summer, Bevington had devoted much of his time to composing a lengthy memorandum discussing the issue of the firm becoming a limited company ('the main advantage would be that the death of a partner or shareholder, or depositor of funds into the firm, would not necessarily entail the withdrawal of capital from the firm and would not in this respect interfere with the continuance of its activities') and the need for 'some reinforcement in the Partners' Room'. Anthony was in agreement, not least on the latter point. 'I have seen someone with suitable City Experience, about the right age, who would I think be of great value as an assistant to myself,' he wrote in July to Victor (by this time barely a part-time presence in New Court). 'This person would have no definite title but would be generally known as an assistant to the partner...' Victor did not dissent. 'I think that from your point of view the idea of an assistant is an excellent one,' he replied, 'if it will enable you to get away from New Court more, as I have the impression that at present you are completely tied there, which must be a frightful bore.' Anthony's next letter to his cousin, identifying Colville by name and noting that Lloyds 'give a very good account of him', had a certain edge to its final sentence: 'I think he will be most useful here, so that I hope his presence will help to give you more confidence in the future.'

In the event, the question of Victor's confidence or otherwise in the future of Rothschilds played a key role when, in the early months of 1947, the creation of a limited liability company involved a restructuring of the capital. At that point, Anthony and Eddy (as Lionel's son) each owned 50 per cent of the bank. But under the new arrangements – put forward, as far as one can tell, entirely by Anthony – the power balance between the branches of the family crucially shifted: £500,000 of ordinary (voting) shares were created, with 60 per cent going to Anthony, 20 per cent to Eddy and 20 per cent to Victor; while at the same time, Victor took the major portion of the £1 million of cumulative preference shares (non-voting), partly it seems through selling to Anthony some of his voting shares. It proved in every sense an advantageous arrangement for Anthony and his descendants: not only did the voting shares give them power, but they also, in Kenneth Rose's words in his biography of Victor, 'soared in value from decade to decade while the cumulative preference lagged far behind'.

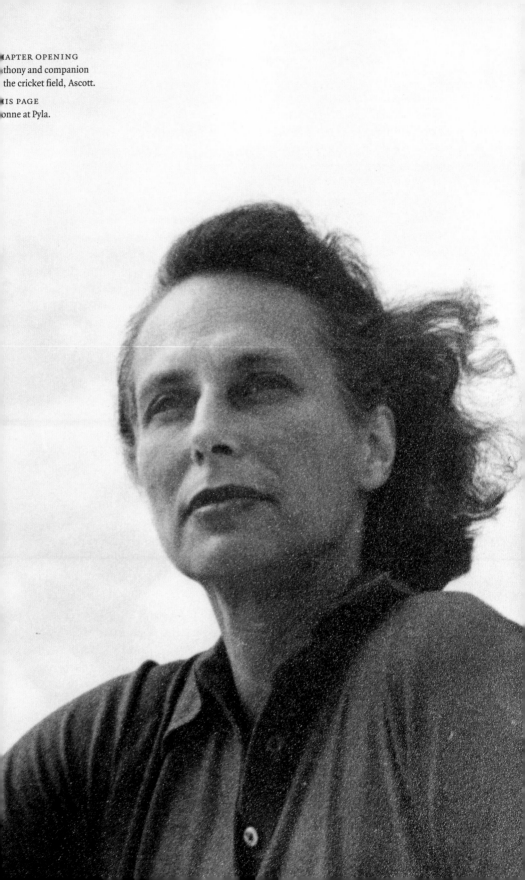

Eddy probably had no alternative but to accept the restructuring – given the financial straits his father had left him in – but the harder question is why Victor, a highly intelligent man, in effect backed the wrong horse; and Rose's explanation, that Victor (and/or his advisers) simply did not believe that Rothschilds had remunerative prospects in the challenging conditions of the post-war world, may well be the right one. Just possibly it might have been a different story if he (and conceivably Eddy) had had slightly more time to think it all over and take a longer view. 'As you will have heard,' Anthony wrote in May 1947 to Eddy in New York (where he was learning his trade at Kuhn Loeb), 'we got through all our reorganisation according to schedule – to use a word which must be dear to your Americanised heart – but in point of fact Dalton had nothing up his sleeve [a reference to Hugh Dalton's recent budget] which would have made any difference, so that a great part of our agitation and hurry was unnecessary.'[3]

Anthony at this point was a few weeks away from his sixtieth birthday. Easily the most intimate sense we have of him in this final phase of his working life comes from the reliably evocative Ronald Palin:

> He did not suffer fools much more gladly than before; there were still occasional painful flashes of the old impatience and his sense of humour, though more strongly in evidence, was still unpredictable. When my old friend Hawks was sent on a mission to Tangier I remarked that this was rather like sending Miss Coles, one of the senior secretaries, to Newcastle. The apophthegm pleased me, was well received throughout New Court and is still remembered [in 1970]; but when it was repeated to Anthony it fell, I was told, remarkably flat. However, there is no doubt that the years had mellowed him to an extent which I should not have thought possible. To me he was an almost totally different man...

> He would ring me on the house telephone instead of imperiously pressing the bell which summoned me to his presence and pull my leg and laugh. He called upon me for help with The Times crossword puzzle on days when he had been unable to finish it in the train...

'The hard work and frequent anxieties which were my lot at this time were immeasurably sweetened by the warmer personal relationship that I began to establish with Anthony,' adds Palin. 'Nobody who had not experienced life at New Court in the old days and worked on the hither side of the great gulf that separated the partners from even the most senior members of their staff could have appreciated how great and refreshing was the change.'[4]

As ever in Anthony's New Court life, the humdrum, to judge by Eddy's recollections, featured strongly:

> It was our practice in those days [as of course it had been before the war] for all letters, cheques, bonds, bills of exchange and other such papers to

be signed by a partner; per procuration signatures were virtually unknown. In consequence, there was always a mass of documents waiting to be signed. One of our senior stockbrokers, Denzil Sebag-Montefiore, of Joseph Sebag & Co., remembered that whenever he came to see my uncle in the Room at New Court Tony would carry on signing without looking up, and seemed hardly to have time to talk. Once I became a partner, I was able to share the burden of the interminable signing; but if ever, before putting my signature to a document, I ventured to say to Tony (as, to begin with, I frequently did), 'I'm afraid I don't quite understand this,' his reply was invariably the same: 'No. You wouldn't.'

Nor was hosting visitors always a pleasure rather than a duty. 'We had a Brazilian lunch today and Eddy worked very hard to keep them all entertained,' Anthony told Evelyn in May 1952. 'I really believe we ought to invite the Ambassador and his wife down to Ascott one week-end if I can get your mother to face it.' More enjoyable was a few weeks later:

> On Wednesday [he related to Evelyn] we had the Annual General Meeting of the Alliance [the Alliance Assurance Company, of which Anthony had been chairman since 1949], which seemed to go through fairly smoothly, and yesterday we had our golf match against Barings at Swinley, which unfortunately New Court lost. I regret to say I lost my match in the morning on the last green, but with Hobbs's help was able to win in the afternoon. The Ponticum [a type of rhododendron] were a wonderful mass of colour in clumps around the course and it is a very lovely place. I stayed up in London afterwards and dined with Evelyn Baring.

Anthony by this time was undoubtedly one of the City elders, and a year later it was his brains that the veteran Conservative politician Leo Amery (who in the Commons in 1940 had famously given Chamberlain his marching orders) sought to pick, in the context of a book Amery was writing about the problems of the British economy. 'I agree with the substance of what you write,' Anthony responded to a draft chapter on taxation and investment in which Amery had argued strongly for less taxation and less public expenditure, before going on: 'I think it is difficult, or perhaps unwise, to include the suggestion about exempting equity shares from death duties, or at least charge them at a reduced rate, as this would be both politically and psychologically inexpedient...'

As a City elder, Anthony commanded considerable respect. When Helmut Schroder in June 1954 wrote to 'Dear Mr Rothschild' inviting him to a black-tie dinner at Claridge's to mark the 150th anniversary of Schroders, he added a rather touching postscript: 'I really don't know whether you expect me to call you by your first name or not!' 'Dear Helmut,' replied Anthony in his letter of acceptance, 'of course you know me well enough to call me by my first name!'[5]

TOP
Field Marshal Earl Wavell at the
unveiling ceremony of the housing built
in memory of Evelyn de Rothschild. Far
right is Adrian Carton de Wiart.

BOTTOM
Anthony (far right) arriving at the
service to unveil Evelyn Close, 1947.

Anthony's main business concerns by the early-to-mid 1950s certainly included the Refinery in London on the one hand, far-away Newfoundland on the other. The Refinery was now predominantly Eddy's responsibility, but in early 1953, in his nephew's absence, Anthony left a series of far from gruntled 'Notes for Mr Edmund':

> Raven came in and reported the loss of 1,000 ounces gold in the stock-taking. This is very disquieting as there has never been a figure like it since 1905. The suggested explanation is that we have never refined so much gold before without having a large amount of silver and the recovery of unpaid gold in the silver has in the past more than compensated for the actual loss in the gold refined. This year, however, we have proportionately a very small amount of silver. I am not satisfied with this explanation and have asked for the whole matter to be thoroughly explored. (3 February)

> Went to the Refinery, where they have made no progress about the gold, but Belcher wants two alarms putting up as ordinary security precautions. I agreed, the cost being very small. (19 March)

> Very bad reports about the Refinery accounts and a deficit in the cash. This is being thoroughly examined with the help of the auditors, but it is most unsatisfactory. (2 April)

Meanwhile, the London gold market was still closed; but in March 1954 the Bank of England's Kim Cobbold summoned Anthony and Eddy to his room:

> The governor told them [noted the Bank's account of the meeting] that it was proposed to re-open a Gold Market... In the first place, it was proposed to re-open the Market on the old lines, but he could give no assurance that this would be welcome to the other members, nor that the relations between Rothschilds and the Bank would remain exactly as before. At this stage he wished to know whether Rothschilds thought they could undertake what was necessary: and to tell them that if a Market on the old lines did not prove satisfactory, he must feel free to promote some other arrangement.

> Mr [Anthony] de Rothschild said that their physical facilities were still in existence, and he thought they could do it.

It was probably an uncomfortable quarter of an hour for the two visitors; but in the event, after the gold market had re-opened later that month, Rothschilds did remain a pivotal part of it.

As for Newfoundland, that had begun on a hot afternoon in August 1952 when 'Jock' Colville, just returned to Downing Street from a lunch at New Court, heard that Joseph Smallwood, Premier of Newfoundland and Labrador, was in London looking for British expertise and investment in a potentially very ambitious enterprise. In the

course of that afternoon, not only did Smallwood get to see Winston Churchill at No 10, but the PM and Colville agreed that Smallwood's first stop in the City should be New Court. Soon afterwards he went to lunch there – subsequently confessing that the rather forbidding Anthony was 'the only man in the room I feared at all' – and explained that what he wanted to do was to get backing for the development of his province's considerable timber, mineral and water-power resources.

Over the next month or two, while Rothschilds was doing its due diligence locally and Anthony was starting to assemble a London syndicate to capitalise the venture, Smallwood visited New Court several more times, usually accompanied by Dr Alfred Valdmanis, a Latvian who before the war had worked closely with Hitler's finance minister, Hjalmar Schacht, and was now Smallwood's man in charge of economic development. His involvement almost scuppered the whole thing. 'Valdmanis came to see Tony privately, to tell him that for a $1 million under-the-counter payment the iron-ore concession in Labrador could be Rothschilds' alone,' Eddy would recall. 'Tony showed Valdmanis the door, and the suggestion so appalled him that for some time afterwards, though without choosing to publicise the reason, he refused even to see Smallwood.'

But eventually, that unfortunate if revealing episode blew over; the following March, an agreement was signed between the Newfoundland government and a syndicate headed by Rothschilds which also included Rio Tinto, Morgan Grenfell, English Electric, Schroders, the Prudential and Hambros among others, prompting *The Times*'s City editor to comment that 'it is difficult to recall any other occasion on which a syndicate representing such wealth as this was formed for any purpose'; and over the ensuing years, the British Newfoundland Development Corporation (BRINCO) largely fulfilled Smallwood's original vision, including a massive hydroelectric project at the Churchill Falls. For Palin, intimately involved for several years from 1953, 'the story of the birth and early years of this great enterprise' was a prime example of Anthony's 'far-sightedness', mixed with just a dash of 'romantic adventurousness'.[6]

By this stage, some four and a half decades after he had started work at New Court, few could have denied his huge contribution to the firm – in effect, keeping it going when a series of circumstances (mainly external) might easily have sunk it, and thereby paving the way for future generations to enjoy what would be a largely more benign economic and political environment. He had done so through dedication, through clear-sightedness, and perhaps ultimately – for all his realism – through a certain dogged faith. 'I see no reason for not being an optimist,' he had written to Eddy in May 1945 amidst seemingly gloomy prospects; and he had added, 'anyhow it is the only thing that is worth while.'[7]

<p style="text-align:center">★　★　★</p>

Anthony's extra-curricular interests remained almost as varied as ever during the ten years after the war, even if he pursued some more vigorously than others. A list of his life memberships, compiled after his death, would include *inter alia*: Hunters' Improvement Society; Jewish Historical Society; National Institute of Agricultural Botany; Society for the Promotion of Hellenic Studies; Friends of the National Libraries; and the Anglers' Co-operative Association.[8] It is quite hard to imagine a comparable list for, say, a modern investment banker based in Canary Wharf.

Meanwhile, even in those more high-tax times, the philanthropy continued – whether to causes or to institutions or to individuals, the last typified by how Anthony, soon after the war, went to considerable lengths to use his contacts with the brewers Charrington & Co in order to enable the newly retired squash professional at the Bath Club to buy and manage a country pub ('some arrangement could be made here to help him with the financial side of the question, as if it were necessary the funds could be lent to him – as presumably the security would be reasonably good'). He also went on serving where he felt he could spare the time, for instance as one of the two Hon Treasurers for the National Association of Boys' Clubs, whose Finance Committee usually met monthly at New Court. 'I quite agree that we should go very slow in increasing the expenditure on the Research Department,' he wrote in 1946, after seeing the relevant papers, to the Association's chairman, Lord Aberdare. 'I am sure the Finance Committee would wish to keep the staff down to the minimum consistent with efficiency.' One philanthropic initiative, however, produced disappointment – namely, his gift of the Palace House estate, at Newmarket, to the Jockey Club.

The precise details and chronology of what unfolded are unclear, but it seems that disenchantment came quite soon:

> I must admit [he wrote in May 1946 to 'Harry', his cousin Lord Rosebery] that I am rather disgruntled with the whole matter, as, having made a suggestion which I thought would be welcomed, I find it is treated in high quarters rather as though one was trying to pull a quick one over. I suppose one must try to be philosophical … In view of what has happened and the doubt as to whether the house will be used as suggested, I feel rather inclined to review the whole matter and, even if I stick to the original proposal so far as Palace House itself is concerned, sell the rest of the property to the best advantage, as the whole idea of putting it with the other was so as to avoid letting the [Jockey] Club in for any expense.

An explicit part of Anthony's original purpose for gifting Palace House had indeed been 'in the hope that it would be used by the Royal Family when they attend the races'; but by May 1950 he was telling Renée not only that Palace House was conclusively 'not being used as intended and there seems no prospect of the Royal Family wishing to go there,' but also that the Jockey Club now intended to sell it to the RAF or suchlike:

I was definitely of the opinion that this was a mistake, and today I had
Cousin Harry and Humphrey de Trafford to lunch and discussed the whole
matter. They have now come forward very strongly with the suggestion that
the whole of the Newmarket property should be handed back for the benefit
of the children if they would be likely to want to go there. Evelyn was at lunch
and heard all the story and I have spoken to your mother on the telephone,
who likes the idea. I imagine it will also appeal to your horsy instincts, and
if this is the case I will go ahead with the plan.

So apparently he did, and in the event the Palace House estate stayed in Rothschild hands
until the 1980s. In the fullness of time, though, Palace House and the Stables became
home to the National Heritage Centre for Horseracing & Sporting Art, a develop-
ment which would surely have pleased Anthony.[9]

One cause still close to his heart was the Central British Fund for Jewish Relief
and Rehabilitation, as it was now called and of which he was chairman. 'It becomes
more and more important that as many as possible of the children should stand on
their own legs and meet the whole of the cost of their maintenance, including an
allowance for overheads, out of the wages which they receive,' he insisted to a colleague
in July 1946 in the context of the CBF's difficult financial position. 'This is only fair
so that they should not be in a position of advantage compared with English boys of
the same age, apart from which it is essential as the CBF does not command funds
to do otherwise.' Some six months later, Anthony was asking another colleague if
he would host a cocktail party to launch a new drive for funds. 'The funds we have
at present will be exhausted before the end of the year [1947],' he told Sir Edward
Baron, chairman of Carreras, 'and we have the responsibility of looking after their 700
children who have been brought over from the Continent, apart from which there is
an ever increasing demand for workers amongst the unfortunate displaced persons
on the Continent, and at the present time many of the [Jewish] communities who are
struggling to re-establish themselves are asking for our help.'

Anthony also stayed closely involved with the Jewish Orphanage at Norwood,
including in May 1950 having another run-in with Basil Henriques, this time after
the latter had apparently complained about the severity of the punishment given
to a boy there. Anthony disagreed: 'My only criticism is that the punishment was
not sufficiently severe ... I am told that the grandchildren of your colleague on the
Bench are given cold milk every morning for breakfast and do not appear to be any
the worse for it.'

Of course, this was the period in which, on 14 May 1948, the state of Israel came
into being. Some ten days earlier – the day after a parcel bomb in Codsell had killed
the brother of a British army officer who had been acquitted of the murder in Palestine
of a member of the ultra-Zionist Stern Gang – Anthony gave his response to a request
from other leaders of the Anglo-Jewish community to add his name to a letter to

The Times, a letter emphasising how, 'at this solemn and anxious hour', the Balfour Declaration had been 'born not only of Zionist but also of British idealism'. Anthony's perhaps predictable reaction was to distance himself from such sentiments. 'I do not think we have anything to thank the British Government for in the Balfour Declaration,' he told them, 'as it has only caused a heap of trouble and, in view of recent happenings such as yesterday's bomb, I feel that the best thing to do is to keep completely quiet.'[10]

Probably the public cause which occupied most of Anthony's post-war time was his chairmanship of the Board of Management of St Mary's Hospital. Typical was a detailed letter in June 1945 to the House Governor, Colonel Parkes, about the appointment of a steward for the hospital and what his duties would involve, which essentially were 'all activities in connection with food'. 'I should like,' emphasised Anthony, 'to see this matter progressing reasonably fast, because I think this is just the time to get the very best people who will be available.' Soon, following Labour's election victory, Aneurin Bevan would be setting out to create the NHS; but over and above the level of local practicalities – for instance, how the impending legislation would affect the hospital's inoculation department (where Alexander Fleming had invented penicillin), or its medical school – it is hard to gauge the precise extent of Anthony's involvement in this historic development. But whether before or after nationalisation, hospital finance remained his important particular expertise. A long letter in June 1951 to a sympathetic Conservative MP, Walter Fletcher, sought to identify one of the main problems:

> Owing to the way the budgets are prepared and presented, it is almost inevitable that the hospitals should protect themselves by having some margin for contingencies. I think this is a real difficulty: for instance, should a hospital budget be for the staff it has at present or the establishment which has been approved by the Authorities, including nurses? ... If the hospitals only budget for the staff they have at the time of budgeting, which is some nine months before the financial year begins, they will be unable to take on any recruits which may turn up and the whole standard of the service is anchored at a low level.

Later that year, the Queen paid a visit to Paddington. 'The whole place was crowded and the passages were lined by nurses; we none of us imagined there were so many in the Hospital,' Anthony reported to Adrian de Wiart. 'While the Queen was visiting one of the wards she spoke to one of the patients who seemed completely down and out, but to everybody's astonishment he wished to tell the Queen a story, which created a certain amount of anxiety as to what it might be,' he added with his own storytelling relish. 'He then said "Does Your Majesty know what building is represented when the Duke of Edinburgh kisses Princess Elizabeth?" "No, I am afraid I don't." "The Royal Exchange, Ma'am."'[11]

By this time, St Mary's had a new wing. 'Not unmindful of the fact that in your illnesses whilst Prime Minister you were looked after by nurses from St Mary's Hospital, and had as your medical attendant Lord Moran, the Dean of St Mary's Medical School, I am venturing to write to you to ask if you would allow your name to be associated with this new part of the Hospital, so that it should be called the Winston Churchill Wing,' Anthony had successfully petitioned the great man back in December 1945 after the hospital had received the gift of a site adjoining the main building. 'I need not add how greatly we should appreciate it if you could see your way to agreeing to our request. We are justly proud that the Hospital contributed to your restoration to health and we should be happy that this association should be commemorated for future generations to remember.'

Did Anthony ever reflect on how much his attitude to Churchill had changed since the First World War, especially those angry days of July 1917? As so often, it is impossible to know. Certainly, no qualms were apparent when, in early 1950, Anthony not only congratulated Churchill on his 'magnificent exertions' during the recent election (narrowly won by Labour) and hoped he was 'not too disappointed', but also asked him to write a few lines for the next issue – being edited by Evelyn – of the Harrow school magazine. Churchill agreed, apparently over a conversation at the French Embassy, and Anthony then suggested some possible words, gratefully received: 'At Harrow you have had your first lessons in citizenship. If you know your Harrow songs well you will have much to guide you in after life.'[12]

Presumably Anthony was pleased with his son having become editor of the Harrovian; but in truth, what survives in relation to Evelyn's school career conveys a father's approach which would not have been out of place in that Victorian era when Anthony himself had begun his schooling. Take the grand remonstrance in September 1946 (when Evelyn had recently turned fifteen) to Cyril Browne, his housemaster at Harrow:

> I think it is essential in the coming term that he should not be allowed to drop back into his old ways. He is not sufficiently good at or keen about games to make this an excuse for comparative indifference to work, and it is high time something was done to make him bestir himself and understand how necessary it is for his future life to get the most out of his education. I can't help feeling that over the past terms he has just been able to reach a standard which keeps him out of trouble without bestirring himself, but this must not be good enough in the future. You will probably answer me that you are doing the best you can with the material which is there. This may be so, but I am troubling you with these lines to suggest that this is not taken for granted too readily – but that his new form master is told that the boy is inclined to take things very easily if allowed.

TOP
Anthony and Eddy, with Royal Mint
Refinery managers in 1952, the
centenary of the acquisition by NMR.

BOTTOM
Sir Alexander Fleming (right), Anthony
(2nd right) and senior members of St Mary's
Hospital with HM Queen Elizabeth.

A year later, Anthony was writing reproachfully again to Browne after an exam ('I cannot help feeling that the result is far from creditable to all concerned'); while soon afterwards, it was another discouraging assessment of Evelyn's progress. 'He tried his exam. again this month, though both of us [i.e. Yvonne as well] thought it was rather a mistake, but we were told that it would disappoint him too much not to let him try,' Anthony at Christmas 1947 told Evelyn's former private tutor Hugh Carey, recently graduated and now in South Africa. 'My attitude was that at best he would scrape through, which is not nearly good enough.' A culminating moment came in March 1949 with Anthony's stern letter to Evelyn himself:

> I read your two essays, which showed some improvement but there were still a number of slips in spelling and words omitted, entirely due to carelessness and lack of concentration and you must do better and reach a higher standard...

> I gather you told your mother on the telephone that it would be very difficult for you to do much work at Harrow if you did not have the Higher [School Certificate] to work for. I cannot understand this at all and you must get such nonsense out of your head and at last get down to work.[13]

Evelyn was his only son; and in Anthony's mind he therefore represented, in some very real sense, the future of Rothschilds, certainly as far as his side of the family was concerned. The paternal stakes, in other words, were understandably high; and in the event, Evelyn would fully meet his responsibilities, steering a sure course for the bank in a way which would undoubtedly have made his father proud.

Restoring Ascott from the ravages of war was another preoccupation. 'The garden is to some extent recovering from neglect during the war, but we are not quite sure whether it is yet in a fit condition for people to pay and come and see it, though I dare say this applies to quite a number of gardens which are now being opened,' he wrote to an acquaintance in January 1946, somewhat reluctantly consenting to have the garden open for one day in the spring in aid of the Buckinghamshire Nursing Association; some months later, Anthony sent Victor some notes on the Ascott estate, mentioning that before the war its 'rather more than 1,000 acres' had been 'mainly pasture', but that 'during the war more than 600 acres were ploughed up'; by December 1947 he was telling Carey that 'we have been very busy in the house at Ascott spreading further over the other rooms and there has really been great progress', that indeed 'we are to have a New Year's party to celebrate the occasion'; and in September 1948 he was willing to agree that the cricket ground, no longer being used by the RAF, could be used the following summer for a Buckinghamshire match. 'The ground has had a lot of play but I think that with luck Pitchford can get you a good wicket,' he told the county club's Henry Aubrey-Fletcher. 'Of course the catering will not be up to pre-war standard, but I have no doubt I can find somebody who

can put up a reasonable meal and I shall be very pleased if the County team will come as my guests.'

A house guest earlier in 1948, staying for a weekend in February, was Jock Colville. 'Tony has a magnificent library and some admirable pictures,' he recorded in his diary entry for the Saturday. 'The house is certainly as comfortable as could be wished, but overheated bedrooms always give me restless nights.' Then next day:

> After Tony, Anne and I had been for a seven-mile walk (very hard going on the high road) we returned to tea where we found that agile conversationalist Princess Marthe Bibesco...

> We spent most of the evening after dinner trying to persuade Madame Laffon, an attractive French friend of Yvonne, who has three children at school in England, that English schools were not riddled with homosexuality and that incessant and brutal corporal punishment was not an invariable feature of the curriculum.

Yvonne herself was increasingly busy locally: in May 1946 she had been elected as a local councillor; and then over the next few years she was the driving force behind the building, on land in Wing given by Anthony, of twenty-eight houses mainly for ex-Servicemen and their families, with Evelyn Close (named in memory of Anthony's brother) being formally unveiled by Lord Wavell in May 1949. The garden was by now sufficiently recovered for Anthony, knowing her particular weakness for the fruit, to be able to start sending Queen Mary a regular supply of cherries; and in June 1952, thanking Anthony for thinking of 'old me', she affirmed that there were none as good as those from Ascott.[14]

Colville was not the only diarist inspecting Ascott, for so too – motoring there on a Saturday in October 1949 – was the National Trust's resident connoisseur of all things artistic, the often waspish James Lees-Milne:

> This is another case of a rich man's collection of treasures housed in an unworthy building – half-timber of the 1870s – and set in poor surroundings. House and gardens spick and span. The owner, Mr Anthony de Rothschild, is a very nice man indeed, and so is his pretty wife a sweet woman ... I arrived at midday and stayed till 5 o'clock. French furniture particularly good. Dutch paintings, Lawrence sketches, two full-length Gainsboroughs, one head and shoulder Gainsborough of a young man, a Lorenzo Lotto of a dark young man, two Rubenses, one of mother and child and one of Hélène Fourment, very seductive. A collection not to be sniffed at. It is sad that the rich so often have indifferent houses.

The context was Anthony's intention to give Ascott to the National Trust – an intention, at this time of unprecedentedly high death duties, widely shared amongst the nation's country-house owners – and the purpose of Lees-Milne's visit was

clearly to check out that this was an offer that the Trust would want to accept. He must have given it an overall pass mark, for by the next month Peter Hobbs (nicely described by Anthony's nephew Eddy as 'general New Court *homme d'affaires*') was seemingly describing a done deal. 'When Mr Anthony first mentioned the possibility of it being made over to the National Trust I was considerably shocked & made a number of explorations for alternatives,' he wrote to a perhaps still doubtful Yvonne. 'All were aimed at preserving Ascott for the family, but none seemed to guarantee this for Evelyn, Renée & Anne & I have since come regretfully to the conclusion that the N.T. plan is the safest.'

In September 1950, following the formal announcement, *Country Life* gave the full four-page, heavily illustrated treatment to Anthony's gift – a gift which, 'with its superb collections of works of art and the exquisitely planted gardens and grounds surrounding it, together with a handsome endowment fund, will be a source of great pleasure to art lovers and horticulturists and to the public in general'. The writer (H Clifford Smith) identified, against much competition, Aelbert Cuyp's *View of Dordrecht on the Maas*, purchased by Anthony in 1929 and dominating the dining-room, as 'the outstanding masterpiece of the collection', with Professor Anthony Blunt's words ('one of the most romantic renderings of light effects in the whole of Dutch painting') being approvingly quoted. The other Anthony seems to have been happy enough. 'The arrangement at Ascott is that we go on living there and as long as I have a direct descendant wishing to live at Ascott he or she can do so, and I think that it is reasonable to hope that nothing will interfere with this unless of course what is quite likely the time comes when nobody wishes to live in a house of that size,' he informed a friend, Lord ('Brownie') Lurgan, later that autumn. 'It is too early to say yet, but so far as we understand the only real difference will be that for the summer months the public will have the right to visit the place twice a week on payment of a small fee.'[15]

Evelyn had recently started his National Service, unsurprisingly in the Navy; and over the next two or so years, Anthony's letters to him, almost invariably wishing 'Best of luck', give at least something of a sense of daily life at Ascott and elsewhere:

> There is a Housing Society meeting this evening at which I am going to help your mother decide on some new tenants, though of course she has settled it all beforehand. (13 October 1950)

> Yesterday we had an Accepting Houses meeting at the Bank of England – a new arrangement – followed by an enormous luncheon party of 32 all told in the Board Room. I then went to the Wright Fleming Institute for a committee meeting after which I attended a dinner at a restaurant for the Orphan Aid Societies of Norwood with some 75 people there. They do very good work and collect large sums of money. It was rather curious that the waiter at our table had been a Norwood boy, leaving in 1917. Somebody had had a brilliant idea

and had called the roast chicken by the name of our chief guest whom we were thanking for 25 years of work – so I was able to say that when I saw the menu I was very worried as I thought it would be a tough old bird like the individual in question. This went down very well. (20 October 1950)

Yesterday Wing just beat the Hawkins Eleven. Both the General [probably de Wiart] and I thought it was the worst cricket we had seen for a long time – both bowling and batting. It was a really hot day and I was quite exhausted after walking to Southcourt and back, and in the afternoon we went to see Harry's yearlings and foals at Crafton. (2 July 1951)

The four of us [Anthony, Yvonne and their daughters] went to Buckingham Palace on Tuesday night and, as usual, it was a very lovely sight and your sisters remarked on the excellence of the provisions which were supplied. They seemed to do them full justice. I met a lot of people I had not seen for a long time and your mother was quite worried when I found I could not remember half their names. (13 July 1951)

The weather has been fine the last few days and the gardens are really looking lovely. We had over 400 visitors on Sunday for the Nurses' Fund. (17 July 1951)

A party of French athletes came round the gardens on Sunday – rather a strange looking crowd – and one gigantic dandy walked about with his arms round four of the young ladies. Luckily there was a cricket match so that a few more Frenchmen learnt something about English habits. (7 August 1951)

I put on my sweaters and walked about quite a lot. We went to Deauville several times but I did not go to the races or to the Casino, and Guy [de Rothschild] made me play nine holes of golf one afternoon. (25 September 1951, after holidaying at Reux)

The hunting for the season is ruined by foot-and-mouth and they are only going to have a few days in the woods. (10 March 1952)

We went to the Point-to-Point on Saturday, but it was a terrible day – cold, windy and wet – and we had to get out in order to push the car off the course and became covered in mud. (7 April 1952)

We had good weather for Easter and a cheerful house party with Adrian, Arthur Villiers and Fred Cripps. (16 April 1952)

We had a lovely day yesterday when the gardens were open for the Queen's Institute. There were over 300 visitors. So far on National Trust days there have been very few. (21 April 1952)

I am going to the Chelsea Show for an hour this afternoon to meet Yeoman to try and discover some more specimens to get down to Ascott. (20 May 1952)

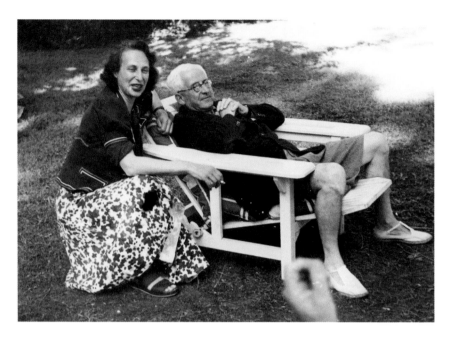

TOP
Anthony and Yvonne on
holiday in Pyla.

BOTTOM
Renée, accompanied by
Anthony, on the day of her
marriage to Peter Robeson,
Olympic equestrian champion.

The following month saw the annual local 'Puppy Show'. Fond though he was of Laddie his own dog, Anthony offered a crisp verdict: 'As I never see any difference between one hound and another, I thought the judging went on far too long.'[16]

We have some late glimpses. 'It must have been in 1954, one day at Ascott, as we were alone together in the hall,' remembered his mother-in-law Sonia, 'that he either read or recited to me Tennyson's "Crossing the Bar", with such simplicity and feeling, his voice modulating each word to perfection.' The same year, he regretfully declined ('I seem to have too many engagements on hand and cannot manage it') an invitation from de Wiart in County Cork to 'come over and throw a fly'. That September he was on the Continent for a holiday, reporting to de Wiart that 'I bathed nearly every day at Venice and walked with many sweaters on in the forest'. In February 1955, after Renée's wedding, Ronald Palin watched him at the Ascott reception as he 'moved smiling among his guests', presenting a picture of 'positive joviality'. As ever, Anthony continued to read, with books listed in the early months that year including Martha Gellhorn's *The Honeyed Peace*, a collection of Graham Greene short stories, and – perhaps improbably – DH Lawrence's *Lady Chatterley's Lover*. 'I personally miss the papers, though many of my friends say they rather enjoy not having to read them,' he told another friend in April in the context of the national newspaper strike; while in early June, in response to a request from Soame Jenyns of the British Museum's Department of Oriental Antiquities to come and see his collection, he replied that 'a week-day is not really convenient for me at Ascott, as I am up in the City the whole time'.

Anthony's last letter seems to have been to the future architect of Thatcherism, Sir Keith Joseph, with whom he had Harrow as well as business links and who had lost at Barons Court by 125 votes in the recent general election. 'Thank you very much for thinking of me and asking me to your box at Lord's, but I am afraid I shall not be able to get away,' he responded on 9 June to Joseph's offer in relation to the South Africa Test a fortnight hence. And he added: 'I was very disappointed that you were so narrowly beaten, but I am sure you will get in next time.'[17]

★ ★ ★

A few days later, Anthony left New Court in the afternoon to attend a meeting at St Mary's. Soon after arriving, he suffered a severe stroke. By the 15th his secretary, Miss Owen, was informing Lady Burnham that he had been 'ordered a complete rest by his medical advisers and I am not sending him any of his mail'. A week later, ahead of the annual cricket match at Ascott between Wing and the New Court staff, she was writing to Tarver: 'It will be very sad to be without Mr Anthony. I am missing him so much – as is everyone, of course – and am longing for him to be back with us again.'

Anthony himself remained at St Mary's; while over the rest of the summer, the

general message from New Court was, as Eddy put it in July to his cousin Guy, that 'Tony continues to improve though the progress is bound to be slow'. By September, though, he was back at Ascott, by October even playing host to de Wiart, who in his thank-you letter declared that 'it was great to see you in better trim than you were even the week before'.

Over the rest of the year, he received a series of warm letters: from the leading merchant banker Lionel Fraser about how 'the City has need of you and misses you'; from Joseph about how 'it seems odd that someone as vigorous and vital as you should have more leisure than you may wish'; and from a fellow-member of the St Mary's management board, ICI's Lord (Harry) McGowan, about how 'no Chairman can have devoted more time than you did to the work of the Hospital, and you have the satisfaction of knowing you are loved by all there'.

What were his prospects of a proper recovery? 'I need hardly say what an enormous difference there is in your condition now as compared with when I first saw you in the Lindo Wing,' Dr Harold Edwards of Devonshire Street, w1, wrote to Anthony shortly before Christmas. 'May I say that I have every reason to believe, and so has Dr Britton, that you will continue to make more and more improvement in every way. I look forward to seeing you walk with much greater assurance and, indeed, with perhaps only a slight limp as the final evidence of what you have been through.'[18]

For a time in 1956, with Anthony recuperating in warmer climes, that optimism seemed justified. 'News from France is very good and I think the whole thing is proving a great success,' Miss Owen updated a well-wisher, in March. 'The journey went off without a hitch and did not appear to tire Mr de Rothschild unduly.' But by June, with Anthony back at Ascott for the summer, her tone to another well-wisher, Raoul Söderström, was gloomier: 'I am sorry to say that Mr de Rothschild's health does not improve as quickly as one would wish, and he still has a long way to go before he is likely to be fit again.' Six months later, Eddy was telling Josef Perugia in Buenos Aires that Anthony was 'still unwell'; and after perhaps the odd flicker of hope in 1957, by June 1958 the main consolation Miss Owen could offer Söderström was that, although 'Mr Anthony's health has not improved as much as was hoped, and he is forced to lead a very quiet life at Ascott,' he was getting 'a lot of pleasure from the beautiful gardens there, particularly at this time of year'.

The pattern had now been established of winters in France, summers back home, and a complete absence of activity whether at New Court or in public. 'Mr and Mrs Anthony have both been in France since before Christmas, to avoid the worst of the winter over here,' Miss Owen told Lord Lurgan in March 1960. 'Mr Anthony was not so well when he first got there, but he is much better now and, although the weather has been rather mixed, he manages to get out in the garden and to go for lovely drives in a way that he could not do if he were in England...'[19]

Some three months later, at the end of June, Anthony formally relinquished his

ABOVE
Villagers and huntsmen
gathering at All Saints' Church,
Wing to watch the arrival of
Renée and her wedding guests.

partnership – a year after Evelyn had become a partner and on the same day that David Colville, the first non-Rothschild, entered the partnership. Around the same time, Palin came across him, 'sitting in his wheelchair and attended by a nurse,' at the annual cricket match at Ascott:

> The brim of his hat was turned down and the lower part of his face was swathed in a woollen scarf. Between them his eyes seemed to be peering at me with something of the old keenness. I did not know if he recognized me or was well enough to talk to me or would have wanted to do so ... I hesitated uncertainly, stopped and turned sadly away.

By September he was back at St Mary's; and there Anthony died, aged seventy-three, on 5 February 1961.

'Banking and Philanthropy' was the headline next day for his obituary in The Times, as immediately the letters of condolence to Evelyn started arriving. Many of them, inevitably, were from the great and the good; but perhaps the one that Anthony might have appreciated the most, certainly for its heartfelt sentiment, was from the leader of Poplar Boys' Club: 'To us your Father was a great friend.'[20]

Endnotes

All references unless otherwise stated are to The Rothschild Archive London.
All books are published in London unless otherwise noted.

CHAPTER ONE: I WISH I KNEW MY OWN AMBITION

1. 'Mr Anthony de Rothschild', *Times*, 6 February 1961.
2. 000/2019/13/1, 28 August 1889, circa 1890, 30 October 1891, 30 July 1892, 15 October 1896, 16 June 1897, 5 May 1898.
3. 000/2019/13/1, 5 February 1899, 21 May 1899, 28 May 1899.
4. 000/2019/13/2, 28 October 1899; 000/2019/13/5, 'Pupil Room' report for month ending 21 October 1899; 000/2019/13/2, report by I.G.
5. 000/2628/20; *Wikipedia*, 'Hwfa Williams'; Mrs Hwfa Williams, *It Was Such Fun* (1935), pp.90–2.
6. David Kynaston, *The City of London, Volume Two: Golden Years, 1890–1914* (1995), pp.220, 271, 273–4.
7. 000/2019/13/5, 24 March 1900, 2 June 1900, 30 June 1900, 20 October 1900, 17 November 1900, 23 February 1901, 23 March 1901, 7 December 1901; 000/1373/8/4, 21 February 1904, 30 October 1905; 000/2628/28; 000/2019/13/5, 28 July 1906.
8. 000/2019/13/2, 26 January 1900, Wednesday 21st 1900, 16 May 1900, 1 December 1900; 000/2019/13/3, 9 November 1901, 20 November 1901, 2 December 1901, 5 February 1902, 29 October 1902; 000/2019/13/4, 21 June 1903, 11 November 1903, 1 May 1904, 14 November 1904.
9. 000/2019/13/4, 19 March 1904; 000/2628/30.
10. Niall Ferguson, *The World's Banker: The History of the House of Rothschild* (1998), p.971; *Times*, 6 February 1961; 000/2628/35/1, 26 June 1908. 000/2628/27/3 has the exam papers that Anthony tackled in that first part earlier in June 1908.
11. 000/2628/31, vol 1, 11 April 1910, 14 April 1910, 17 April 1910, 23 April 1910, 29 April 1910, 4 May 1910, 12–13 May 1910, 15 May 1910, 22 May 1910, 24 May 1910, 30 May 1910, 11–12 June 1910, 19 June 1910, 22 June 1910, 29–30 June 1910, 1 July 1910, 11 July 1910, 8 August 1910, 13 August 1910, 13–14 September 1910, 2 October 1910.
12. 000/2628/31, vol 1, 12–13 October 1910, 16 October 1910, 18–19 October 1910, 24 October 1910, 27–30 October 1910, 2 November 1910, 4–5 November 1910, 7–9 November 1910, 12 November 1910, 14 November 1910, 16–18 November 1910, 21–3 November 1910, 25 November 1910, 28 November 1910, 30 November 1910, 3–4 December 1910, 6 December 1910, 11 December 1910, 15 December 1910, 3–4 January 1911, 7 January 1911, 10 January 1911, 12–14 January 1911, 16–18 January 1911, 22–3 January 1911, 25 January 1911, 2 February 1911; 000/2628/31, vol 2, 13 February 1911, 27 February 1911, 6 March 1911, 8 March 1911, 27 March 1911, 29 March 1911, 31 March 1911, 3 April 1911, 11 April 1911, 20–1 April 1911, 29–30 April 1911, 4 May 1911, 18 May 1911, 25 May 1911, 23 May 1911.
13. XI/130A/5/119, 29 June 1911; 000/2628/25, cricket file; 000/2019/36/1, 28 May 1912, 30 May 1912; XI/130A/7/157, 7 August 1913.
14. 000/2628/119/2, 5 November 1913.
15. 000/2628/119/4, 29 November 1913.
16. XI/130A/8/2, 2 January 1914; 000/2628/30; XI/130A/8/77, 17 April 1914; XI/130A/8/133, 13 July 1914; 000/2019/37/1, 29 July 1914.

CHAPTER TWO: WASTAGE OF HUMAN LIFE

1. 000/2019/37/1, 18 August 1914, 15 November 1914, 23 November 1914, 8 December 1914.
2. 000/2019/37/1, 24 January 1915, 16 February 1915.
3. 000/2019/37/1, 6 March 1915, 13 March 1915; 000/2019/15/1, 7 April 1915. See generally: 000/1590, Duncan Anderson, 'Evelyn and Tony de Rothschild in the Gallipoli Campaign, 9 April–2 November 1915' (September 2005).
4. 000/2019/15/1, 12 April 1915; 000/2019/37/1, 15 April 1915; 000/2019/15/1, 24 April 1915.
5. Colonel the Hon FH (Fred) Cripps, *Life's a Gamble* (1957), p.100; 000/2019/15/1, 2 May 1915; 000/2019/37/1, 2 May 1915.
6. 000/2019/15/1, 8 May 1915; 000/2019/37/1, 8 May 1915; 000/2019/15/1, 14 May 1915, 21 May 1915;

000/2019/37/1, 26 May 1915; 000/2019/15/1, 1 June 1915; 000/2019/37/1, 15 June 1915, 22 June 1915, 3 July 1915.

7 000/2019/15/1, 7 July 1915, circa 17 July 1915; 000/2019/37/1, 10 July 1915, 25 July 1915; 000/2019/15/1, 10 August 1915, 13 August 1915.

8 000/2019/37/1, 19 August 1915; 000/2019/15/1, 19/20 August 1915.

9 000/848/37/1, 25 August 1915; 000/2019/37/1, 24–5 August 1915.

10 000/2019/37/1, 9 September 1915.

11 000/2019/37/1, 31 August 1915; 000/2019/15/1, 8 September 1915; 000/2019/37/1, 8 September 1915.

12 000/2019/37/1, 18 October 1915, 4 November 1915; 000/2019/15/1, 5 November 1915; 000/2019/37/1, 11 November 1915. Neil Primrose (1882–1917), Liberal politician and soldier, second son of Archibald Primrose, Lord Rosebery (1847–1929) and Hannah, (née de Rothschild) (1851–1890). Primrose was commissioned into the Buckinghamshire Yeomanry (Royal Bucks Hussars). He died in November 1917 from wounds received in action at Gezer during the Sinai and Palestine Campaign; his cousin Evelyn de Rothschild (1888–1917) was killed in the same battle.

13 000/2019/37/2, 30 December 1915, 27 February 1916, 19 April 1916, 12 July 1916; 000/2019/15/1, 21 July 1916; 000/2019/37/2, 21 July 1916, 31 July 1916; 000/2019/15/1, 25 August 1916; 000/2019/37/2, 1 September 1916.

14 000/2019/37/2, 25 June 1916, 26 July 1916, 30 August 1916, 11 August 1916, 10 October 1916.

15 000/2019/37/2, 14 November 1916, 18 December 1916, 21 December 1916; 000/2019/15/1, 26 December 1916, 11 January 1917, 13 January 1917, 6 February 1917.

16 Wikipedia, 'Adrian Carton de Wiart'.

17 000/2019/37/2, 27 April 1917, 13 June 1917.

18 000/2019/37/2, 14 June 1917, 19–20 June 1917; 000/2019/37/3, 5 July 1917, 11 July 1917, 20 July 1917, 22 July 1917, 24 July 1917, 3 August 1917, 22 August 1917, 24 August 1917, 28 August 1917, 31 August 1917, 1 September 1917, 6–7 September 1917, 26 September 1917, 29 September 1917; Niall Ferguson, *The World's Banker: The History of the House of Rothschild* (1998), p.738; 000/2019/37/3, 30 September 1917, 5–6 October 1917, 13 October 1917, 16 October 1917.

19 000/2019/37/3, 9 November 1917; *Punch*, 7 November 1917.

20 Wikipedia, 'Balfour Declaration'; 000/2019/37/3, 10 November 1917, 15 November 1917, 18 November 1917.

21 *A Gilt-Edged Life*, p.18; 000/1590, file 1, 5 December 1917 (Fred Lawson to his father); 000/2019/37/3, 20 November 1917, 21 November 1917.

22 XI/35/74, 'Details of Military Service of Anthony G de Rothschild'; 000/2019/36/3, 2 July 1918, 31 July 1918, 16 August 1918, 21 August 1918; 000/2628/31, vol 2, 7 September 1939.

CHAPTER THREE: VERY HEAVY PAYMENTS

1 The Rothschild Archive, *A Place in Czech History – Yesterday and Today* (2000), unpaginated; David Kynaston, *The City of London, Volume 3: Illusions of Gold* (1999), pp.81–3.

2 000/2019/36/3, 4 October 1919; 000/2628/35/1, undated, 16 October 1923.

3 Ronald Palin, *Rothschild Relish* (1970), pp.118–21, 154.

4 000/977/1/284; Wikipedia, 'Basil Henriques'; Basil LQ Henriques, *The Indiscretions of a Warden* (1937), p.187.

5 000/2019/36/3, 9 October 1919, 31 July 1920.

6 XI/35/8, 11 November 1919; XI/35/28, 'Notes on Laerdal fishing 1923'.

7 *Country Life*, 26 July 1924; John Martin Robinson et al, *Ascott* (2008) p.14; *A Gilt-Edged Life*, p.15; Sir Alfred Munnings, *The Second Burst* (1951), pp.90–2; Wikipedia, 'Palace House, Newmarket, England'; 000/2628/50/1; *Times*, 1 May 1926.

8 Ferguson, *World's Banker*, p.1010; 000/2019/36/4, 30 March 1926; 000/2019/40/6, 11 April 1926, 13 April 1926; 000/2019/36/4, 16 April 1926.

9 *Jewish Graphic*, 11 June 1926; 000/2019/36/4, 16 June 1926; 000/2628/38/1, 6 July 1926; Regina Krahl, *The Anthony de Rothschild Collection of Chinese Ceramics: Volume One* (1996), p.IX; James Lees-Milne, *Midway on the Waves* (1985), pp.220–1.

10 Sonia Cahen d'Anvers, *Baboushka Remembers* (1972), pp.280, 285–6; Kenneth Rose, *Elusive Rothschild: The Life of Victor, Third Baron* (2003), p.197; Palin, *Relish*, pp.31, 57, 96, 66–7.

11 000/2019/37/2, 14 December 1916; 000/2019/36/3, 30 July 1924; 000/2628/35/1, 30 May 1928; 58/6,
 21 March 1961.
12 000/2019/36/4, 22 November 1926; *Illustrated London News*, 25 September 1926; 000/2019/36/4,
 10 February 1927; 10 February 1927, 16 September 1927; XI /35/9, 4 February 1928, 6 February 1928.
13 Victor Gray, *Bookmen: London* (2011) pp.267–8; XI/35/51, 16 January 1929; 000/2628/54, undated
 newspaper cutting.
14 000/2019/36/4, 25 February 1928, 26 September 1928, 18 March 1929, 10 September 1929,
 13 September 1929, 9 September 1930, 17 September 1930, 5 October 1930, 17 July 1931.
15 Palin, *Relish*, p.20; Niall Ferguson, *High Financier: The Lives and Times of Siegmund Warburg* (2010), p.42;
 XI/III/433, 1 November 1926; 000/2235/1, 6 August 1930.
16 000/2235/1, 29 August 1929, 25 November 1929, 9 December 1929, 20 January 1930, circa February
 1930, 3 November 1930, 6 February 1931, 17 April 1931.
17 Kynaston, *Illusions of Gold*, p.144; 000/2235/5, 12–13 September 1929; Bank of England Archive,
 ADM34/18, 13 September 1929; 000/2235/5, 13 September 1929; Bank of England Archive, ADM34/18,
 20 September 1929; 000/2235/1, 14 January 1930.
18 000/2019/36/4, 20 September 1929; 000/2235/5, 20 September 1929; Bank of England Archive,
 ADM34/18, 2 October 1929; 000/2235/1, 1 December 1930, 19 June 1931. Generally on Philip Hill,
 as well as the Woolworths issue, see Palin, *Relish*, pp.104–8.
19 XI/35/1, 7 May 1931; 000/2235/1, 10 October 1929, 15 May 1931; 000/2019/36/4, 26 May 1931, 31 May
 1931; Miriam Rothschild, *Dear Lord Rothschild: Birds, Butterflies and History* (1983), p.18; 000/300, 29 May
 1931 (and see also 31 May 1931, 20 May 1936); *Dear Lord Rothschild*, p.18. Generally on the Credit Anstalt
 crisis, see: Ferguson, *World's Banker*, pp.993–4; 000/1117 (31/44), especially for 'Chronology of Events'
 and the account by Michael Bonavia.
20 Bank of England Archive, ADM34/20, 28 July 1931; Kynaston, *Illusions*, pp.232–3; 000/2019/36/4,
 2 August 1931; Kynaston, *Illusions*, p.237; 000/2235/1, 18 August 1931, 7 September 1931;
 000/2628/34/2, 11 September 1931; 000/2019/36/4, 20 September 1931, 22 September 1931.

CHAPTER FOUR: A CLEAR AND LIMITED OBJECTIVE

1 000/2019/36/4, 19 September 1932; Michael Bonavia, *London Before I Forget* (Upton-upon-Severn,1990),
 chapter 8; 000/2235/2, 11 October 1932, 13 September 1934; 000/2235/4, 5 March 1937.
2 Ronald Palin, *Rothschild Relish* (1970), p.187; 000/2235/4, 25 October 1937; 000/2235/2, 4 October
 1932; 000/2235/3, 9 October 1936; 000/2235/5, 5 September 1938; 000/2628/31, vol 2, 26 March 1940.
3 000/2235/2, 25 September 1934; 000/2235/4, 15 January 1937, 3 September 1937; 58/6, 21 March 1961.
4 Michele Blagg, 'The Royal Mint Refinery, A Business Adapting to Change, 1919–1968' (King's College
 London PhD, 2013), p.115; 148/12, 2 January 1932; Blagg, p.115; 000/2235/2, 13 October 1933;
 XI/35/45, 4 April 1935; 000/2235/4, 23 August 1937, 27 August 1937.
5 'Lord Rothschild', *Times*, 22 March 1990; XI/III/870, 21 October 1937, 23–4 November 1937,
 10 August 1938; 000/2235/5, 20 September 1938.
6 000/2235/2, 30 August 1933; *Times*, 15 August 1934; 000/2019/36/4, 17 August 1934, 23 August 1935;
 000/2235/5, 25 August 1938, 12 September 1938; Kenneth Young (ed), *The Diaries of Sir Robert Bruce Lockhart,
 Volume One* (1973), p.406; 000/2235/5, 27 July 1939, 10 August 1939, 31 July 1939, 8–9 August 1939; XI/35/46,
 3 August 1939; David Kynaston, *The City of London, Volume III: Illusions of Gold, 1914–1945* (1999), p.461.
7 XI/35/44, October – November 1935; 000/292/4; XI/35/48; Victor Gray, *Bookmen: London* (2011),
 pp.306–7; *Illustrated London News*, 8 January 1938; Christopher Tyerman, *A History of Harrow School,
 1329–1991* (Oxford, 2000), pp.426–7.
8 Regina Krahl, *The Anthony de Rothschild Collection of Chinese Ceramics: Volume One* (1996), p.XI; *Country Life*,
 8 September 1950; XI/35/28, 2 September 1936, 8 October 1936.
9 XI/35/75, 'Palace House 1932', 'Southcourt Stud, January 1937'; XI/35/49, 14 March 1932; *Daily
 Telegraph* 12 July 1932; Wikipedia, 'Solario'; XI/35/75, 6 July 1936, 17 July 1936; *Daily Telegraph*, 4/5
 August 1936, 22 September 1936.
10 XI/35/30; John Martin Robinson et al, *Ascott* (2008), p.10; XI/35/55, 11 June 1937, 26 July 1937,
 7 March 1938, 1 September 1938; XI/35/15, 10 August 1939.

11 000/2019/36/4, 12 September 1933, 30 September 1933, 4 August 1936; XI/35/47, 16 March 1937, 5 April 1939, 2 May 1939, 27 July 1939.

12 Amy Zahl Gottlieb, *Men of Vision: Anglo-Jewry's Aid to Victims of the Nazi Regime, 1933–1945* (1998), pp.199–200, 234, 29–31.

13 000/2019/36/4, 21 August 1933; Gottlieb, *Vision*, p.25; XI/35/3, 13 August 1933, 16 August 1933, 21 August 1933; 000/2019/36/4, 21 August 1933.

14 Miriam Rothschild, *Dear Lord Rothschild: Birds, Butterflies and History* (1983) p.279; Gabriel Sheffer (ed), *The Letters and Papers of Chaim Weizmann, Volume XVI* (New Brunswick, 1978), pp.192–3, 200, 388.

15 Gottlieb, *Vision*, pp.57–8; 000/2235/2, 17 December 1935; 000/2235/3, 20 January 1936, 17 August 1936, 21 August 1936; 000/2235/4, 19 July 1937; 000/2235/5, 25 March 1938.

16 Gottlieb, *Vision*, p.92; XI/35/78, 24 January 1939; XI/35/80, 9 February 1939.

17 XI/35/46, including Dr Radcliffe N Salaman to Earl of Rosebery, 1 July 1939; Alison Hayes, 'New project delves into hidden history of Newmarket's Palace House when it was a haven for Jews fleeing the Nazis' (Iliffe Publishing, Cambridge, 24 May 2021).

CHAPTER FIVE: ONE CAN ONLY HOPE AND PRAY

1 000/2628/31, vol 2, 1–3 September 1939.

2 XI/35/18, 13 December 1939; *Wikipedia*,' Palace House, Newmarket, England'; John Martin Robinson et al, *Ascott* (2008), p.10; recollection of Geoffrey Bond; Ronald Palin, *Rothschild Relish* (1970), p.143.

3 000/2628/31, vol 2, 5–8 September 1939, 10 September 1939, 12 September 1939, 18 September 1939, 20 September 1939, 1–2 October 1939, 4–4 October 1939, 21 October 1939, 25 October 1939, 29 October 1939, 7 November 1939, 12 November 1939, 17 November 1939, 28 November 1939, 30 November 1939, 15 December 1939, 24 December 1939.

4 Amy Zahl Gottlieb, *Men of Vision: Anglo-Jewry's Aid to Victims of the Nazi Regime* (1998), pp.149–51; 000/2628/31, vol 2, 21 November 1939; Gottlieb, *Vision*, pp.152–60; 000/2628/57/7, 12 February 1940; *Manchester Guardian*, 8 February 1940; Gottlieb, *Vision*, pp.161–3; 000/2628/31, vol 2, 10 January 1940, 3 October 1939; XI/35/18, 22 December 1939, 25 January 1940; 000/2628/31, vol 2, 16 January 1940, 16 February 1940.

5 XI/35/18, 16 February 1940, 19 February 1940, 22 February 1940; Anthony Grenville, 'Lutz Weltmann: A forgotten voice', *AJR Journal* (February 2012), pp.1–2; XI/35/19, 26 March 1940 (to 'Gerald'), 20 March 1940.

6 000/2628/31, vol 2, 2 January 1940, 5 January 1940, 9 January 1940, 20 January 1940, 22 January 1940, 24 January 1940, 26 January 1940, 5 February 1940; Niall Ferguson, *High Financier: The Lives and Times of Siegmund Warburg* (2010), p.123; 000/2628/31, vol 2, 14 February 1940, 28 February 1940, 11 March 1940, 4 April 1940, 13 April 1940, 28 April 1940, 2 May 1940, 8 May 1940, 10 May 1940.

7 XI/35/18, 24 December 1940; XI/35/81, 18 February 1941, 13 March 1941, 15 July 1941.

8 XI/35/18, 27 June 1940; XI/35/13, 28 August 1940; XI/35/81, 20 October 1941; XI/35/18, 8 January 1941.

9 XI/35/18, 10 December 1940, 24 December 1940; XI/35/81, 8 July 1941, 9 September 1941, 15 September 1941, 7 October 1941.

10 Michele Blagg, 'The Royal Mint Refinery, A Business Adapting To Change, 1919–1968' (King's College London PhD, 2013), p.165; XI/35/53, 30 December 1940; Mrs Robert Henrey, *London Under Fire, 1940–45* (1969), pp.45–6; XI/35/81, 7 January 1941.

11 XI/35/62, 16 December 1940, 12 February 1941; XI/35/61, 19 August 1941, 5 September 1941; Michael J Cohen (ed), *The Letters and Papers of Chaim Weizmann, Volume XX* (New Brunswick, 1979), pp.200–1; XI/35/61, 3 December 1941; XI/35/63, 17 December 1941.

12 Palin, *Relish*, p.154; Bank of England Archive, ADM34/30, 2 December 1941; Kenneth Rose, *Elusive Rothschild: The Life of Victor, Third Baron* (2003) p.202; XI/35/14, 30 January 1942.

13 Edmund de Rothschild, *A Gilt-Edged Life* (1998), p.165; Bank of England Archive, ADM34/31, 15 April 1942, 8 September 1942, 10 September 1942, 2 October 1942, 23 October 1942, ADM34/32, 21 January 1943; 58/6, 8 February 1961.

14 XI/35/84, 5 June 1942; XI/35/53, 2 January 1942; XI/35/69; XI/35/65, 22 August 1944; XI/35/89; XI/35/82, 23 December 1943, 9 April 1943, 19 April 1943, 8 June 1943, 22 July 1943, 23 August 1943; 000/2628/35/3, 7 July 1944.

15 XI/35/67, 26 January 1943, 2 February 1943, 16 March 1943; XI/35/82, 29 July 1943; XI/35/84, 4 January 1945, 6 February 1945, 13 March 1945.

16 XI/35/82, 25 August 1942, 7 January 1943, 23 March 1943; XI/35/83, 13 June 1944; 000/2628/35/3, 13 October 1944; X/III/908, undated memo, circa 1944; Michele Blagg, 'Rothschild and the Royal Mint Refinery', London's Industrial Archaeology (15), 2017, p.8.

17 XI/35/82, 2 July 1943, 29 October 1943; 000/2628/35/3, 5 April 1944; XI/35/83, 13 June 1944; 000/2628/35/3, 28 July 1944, 4 August 1944, 1 September 1944, 6 December 1944, 12 April 1945; John Colville, The Fringes of Power: Downing Street Diaries, 1939–1955 (2004), p.564.

CHAPTER SIX: NO REASON FOR NOT BEING AN OPTIMIST

1 000/2628/35/3, 11 May 1945, 8 June 1945, 6 July 1945; David Kynaston, The City of London, Volume IV: A Club No More, 1945–2000 (2001) p.9; XI/35/85, 16 January 1946, 12 April 1946; XI/35/117, 13 March 1952.

2 Ronald Palin, Rothschild Relish (1970), pp.185–7; Edmund de Rothschild, A Gilt-Edged Life (1998) p.144; 000/1373/10/5, 22 December 1949; XI/35/110, 8 February 1950; Kynaston, Club, p.215.

3 000/191, 12 July 1946; Gilt-Edged, pp.165–6; Kenneth Rose, Elusive Rothschild; The Life of Victor, Third Baron (2003), pp.199–200; XI/35/86, 19 May 1947.

4 Palin, Relish, pp.182–3.

5 Gilt-Edged, p.137; XI/35/117, 5 May 1952, 6 June 1952; XI/III/1172, 6 February 1953; XI/35/145, 8–9 June 1954.

6 000/2235/6, 3 February 1953, 19 March 1953, 2 April 1953; Bank of England Archive, G3/III, 2 March 1954; Gilt-Edged, pp.145–56; Times, 12 March 1953; Palin, Relish p.183.

7 000/2628/35/3, 15 May 1945.

8 1/284 (000/977)

9 XI/35/84, 22 June 1945; XI/35/88, 3 December 1946; XI/35/85, 1 May 1946; 'Mr Anthony de Rothschild,' Times, 6 February 1961; XI/35/110, 2 May 1950; Wikipedia, 'Palace House, Newmarket, England'.

10 XI/35/85, 11 July 1946; XI/35/86, 23 January 1947; XI/35/110, 10 May 1950; Times, 4 May 1948; XI/35/87, 4 May 1948.

11 XI/35/89, 1 June 1945: XI/35/113, 21 June 1951, 7 December 1951.

12 XI/35/89, 13 December 1945, 15 December 1945; XI/35/110, 27 February 1950, 10 March 1950.

13 XI/35/85, 30 September 1946; XI/35/86, 26 September 1947, 20 December 1947; XI/35/93, 24 March 1949.

14 XI/35/85, 28 January 1946, 11 June 1946; XI/35/86, 20 December 1947; XI/35/87, 27 September 1948; John Colville, The Fringes of Power: Downing Street Diaries, 1939–1955 (2004), p.585; Sonia Cahen d'Anvers, Baboushka Remembers (1972), pp.265–6, 269–70; XI/35/87, 9 April 1948; XI/35/93, 5 May 1949; 000/924/20/9, 21 June 1949, 12 June 1950, 9 June 1952.

15 James Lees-Milne, Midway on the Waves (1985), pp.220–1; Gilt-Edged, p.125; 000/1373/10/5, November 1949 (exact date unclear); Country Life, 15 September 1950; XI/35/110, 6 November 1950.

16 XI/35/110, 13 October 1950, 20 October 1950; XI/35/117, 2 July 1951, 13 July 1951, 17 July 1951, 7 August 1951, 25 September 1951, 10 March 1952, 7 April 1952, 16 April 1952, 21 April 1952, 20 May 1952, 27 June 1952.

17 Baboushka Remembers, p.286; XI/35/145, 22 March 1954, 30 September 1954; Palin, Relish, p.185; 000/2628/30, February–April 1955; XI/35/148, 1 April 1955, 3 June 1955, 9 June 1955.

18 Gilt-Edged, p.181; XI/35/148, 15 June 1955, 23 June 1955; 5 July 1955 (Eddy to Guy, uncatalogued material); 000/2628/40, 10 October 1955, 15 November 1955, 21 November 1955, 20 December 1955, 19 December 1955.

19 XI/35/148, 13 March 1956, 20 June 1956, 18 December 1956; XI/35/165, 18 June 1958, 29 March 1960.

20 Financial Times, 1 July 1960; Palin, Relish, p.184; 'Mr Anthony de Rothschild', Times, 6 February 1961; 58/6, 6 February 1961 (AL Boor).

Index

ABOUT THE AUTHOR

David Kynaston has been a professional historian since 1973. His many books include a four-volume history of the City of London, the centenary history of the *Financial Times*, and a history of the Bank of England. He is currently engaged on a multi-volume history of post-war Britain, so far reaching 1962.

BANKER AND PHILANTHROPIST

First published in 2022 by Hurtwood Press, London

ISBN 978-0-903696-56-2

© 2022 The Rothschild Archive

Edited by Vaughan O'Grady

Designed by Sally McIntosh

Produced by Hurtwood, London